BEDROCK

THE MAKING OF A PUBLIC GARDEN

JILL NOONEY

Peter E. Randall Publisher
Portsmouth, New Hampshire
2025

© 2025 Jill Nooney

All rights reserved. No part of this publication may be reproduced, distributed, or transmitted in any form or by any means, including photocopying, recording, or other electronic or mechanical methods, without the prior written permission of the publisher, except in the case of brief quotations embodied in critical reviews and certain other noncommercial uses permitted by copyright law.

ISBN: 978-1-942155-81-2
Library of Congress Control Number: 2024917279

Published by
Peter E. Randall Publisher LLC
Portsmouth, NH 03801
www.perpublisher.com

Editor: Andi Axman
Photography Editor: John W. Hession
Book and Cover Design: Alicen Armstrong Brown

Visit https://www.bedrockgardens.org/ for more information.

Printed in China

Cultivation is just another word for commitment. You think you are just pulling weeds, but what you are really doing is writing a love letter to your patch of earth.

—Thomas Rainer, landscape architect

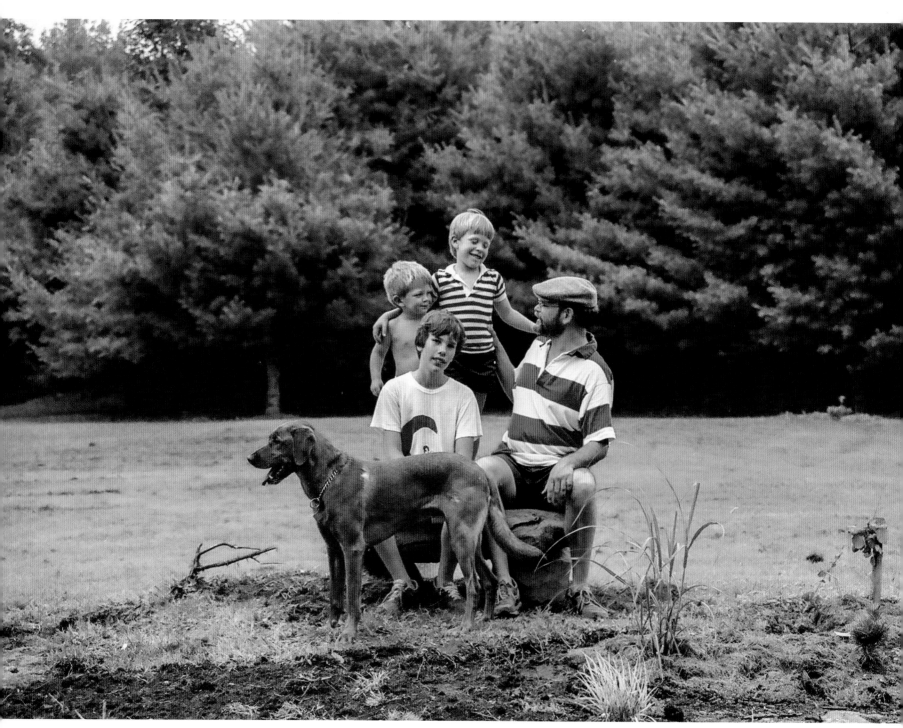

Bob and the boys, Rob, Dylan, Spencer, and Finnegan the dog.

To Bob, the love of my life
and maker of dreams,
and to my other Loves
Rob, Spencer, Dylan, Oren, and John.

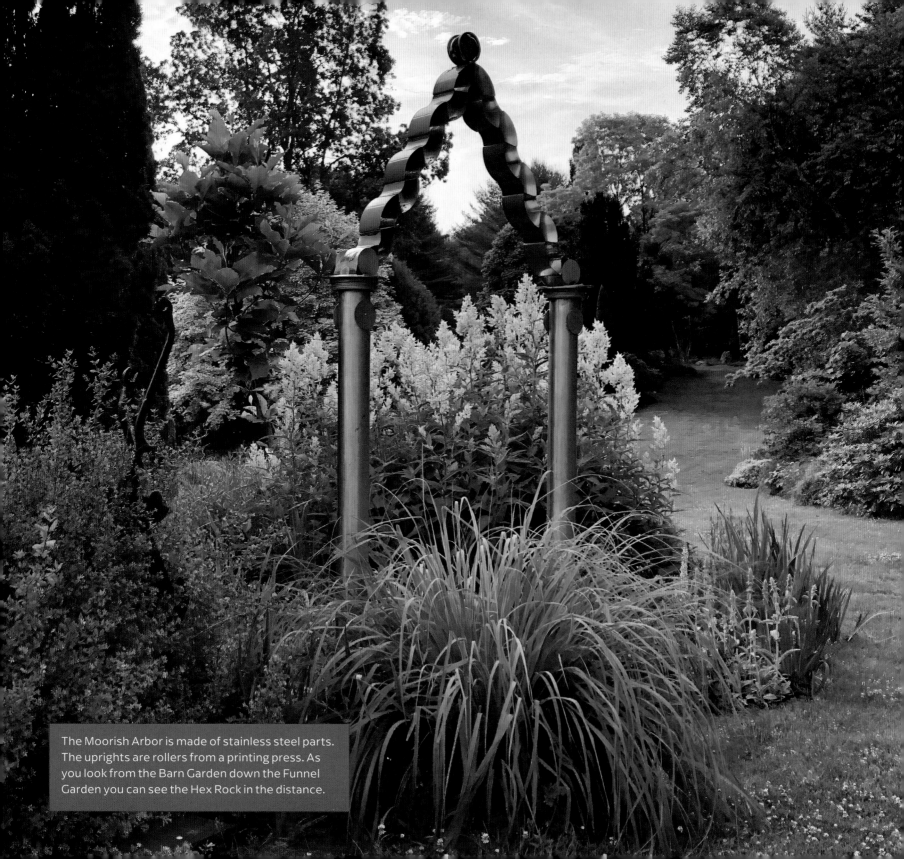

The Moorish Arbor is made of stainless steel parts. The uprights are rollers from a printing press. As you look from the Barn Garden down the Funnel Garden you can see the Hex Rock in the distance.

TABLE OF CONTENTS

Acknowledgements..................................ix
Foreword .. x
Map of Bedrock Gardens xii
Introduction xv

I. The Germination of Bedrock Gardens1
 Sense of place 3
 My first garden.................................. 3
 Finding the house in Lee 4
 Clearing fields................................... 7
 Existing plant materials.......................... 7
 The first flower garden 8
 The Radcliffe Seminars Program
 in Landscape Design 8
 Bob... 13
 Bob's and my work life14
 Plant collecting14
 Plant hunting16
 Art in the garden................................21
 Naming parts of the garden 28
 Connect the dots 29
 The Zipper 30
 Lumbering 30

II. The Blossoming of Bedrock Gardens 34
 1 Welcome Court 36
 2 Forest Bathing Path...........................41
 3 Nexus and Gothic Arbor 42
 4, 5 Termi and Pond........................... 46
 6 Allée... 54
 7 Dark Woods 65
 8 Baxis 70

 9 Torii..75
 10 Belvedere and Eyebrow Wall.................81
 11 Spiral Garden.............................. 82
 12 Funnel Gardens 86
 13 The Swaleway 90
 14 Straight and Narrow 93
 15 Parterre97
 16 Barn Garden, Metal Folk,
 the Wave and the Guinea Hens 103
 17, 18 Landing and Rock Garden112
 19 Belgian Fence 120
 20 The Garish Garden 125
 21, 23 Wiggle Waggle and CopTop............ 129
 22 Pate and Hives 136
 24 GrassAcre141
 25 ConeTown151
 26 Shrubaria 156
 27 Petit Pond................................. 158
 27 Tea House................................. 167
 28 The Fernery and the Stumpery 176

III. Impermanence and Evolution................. 181
 Repairing things 182
 Garden maintenance 185
 WIPs ... 192

IV. Becoming a Public Garden 194
 Looking to the future 196
 Volunteers200
 Photo Credits 201
 Reflections................................... 203
 About the Author204

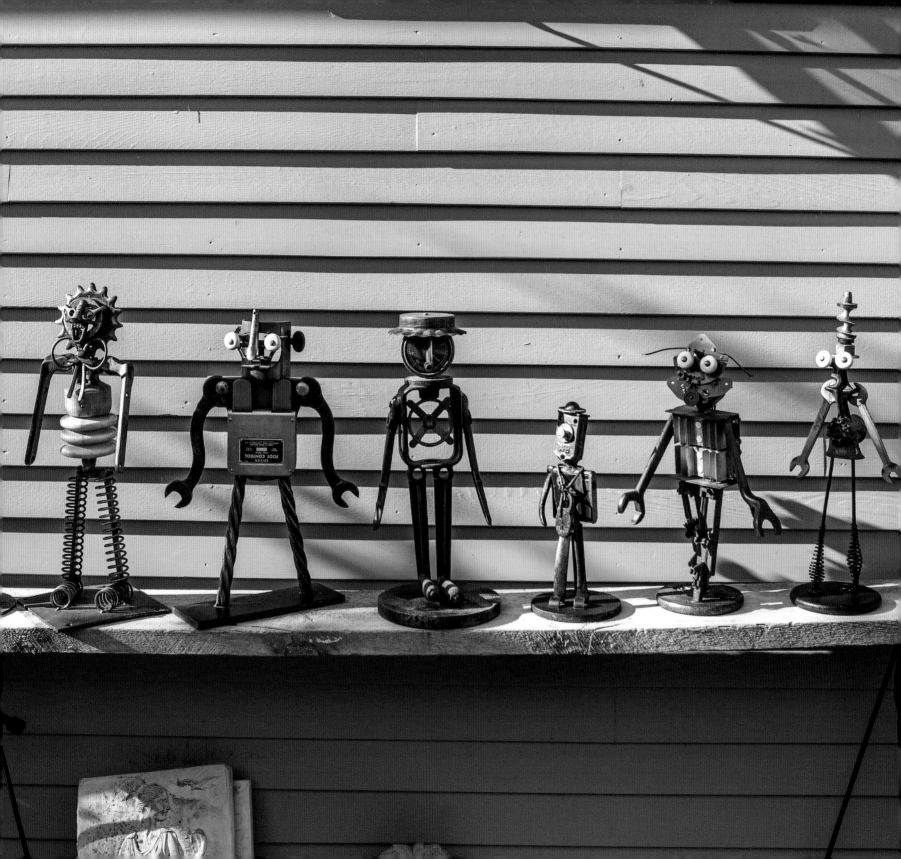

ACKNOWLEDGEMENTS

There are a few people who have been key to making this book.

The first is Steve Lydenberg, my husband Bob Munger's cousin, who was an early supporter of Bedrock Gardens before it was open to the public. He saw its potential to mean so much to so many people. In his softspoken but powerful way, he said the garden needs a book, whether you want to write it or not. He quietly did not let it drop.

Another is John W. Hession, whose patient and steadfast dedication to the book's photographic excellence was a revelation.

Alicen Armstrong Brown contributed her keen eye and book-crafting skills to the design and beautiful layout of the pages.

But there is only one person who made this book happen; Andi Axman. As a seasoned editor she was not put off by my jumbled manuscript. In her calm, focused, and intelligent way, she crafted the story into a cohesive whole, something I could never have done myself and had all but given up on. Her sensitivity, generosity, and commitment to the project—and indeed to the garden itself—have sustained this project.

FOREWORD

Great gardens are often the product of two people. Vita Sackville-West and Harold Nicholson, the creators of England's iconic Sissinghurst, come to mind as one such pairing. But so do American gardeners Ione and Emmett Chase, whose artful garden outside of Tacoma, Washington, brings together two distinct spirits—that of the artist and the engineer. Like the Chases, Jill Nooney and Bob Munger of Bedrock Gardens in Lee, New Hampshire, paired their disparate skills and created a garden that celebrates the vision of a creative spirit (Jill) as well as the pragmatism of a scientist (Bob). To my mind, however, the Americans in this comparison brought something different to these gardens than their British forebearers—the American gardens are distinctive by how their design feels connected to individual spirit rather than the gentility of the ruling classes.

I came to know Jill and Bob through my work as a garden writer and as preservationist for the Garden Conservancy. In 2016, Jill, Bob, and I invited a small group of public garden professionals to visit Bedrock Gardens to create a plan for turning their private landscape into a public garden. We spent the weekend touring the various areas of the garden, learning the history and evolution of the spaces they had created together, and coming to see the distinct roles each of the garden makers played in the composition of Bedrock Gardens. The goal of this committee was to understand what made Bedrock Gardens unique and to understand what it could share with its visitors. It felt unlike many of the traditional public gardens that most of

us knew. Although it held a broad range of trees, shrubs, perennials, and grasses, what Jill and Bob had created was not a collection in the scientific sense of a botanical garden. And although beautiful and artful in its plantings, it was not merely a pretty landscape. The garden was about something more, something harder to articulate. There was a spirit at work in the garden that was intoxicating.

It was not until we sat down after touring the ponds, earth forms, and waterways engineered by Bob, and visiting Jill's workshop, where she created the many sculptures that inhabited the garden—often from the recycled parts of farm equipment—that we came to understand what the garden was stirring within us. As a group more accustomed to examining the horticultural aspects of a garden, we were used to admiring a well-grown specimen or a rare variety in top form. Bedrock Gardens was undoubtedly filled with such plants, but what really took hold for all of us was how the garden inspired a desire to create within each of us. It called on us to use whatever artistry or skills we had to shape and change the landscape. This garden was not just an act of stewardship or the product of simple horticultural accumulation. It was an expressive space that charged its visitors to want to explore what is involved in creating a landscape of their own and to create something that has meaning for them.

It brought to mind the creations of other artists. It had the playfulness of Madoo, the painter Robert Dash's playful folly of a garden with its fauvist tones and artful plantings in New York; the expressiveness of Prospect Cottage, the filmmaker Derek Jarman's spare cinematographic seaside garden in England; and the majesty of the Garden of Cosmic Speculation, architect Charles Jencks's engineered and sculpted postmodern garden of landforms and bridges in Scotland. Each of these landscapes was built to express a unique and personal vision—as expressive as a painting—that takes visitors into the mind and worldview of their creators. These gardens, and Bedrock Gardens, were not simply gardens for horticultural obsessives. They did not require visitors to have a deep knowledge of the plants they contained but instead invited visitors to see each plant, each mindfully placed stone, and each carefully sited artwork—and the world—from a new perspective, all while appreciating how each component contributed to the garden's vision.

Such landscapes remind me of childhood jaunts into the woods with a friend, creating magical spaces to play, imagine, and rethink the world from which we had escaped. But they also connected me to something more: a sense of free-spirited play, the innate creativity we can tap into when we allow ourselves the opportunity to do so, and the confidence that such efforts often exude. Bedrock Gardens made me feel empowered to help shape and create the world we live in and to comprehend what one or two people can do to make the world a more magical place for us all.

— *Lee Buttala, June 2024*

1. Welcome Court
2. Forest Bathing Path
3. The Nexus and Gothic Arbor
4. Termi
5. Pond
6. Allée
7. Dark Woods
8. Baxis
9. Torii
10. Belvedere
11. Spiral Garden
12. Funnel Gardens
13. Swaleway
14. Straight and Narrow
15. Parterre
16. Wave and Metal Folk
17. Landing
18. Rock Garden
19. Belgian Fence
20. Garish Garden
21. Wiggle Waggle
22. Pate and Hives
23. CopTop
24. GrassAcre
25. ConeTown
26. Shrubaria
27. Petit Pond and Tea House
28. Fernery and Stumpery
29. Exit to parking area

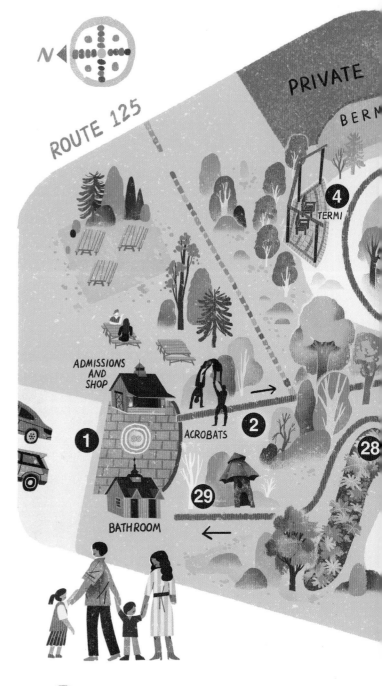

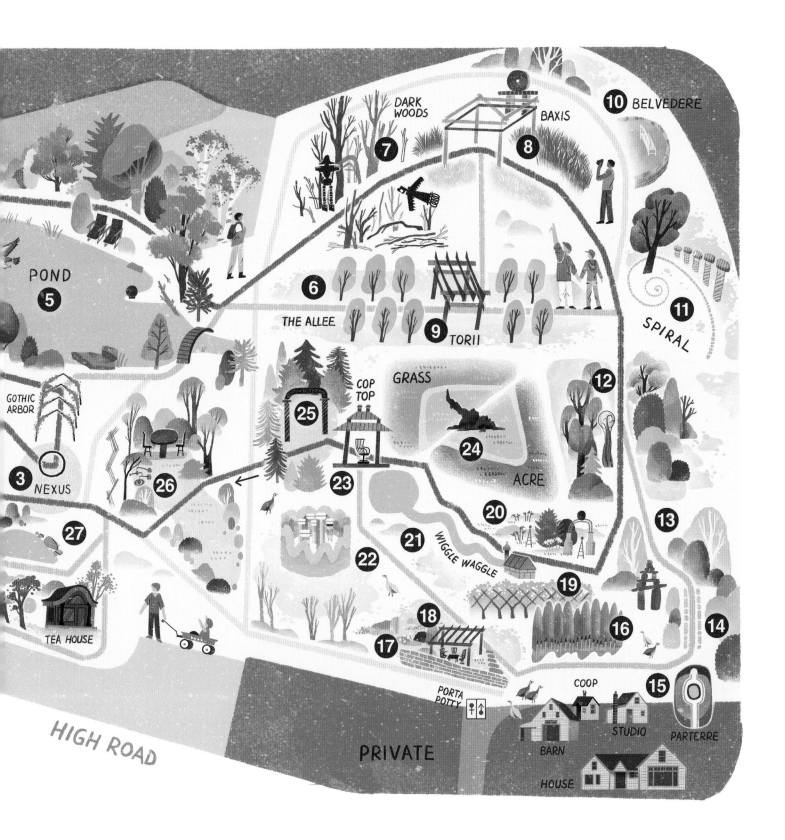

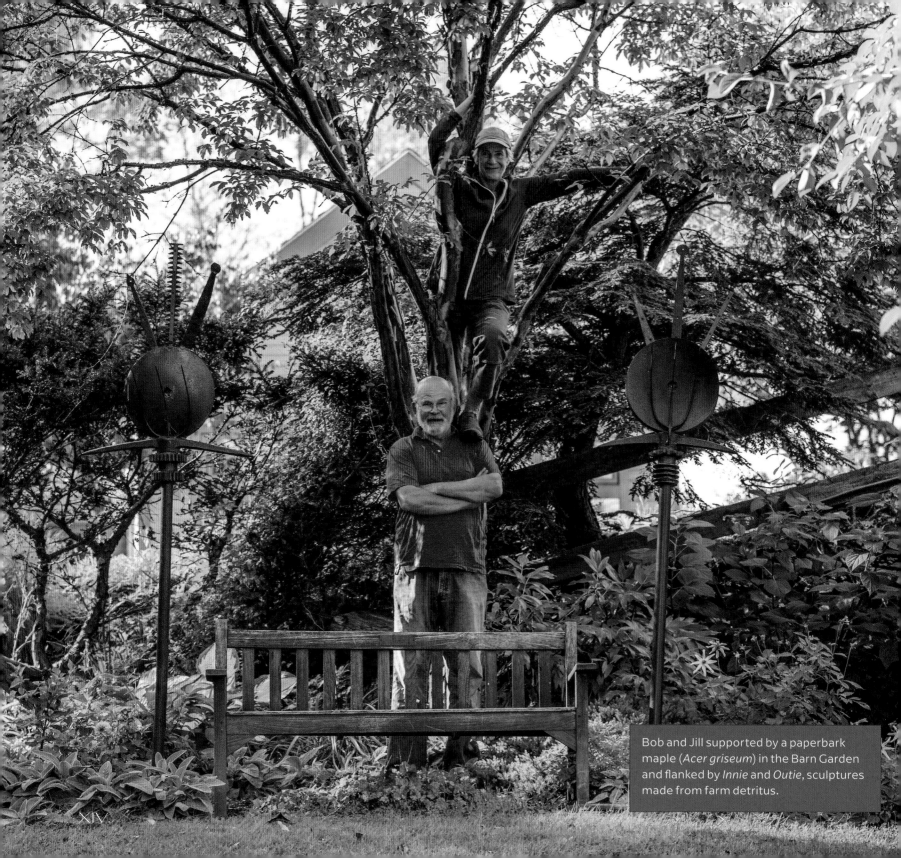

Bob and Jill supported by a paperbark maple (*Acer griseum*) in the Barn Garden and flanked by *Innie* and *Outie*, sculptures made from farm detritus.

INTRODUCTION

When people ask why I created Bedrock Gardens, I tell them the garden provides a healing place of solace. It keeps me company in my worst times, with its pulsing chlorophyll and stunning beauty.

Of course I created the garden to indulge my artistic juices and my plant-collecting lust, as well as to be a repository for my restless energy. But the real reason I created the garden is to bring me some peace and soothe my soul. This garden was to be my private sanctuary, my retreat, a place of beauty, calm, and sustenance.

I have been drawn to plants and gardens for as long as I can remember. It seems inevitable that I would have a big garden if I had the opportunity.

My partner on this journey is Bob Munger, my clever husband, who says, "If you can dream it up, I can make it happen." He solves problems as a hobby and to put himself to sleep. What would keep most of us awake, relaxes him. He might be the most patient person I know, as he chews away at problems without getting irritated. He is an all-around exceptional person, and we really are a dream team. Bedrock Gardens has been our love affair with this piece of land.

We named our creation Bedrock Gardens because bedrock breaches the ground nearly everywhere—prominent in some places and frequently under a thin blanket of soil. We have a marriage of push-pull with bedrock, mostly of accommodation, with the occasional ultimatum of dynamite for the addition to our home's family room and the parking lot. But the name has taken on deeper significance as life wears on. This is where we raised our family and buried the ashes of my mother, father, best friend, and now our sweet son. This is where I have been free to do whatever I want, in peace. Bedrock Gardens has been my anchor.

How the public came to know about the garden was an unanticipated result of starting a business on the property.

In 1997, a friend and I began selling garden art—garden antiques initially, followed by my own works, which were made primarily out of old farm equipment. We held open houses twice a year on the property, using the garden as a gallery to feature my sculptures. Since business was slow, I offered garden tours in the morning and afternoon. Visitors started to come for the tours, and not necessarily to purchase art.

When I got over the fact that I wasn't selling more art, I began to listen to what visitors were saying about the garden. I didn't believe them; their comments felt like flattery, hyperbole. I was suspicious. We were looking at the same garden, and they saw something completely different. I saw the weeds, the plants that needed rearranging, and all the works-in-progress screaming for attention. One guy said he could feel the love and swished his arm around the ground like he was walking in a cloud.

But I knew he was right. I had come to believe him and the others. The garden brought a sense of peace, calm, and delight to so many of them.

After hearing enough of this kind of feedback, I began to ask what right do we have to keep this for ourselves. And, by the way, what are we going to do with the garden in the future? I have always felt land cannot be truly owned, but rather we borrow it for a while like those before us and those who come after. We are all just passing through.

In 2011, we began a ten-year process of nurturing a grassroots organization of folks interested in turning Bedrock Gardens into a public garden. By 2016, it was time to fish or cut bait. Did we have a fighting chance to pull this off? To provide direction I invited leaders of public gardens in the area to what we called a two-day summit. And we asked them, "Do we?"

"Most private gardens don't have a chance," said Bill Cullina, then of Coastal Maine Botanical Gardens. "But the combination of unusual horticulture, a unique art collection, and original garden design makes your chances good."

So we went from being open one weekend a month to two weekends a month.

Our popularity grew rapidly, but so did our problems.

One year, visitors had to park three miles away and take a shuttle bus to the garden. Once, police had to direct traffic. It became clear that we needed to build a parking lot.

This set us on a lengthy process of seeking approval from the town boards, which included expert testimony by a traffic engineer, the state fire marshal, a civil engineer, two lawyers, and the New Hampshire commissioner of agriculture. Our lawyer said a typical approval for a new Walmart

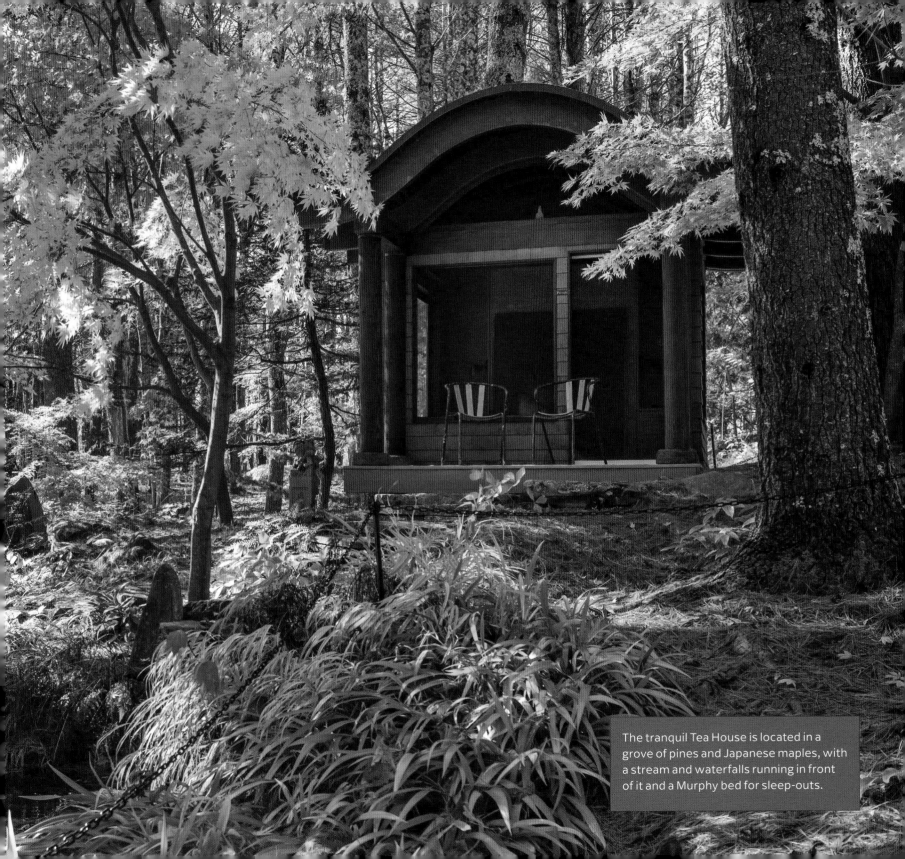

The tranquil Tea House is located in a grove of pines and Japanese maples, with a stream and waterfalls running in front of it and a Murphy bed for sleep-outs.

The Gill School
STRONGHOLD
BERNARDSVILLE, NEW JERSEY

NURSERY

FINAL REPORT - JUNE 1953

JILL NOONEY

Jill is our little flower girl. She brings flowers from home, takes them back again at noon along with the new ones she has just picked. She is **always** carrying flowers.

Jill is a very lovable little child - dainty and graceful in everything she does. She has a good sense of humor and gets along with others, winning new friends easily.

MRS. KOCH

store is between four and five planning board meetings. We endured twenty-two over the course of almost two years. This was excruciating.

Bill also said few gardens have the support and resources to overcome the obstacles often inevitable in becoming a public garden.

So how did we do it?

With a lot of help from our friends. One friend, a future Bedrock Gardens board member, came to the donation tent and, without experiencing more than the driveway, said, "I would like to make a $250 donation."

Another, a recent transplant from Alaska, asked, "What is this place?" I cheekily said, "Why don't you come to a board meeting tomorrow?" He did, and became a board member the next day.

When the planning board wanted verification of the suitability of my landscape design plan from a "professional," a friend volunteered. Many contributed generously to our start-up costs, others spoke on our behalf at the planning board meetings, and still others were ready with hugs of support.

When faced with the daunting cost of construction, an angel jumped in and single-handedly pushed us over the starting line. That was astonishing.

And there are so many more angels. I like to say that we have done the easy part in creating the garden, and it is our donors, visitors, volunteers, and members who do the hard work of ensuring its future.

In June 2023, Bob and I gifted most of the garden to the nonprofit Friends of Bedrock Gardens.

My impetus for writing this book was to create a gift for visitors who are so appreciative and supportive of the garden and curious to know how it came about. It is also my hope that by knowing the garden more deeply, folks will be moved to help preserve it past our short lifespans. That is a pleasant thought with which to leave this Earth.

—*Jill Nooney, 2024*

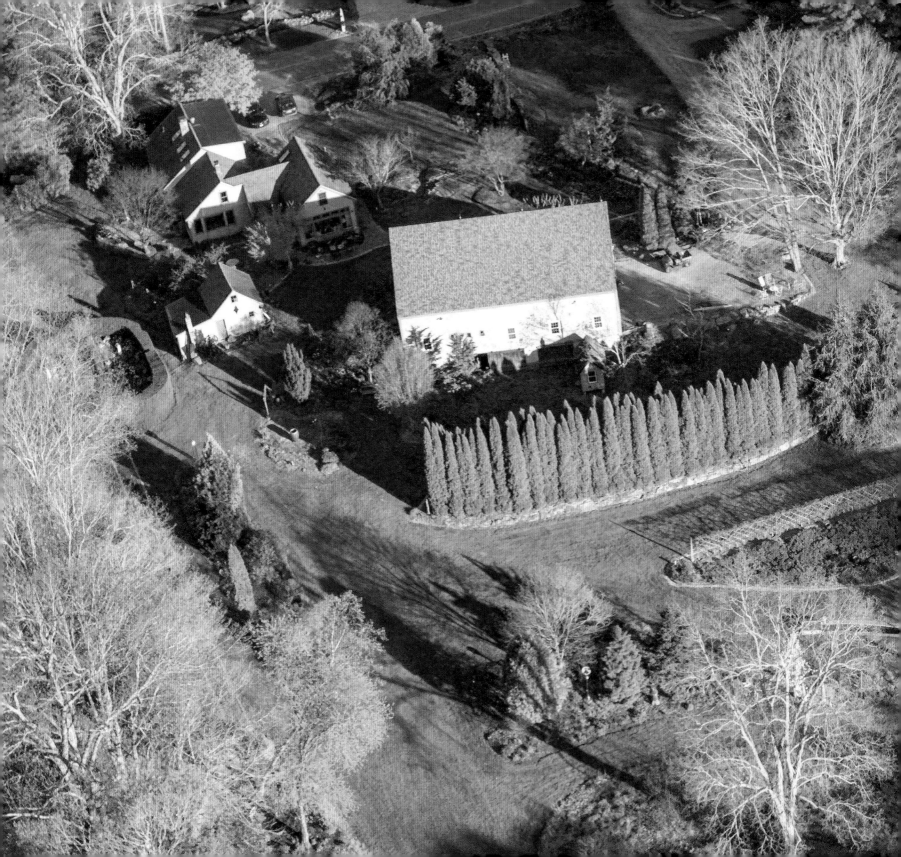

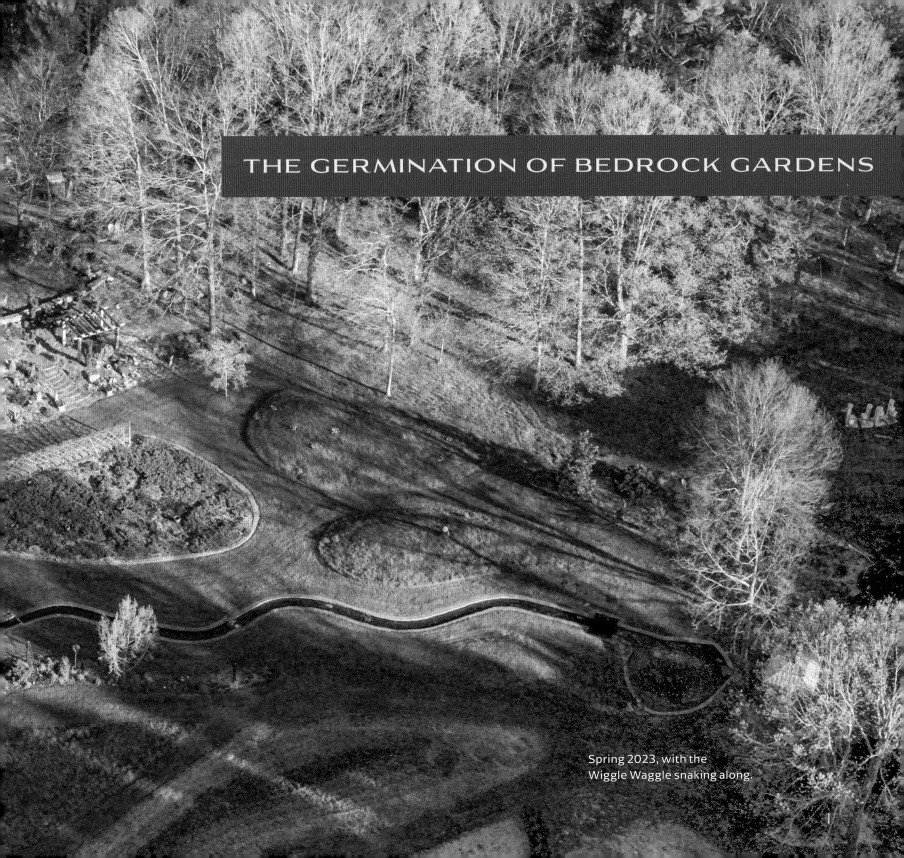

THE GERMINATION OF BEDROCK GARDENS

Spring 2023, with the Wiggle Waggle snaking along.

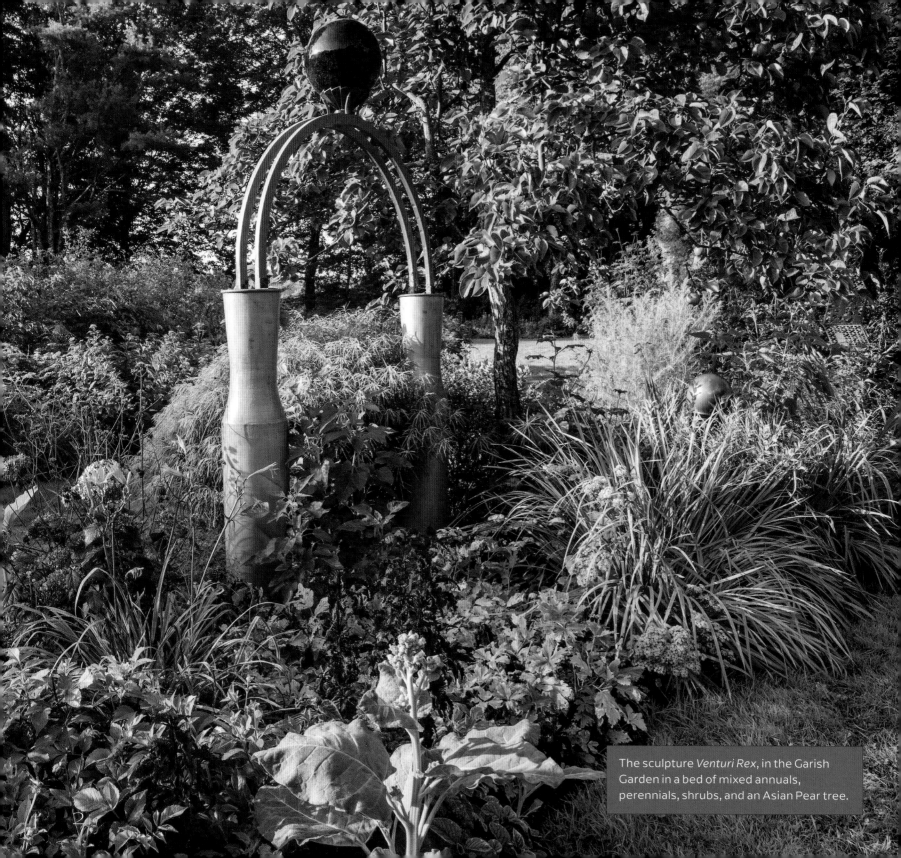

The sculpture *Venturi Rex*, in the Garish Garden in a bed of mixed annuals, perennials, shrubs, and an Asian Pear tree.

SENSE OF PLACE

My mother grew up in Germany and Switzerland. She was a confident, self-reliant, no-nonsense person who approached childrearing with a firm hand. She believed in getting fresh air and talked about bundling us kids in a carriage, and sitting outside on a sunny winter day.

I grew up at a time when parents were comfortable letting kids play outside all day. We did not have a television—the outdoors was our playground, and we came up with plenty of things to amuse ourselves. We wandered around the woods, climbed trees, made ink out of pokeberries, fashioned a fort under an overgrown forsythia, wrote a letter on birch bark (in those days you could send one in the mail), found deer antlers, caught lightning bugs, and ate the neighbor's apples. I vividly remember lying under a pear tree in full bloom as the petals snowed down on me.

We lived in New Jersey, across the street from the Passaic River in its brook stage, which provided swimming and many other adventures. We dammed up a shallow part with rocks hauled from the bottom, caught crawfish, and made a cabin from logs that were washed up in the spring—complete with a roof of sticks and a moss carpet. We made a seemingly huge teepee out of branches that we covered in bedspreads. We built a fort high in the crotch of a tree, with a rope to slide down.

Pre-Barbie dolls, we invented a beauty parlor game of braiding, cutting, and fussing with the long "hair" of hummock grass. In a wet spot in the field, I harvested some mud and mixed it with grass, forming mud men, which I placed on the tin roof over our entranceway to bake. At that time, our area was experiencing an explosion of tent caterpillars and our neighbors, the Davises, paid us a penny for each egg mass. Their apple trees were loaded with these shellacked egg masses. Still now, I have a little thrill of discovery when I see them in my crabapple trees.

I feel fortunate to have lived in one place for my first eighteen years, getting to know the nooks and crannies of the seven acres we lived on. But by far, what stands out most in my many childhood memories was building my first garden.

MY FIRST GARDEN

When I was nine, my mother, a capable gardener, indulged my urge to dig up plants by the side of the road and in the woods. We piled them in the back of our station wagon, and she helped me plant them on a slope behind the house. Our collection included white birch saplings, wild geraniums, partridgeberry, Jack-in-the-pulpits, sheets of moss, chunks of white quartz, and sparkling mica-filled rocks. My mother helped me make stone steps leading five to six feet up the slope. I loved this spot, which brought me tremendous comfort as well as continual interest. Sometimes with a book or homework, I would lay down my blanket and examine things, pick out leaves, add moss, and see what was coming up (really not so different from my today self).

Since our 1600s farmhouse was built into a hill, the back window in my bedroom was at ground level and hinged like a door. It was a wonderful room, the size of a walk-in closet,

in the corner of the house with windows on two sides. My private egress lent a particularly delicious sense of secrecy to my garden, my *hortus conclusus*, or enclosed garden. On the few occasions I was sent to my room, I felt like I had won because I was in my little garden.

FINDING THE HOUSE IN LEE

Fast-forward twenty-five years, and we had become desperate to find a home in a housing market that excluded folks like us with moderate salaries. I would drive around the back roads near Epping, New Hampshire, where we lived, and look at houses. A house nearby in Lee really spoke to me because it reminded me so much of the house I grew up in. It was an authentic Cape Cod–style home just oozing history, with a gigantic old tree hanging over part of it. This house created an intense yearning in me. I almost didn't want to look at it for fear of jinxing our chances of ever owning it. I always felt I was meant to live in a house exactly like

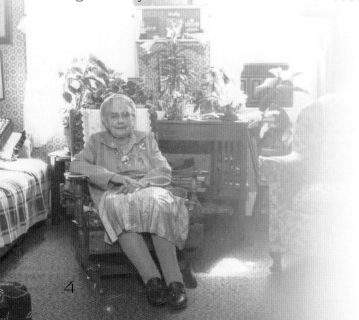

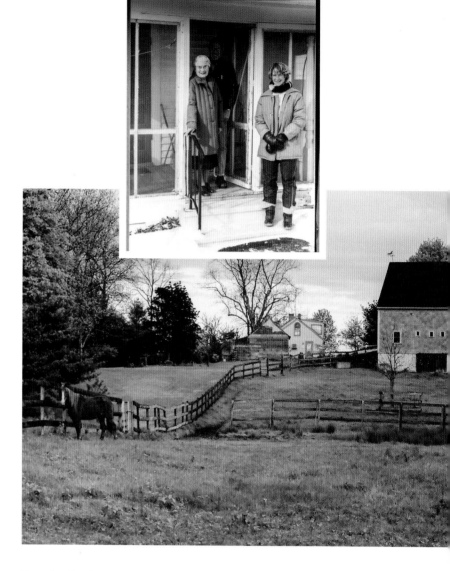

Top: Annie Piper, on her porch with my father and me in 1980.

Bottom: The paddock, barn, shed (now the welding studio), and the house in distant center taken in 1992.

Left: Annie in her living room, now our office.

Right: Aerial photo taken in 1998.

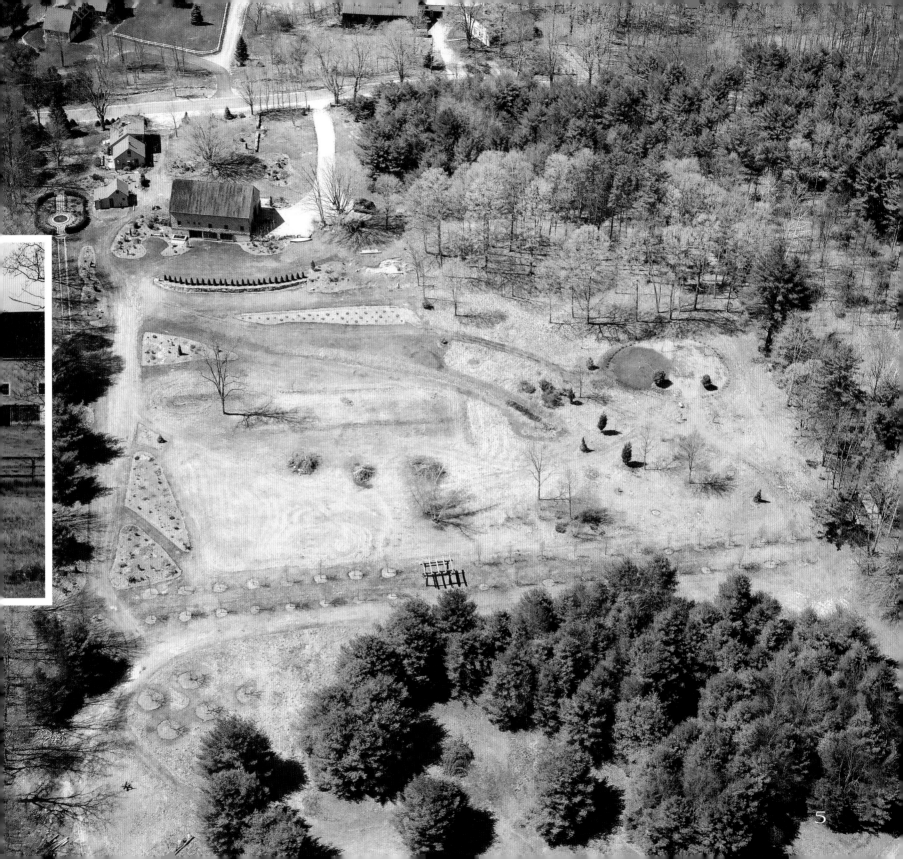

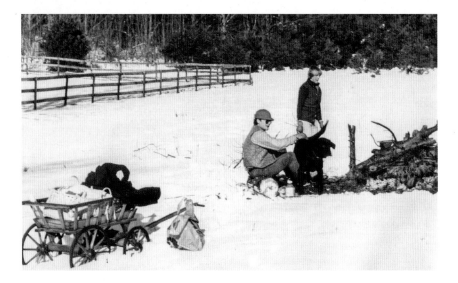

this, but it was not for sale. Figuring we had nothing to lose, we knocked on the door of the house, and an old woman with a shoebox-like body, tightly waved white hair, and clear, bright eyes opened the door. She invited us in, and we made our proposal: We would purchase the house and work the land, and she could live there rent-free as long as she liked, in exchange for a reduced purchase price. Her name was Annie B. Piper, and she had been the Lee town clerk for nearly thirty years. She was eighty-nine at the time.

Annie said she would talk it over with her daughter Myra, who lived across the street, and get back to us in a couple of days. She reported back that they liked the proposal and asked us to come up with a price. We knew what we could afford and what the property would go for on the open market but had no idea how to figure out what the lifetime tenancy clause was worth. So we went with what we could afford, keeping in mind that the property would consume and not make money. A few days later, when we told her our figure of $50,000, she said, "That sounds about right." She agreed to assume the mortgage, and we would make monthly payments. True to her independent spirit, she whited out her lawyer's suggestion of 13 percent interest and reset the rate at the 10 percent we discussed. This was all accomplished without a real estate agent or

Top: We spent endless weekends happily burning brush to make a field. Spencer, age three months, is asleep in the basket.

Middle: A 1984 view of the fence is where the Funnel Garden is now.

Bottom: My first flower garden was located between the house and the shed, with fruit trees between the shed and vegetable garden.

banker. We split the cost for a lawyer to draw up the agreement and deed. When we sealed the deal at the registry of deeds, it appeared we were owed about $10. Someone suggested Annie bake us an apple pie, which she did.

Clearing fields

The thirty-acre parcel had been a dairy farm for several generations of the Piper family but had been abandoned for decades. Cleaning the barn and building the stalls was easy compared to the work of clearing the untended former fields, which had quickly reverted to a forest of white pines and puckerbrush. On winter weekends when there was snow on the ground, we burned huge brush piles. Then came stumping the field, installing paddock fencing, seeding and finally bringing our horses over. Sadly, after a year of working hard on the fields and barn, my husband left the marriage and took his horses with him.

Existing plant materials

We purchased this property because the house called to me. I do wish the existing vegetation had been more noteworthy—maybe a thicket of sassafras like that growing a few miles up the road, a grand white oak, a sycamore like the enormous ones at the river, or a patch of painted trillium. No such luck. This was disturbed land. It had supported a dairy farm, and it's no surprise there were very few large trees or woodland wildflowers.

The few big trees that did exist were growing along the fence lines and stone walls. One was a truly handsome specimen, a shagbark hickory sitting right on the road twenty feet from the house. Although it does not hold the state champion title, it would if something happened to the current record holder. Another impressive tree is the bull pine located in a stone wall separating ConeTown [see the map of Bedrock Gardens on page IV], from Shrubaria. The bull pine has large. multi-stemmed branches reaching up like a candelabra. Two other large old trees on a boundary line are the sugar maple and red oak that support the swinging bench in the Swaleway.

There was some existing plant material that didn't survive. "Behind the shed (now the welding studio) was an enormous rhubarb patch and a tangle of grape vines," I wrote in the Bedrock Farm journal in 1990. "I attacked both with vigor. One does do that, getting rid of almost everything and in a hurry, too." Now I would like the rhubarb and think that would have been a fine place for it.

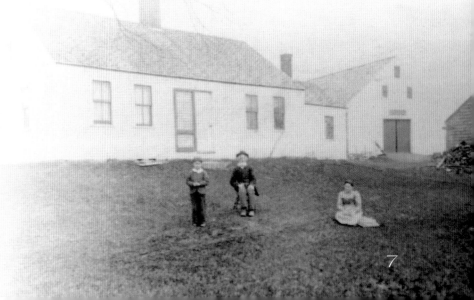

Right: The Piper home in 1896. The barn and shed are unchanged. The branch on the upper left is now a huge shagbark hickory.

Thank goodness I got distracted, and my plan to raze the shed never materialized. This must be one of the reasons that still-intact old gardens usually have stayed in the family. Maybe family members have more reverence or narcissistic investment in what has gone before and less passion to make sweeping changes. I, on the other hand, wanted to make the place my own immediately.

The removal phase continued. Out went the very old thicket of lilacs between the vegetable fence and the stone boundary wall. Lilacs were not my favorite then or now. It made Annie sad to see them go, and I felt embarrassed that I had not considered her feelings. This was not my proudest moment.

THE FIRST FLOWER GARDEN

My first flower garden was right near the front door, between the house and the shed. In those days we received the New Hampshire Department of Agriculture Market and Food's *Weekly Market Bulletin* for $12 a year. I noticed an ad for black humus dredged out of a pond just up the road. I was delighted to learn they had a loader, and I filled my truck a few times at $25 a load. This is the only so-called soil in that garden, and it was nearly three feet deep in spots. This perennial garden was a thrill. It was the first and last time I could grow the fancy Knight series delphiniums. As I look at old pictures of the garden, I see the original pink, white, and red single peonies that I have since moved and divided more than once.

THE RADCLIFFE SEMINARS PROGRAM IN LANDSCAPE DESIGN

A friend told me about the Radcliffe Seminars Program in Landscape Design—she had been attending for a year and thought highly of it. Located in Cambridge, Massachusetts, the program was designed for people who wanted to change careers, most of whom had day jobs and needed to attend at their own pace. I applied, and in 1985 signed up for my first course, Design 1. Someone told me I was crazy to be taking this course, being a parent and working full-time. To which a friend sagely replied, "Are you kidding? It is going to keep her going."

I inched my way through the program, taking one course a year in the fall, as spring was too busy in the garden. Taking courses in such an attenuated fashion allowed me to immerse myself in the subject matter. It is curious that a program accepting seemingly anyone who applied had such a rigorous curriculum, excellent teachers, and a driven student body.

The Design 1 course required making a model every two weeks to illustrate examples of enclosed, partially enclosed and open spaces, among others. What a mess that model-making created in the kitchen with dried plant material, bowls of dusty oregano to represent grass, cardboard, and foam core everywhere. The kids would take my scraps and make models. One time I came home and there were a bunch of Matchbox cars parked in my model.

These models absorbed me but I have always liked making things. One day in 2002, I was caught up in a cleaning frenzy and heaped the models on the dump pile only to see them later hanging high on the wall of the workroom, where they collect dust to this day.

My favorite model from Design 2, one I might have saved, was confiscated by my teacher, who wanted it to show other classes. The assignment was to remake a gas station located in a triangle formed by the intersection of Harvard Street and Massachusetts Avenue in Cambridge. My design morphed the gas station into a restaurant that included an undulating hedge with a similarly shaped bench, circus-like umbrellas on the patio in front of the restaurant, a wavy paving pattern on the ground, and, to ensure its spot as a magnet for visitors, an underground pool covered with glass where customers could watch seals darting playfully around underfoot. Seals might be impractical, but fish might have worked.

For another course, I remember driving to Sugarbush Mountain in Vermont for a family ski vacation. Michael Dirr's book *The Manual of Woody Landscape Plants* was in my lap, as I memorized a long list of Latin names and plant characteristics for an identification test.

A course on garden history and preservation led to researching the plant yellowroot. This resulted in several parking tickets in Cambridge as I searched through the archives of the Gray Herbarium and the Harvard Botanical Libraries. It was a thrill to read early plant explorer John Bartram's description of first finding yellowroot in 1773 in Buffalo Lick, Georgia. It was as if I were a plant explorer myself, searching book indexes for early mention of the plant. Since I happened to be growing the plant, my kids

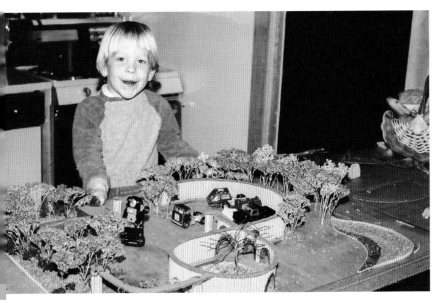

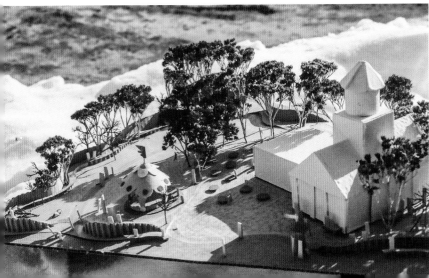

Models for design classes at the Radcliffe Seminars Program in Landscape Design. The upper one is an example of a partially enclosed space transformed into a parking lot for some Matchbox cars; the lower one is a redesign of an existing gas station.

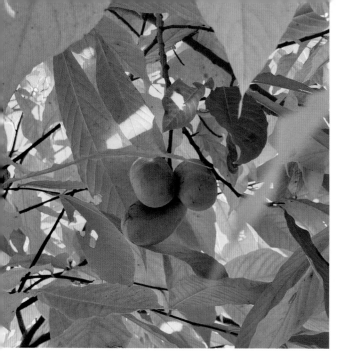

The Flora and Fauna of Bedrock Gardens

Shown clockwise from upper left, among some of the showy plants you'll see in the garden are these: Pawpaw fruit (*Asimina triloba*); Dryad's Saddle mushroom (*Cerioporus squamosus*) sprouting from a branch wound; ivy-leaved cyclamen (*Cyclamen hederifolium* 'Album' Silver Leaf); dahlia 'Verrone's Obsidian'; exfoliating bark of stewartia (*Stewartia pseudocamellia*); blooming spires of Chinese dunce caps (*Orostachys iwarenge*); monarch caterpillar on the milkweed hairy balls (*Gomphocarpus physocarpus*).

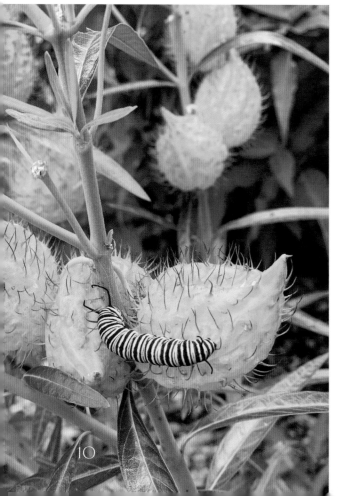

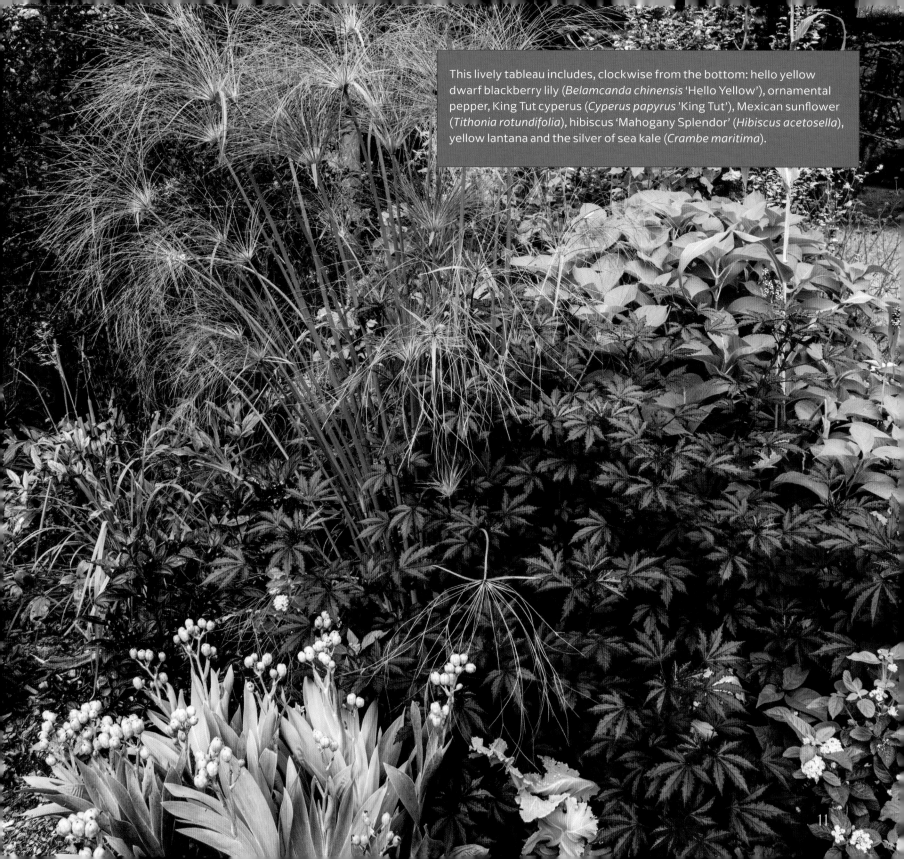

This lively tableau includes, clockwise from the bottom: hello yellow dwarf blackberry lily (*Belamcanda chinensis* 'Hello Yellow'), ornamental pepper, King Tut cyperus (*Cyperus papyrus* 'King Tut'), Mexican sunflower (*Tithonia rotundifolia*), hibiscus 'Mahogany Splendor' (*Hibiscus acetosella*), yellow lantana and the silver of sea kale (*Crambe maritima*).

and I harvested some roots and made an ink that I used to fill in the large block letters on the cover of the paper. Of course I had to sew on a little section of the root, too. One of the teachers recommended the paper be published in *Arnoldia*, the Arnold Arboretum's quarterly, which it was, as "A Very Valuable Shrub: *Xanthorhiza simplicissima*," in the *Arnoldia* summer 1994 issue.

For my final thesis, I gave myself two years to find as many noteworthy New Hampshire gardens as possible that were designed before 1950 and whose important elements remained. My aim was to make a visual record of the gardens before there nothing left. Even though I was getting my certificate in landscape design and not landscape history, the idea of snooping around old gardens appealed to me.

To find these gardens, I contacted every historical society and garden club in the state; researched the archives of landscape architects (at that time a library could order the Olmstead firm's correspondence on microfilm); visited the Smithsonian's Garden history archives and the Boston Athenaeum, and ordered a long list of postcard subjects from the Curt Teich Postcard Archives Collection, the largest public collection in the country. I made a stand with lights called a copy stand, which allowed me to photograph old photographs, postcards, paintings, books, and plans. I also photographed and sketched a plan of the current gardens. I enjoyed trying to reconstruct a designer's intent as well as learning more about how the garden was used and the lives its owners led.

I spent the first year gathering materials and the second writing them up. I am not sure now what to do with the seven legal-sized boxes of documentation stored in the attic—comprising a hodgepodge of old postcards, photocopies of articles in early 1900s shelter magazines, and annual catalogs for members' gardens published by the Garden Club of America. Some items were quite costly to acquire—such as copies of photos from the Cornell University Library of landscape architect Fletcher Steele's work in New Hampshire.

This project taught me that in a garden that has been let go, few elements remain other than trees and hardscape.

Above: Photo documentation for my thesis.

Facing page: Bob taking a break from a complete remodeling of the Wiggle Waggle.

This made me take a hard look at our garden. I realized it would not stand up over time and, in some ways, was not standing up right now. Too much flesh and not enough bones—structure, we needed more structure.

Finally, after eleven years, I graduated. But despite those years in the Radcliffe program, Bedrock Gardens isn't really "designed." Instead, it has evolved through what almost seems like a principle of physics, such as a body in motion tends to stay in motion, but also through acts upon the land with consequences we could not have imagined. The years in the program bracketed a wonderful period in my life: the kids, the garden, and Bob.

Bob

In 1985, when I met Bob, the love of my life, he had no love of plants or the out-of-doors. His set point is in front of a computer, solving problems. He did have more than a passing exposure to plants, plant collecting, and landscape design. He grew up on eleven acres of rolling Virginia land where his father created his own garden. Over twenty-five years, his father had amassed a spectacular collection of unusual trees, shrubs, and art—sculptures he constructed as well as works of other artists—strewn throughout. The property lives on as Boxerwood Nature Center and Woodland Garden in Lexington, Virginia.

Bob did not grow up feeling he would have a large complex garden, like I did. He had, and would continue to have, lots of interests: ham radio, *avant garde* film of the 1970s, listening to hundreds of books on tape, collecting slot machines, classical music, the Rolling Stones, bluegrass, piano, computers, cameras, cars, skiing, and medicine—and, more recently, as our lives intertwine, masonry, creating water features, land clearing, crossword puzzles, genealogy, website development, creating nonprofit organizations, raising guinea hens, building a chicken coop and a Japanese Tea House, writing a manual of the property's infrastructure, learning how to fly an airplane, and assembling animal skeletons. He pursued the interests in this last group while raising our three sons. I have a saying, "Every

problem solver needs a problem maker, and every problem maker needs a problem solver." Bob really doesn't care about which problem he solves as long as it's meaty—and our garden serves them up, all you can eat.

Bob's and my work life

When Bob and I met, I was working as a clinical social worker at Phillips Exeter Academy in Exeter, New Hampshire. I also had begun a small private practice on the side, which became a welcome counterpoint to only seeing adolescents who were living in the unique environment of a boarding school. Bob worked at Exeter Family Medicine Associates as a primary care doctor. When he retired in 2006, the receiving line for his celebration wrapped around the building. The gathering lasted four and a half hours and mirrored his world: folks from the cafeteria, nurses, the grounds staff, his colleagues, and many patients, sometimes three generations proudly in attendance.

Plant collecting

By the time I met Bob, I was already an inveterate plant collector. Like any beginning gardener, nurseries made my heart flutter. My sources of primary plant education were symposiums put on by organizations like the Perennial Plant Association, *Horticulture Magazine,* the Arnold Arboretum and the Massachusetts Horticultural Society. I studied the plant and nursery lists that accompanied the talks and drew up an inventory of plants to look for.

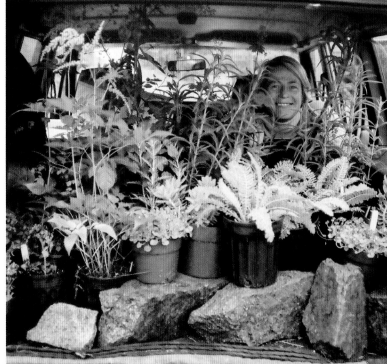

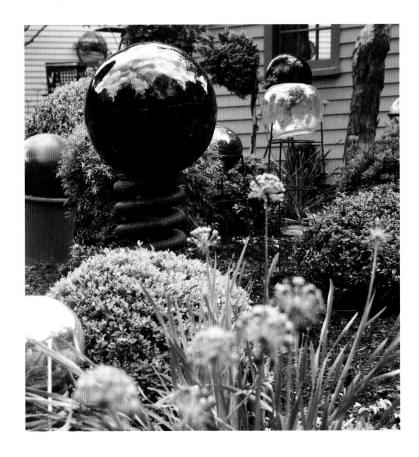

This was before the internet, so I shopped by using mail-order catalogs and visiting nurseries, some of which were far enough away to require staying overnight. As a beginner I tried to collect what was fashionable; perennials were in, hostas were not. Pastels were cool, orange was not. Foundation plantings were laughed at, as was pruning yews into meatballs. I dutifully went along with the crowd, but as time went on I got tired of perennials and fell in love with hostas, got tired of daylilies and found the world of dwarf conifers. Then I collected rare jack-in-the-pulpits and Asian woodland plants, then fastigiate plants and Japanese maples, then annuals and tropicals, bold foliage and clashing colors. Now, ironically, I have a garden full of clipped meatballs that I call "All You Need Is Balls." I suppose everyone's education follows a similar path of emulating one's elders until you find your own voice.

I began by making large beds, first by mowing a section of what was field and then spreading dump-truck loads of manure over sheets of brown paper bags and layers of newspaper. I planted my purchases in a random kind of way until they developed character and I could start making combinations. Since we had yet to run water lines far from the house, most plants were watered only when first planted. I continue to be lackadaisical about watering, even though I know how critical it is to the survival of newly transplanted material. I promise myself I will do better, but that is at odds with my feeling that the plants need to make it on their own. In the beginning, I did pamper some of my borderline hardy plants by covering them with peach baskets in the fall, and for some years I wrapped the trunks of the trees in the Allée to prevent deer rubbing their antler fuzz off and shredding the bark.

My garden has been saved from becoming a mash-up of unrelated, incompatible plants because now there is so much structure it almost does not matter what is planted in the beds. I tell myself when the big projects finally wind down I will properly design the beds. Not all the plants are

Facing page from the left: Spencer guarding my plants at the Arnold Arboretum plant sale at the Case Estates; the station wagon loaded up with plants and rocks, where occasionally grass seed sprouted; Spencer and Bob bidding in the silent auction.

Above: The All You Need is Balls Garden, located next to the welding studio, includes bowling balls, gazing globes, bocce balls, fishing floats, alliums, and eight different kinds of shrubs sheared into balls.

placed willy-nilly—some are placed to become future anchors. I remember explaining to visitors that even though the maple in a particular bed was not even as tall as the daylily next to it, it would dominate the bed at some point. And it did.

In 2010, a visitor remarked on the unusual "bonsai" gingko I was growing on the ledge by the house. I had no idea what he was talking about until he pointed it out. Don't be silly, I thought—that eight-inch stub manifested itself as an eighty-foot-tall tree in my mind's eye and was already filling the hole in the sky left by the 100-year-old sugar maple that blew over in a hurricane. Maybe that's why I can wait, because it is all grown up in my mind.

Plant hunting

In the 1980s, before the Arnold Arboretum began its annual fall plant sale, members received a gift plant in a little tube in the mail. The dawn redwood (*Metasequoia glyptostroboides*) growing by the Pond and the Amur chokecherry (*Prunus maackii*) in the Swaleway sprung from those tubes.

The tubes were followed by the Members' Plant Sale held at the Case Estates in Weston, Massachusetts, a much-anticipated autumn ritual. While members received one free plant, the goal was to scarf up as many offerings as possible. The plants were small so I could pack many in the car. They included varieties not easily found elsewhere at the time: 'Jacqueline Verkade' Canadian hemlock (*Tsuga canadensis* 'Jacqueline Verkade'), Mount Apoi birch (*Betula apoiensis*), Nantucket Shadush (*Amelanchier nantuckentensis*), and Biondi's magnolia (*Magnolia biondii*) to name a few. I went every year for twenty years, until I was growing every plant that I wanted on their list and sources for unusual plants had shifted to specialty nurseries.

I have mentioned Boxerwood, the property Bob grew up on in Virginia, but I did not include all the plants from that garden now growing in my own garden. Bob's father had a remarkable collection of plants and some produced offspring either by seeds, suckers, or through layering. The woods were also full of all sorts of wildflowers. He generously shared my pick of these. For years, every spring vacation we would visit with the kids and come home with a suitcase packed with selections: trillium; green and gold goldenstar (*Chrysogonum virginianum*), a Virginia native before it was offered in nurseries; heart-leaved ginger (*Asarum virginicum*); bottlebrush buckeye (*Aesculus parviflora*) that now forms a stand ten-feet wide; Magnolia 'Betty' (*Magnolia* 'Betty') that I especially like because it is also the name of Bob's mother; and the very odd putty root of the Adam and Eve orchid (*Aplectrum hyemale*) that came up with one leaf for years and then disappeared. But the plants making the biggest impact are the Japanese maple seedlings that, thirty years later, have turned into proper trees—one growing by the Tea House is now twelve feet tall. And now I, too, have a zillion seedlings to share.

In addition to collecting plants from Boxerwood, I made an influential decision to join the Hardy Plant Society of Oregon in 2002. Why? Because in 2001 our son Spencer began his four-year college career in Portland, the home base of the society. I fell into the pattern of visiting him twice a year in October and April. I have no idea how the society even came across my radar, but it is the most active organization of its type in the country. I am sure any plant lover who visits the Northwest for the first time is overcome, as I was, by the beauty, diversity, lushness, and ubiquity of its gardens—in front of malls, at gas stations, on medians, near highways, and in many achingly attractive neighborhoods of bungalows.

At the society's spring plant sale, now called Hortlandia, seventy to eighty specialty nurseries sell their plants during two days in a large convention space. Some of these nurseries had mail-order capability, such as Greer Gardens, Joy Creek, and Heronswood, but many did not, like Cistus, Rogerson's Clematis, Bovees, and the Berry Botanical Garden.

For nearly every year between 2002 and 2019, I volunteered at Hortlandia and came home with two large cardboard boxes of little plants, with an occasional tree that I would carry on the plane with me. I made some good friends in Portland and had a chance to visit lots of private gardens. In 2017, we participated for the first time in their extensive garden travel program. These trips are so popular that our 2022 trip to France filled in forty-five seconds. In 2021, Bedrock Gardens was a stop on their Fall in New England trip. That was such a thrill! Being a part of this society has been a wonderful turn of events and a part of my heart will always be in Portland.

While I scoured and traveled to nurseries throughout New England, I did a portion of my shopping from catalogs and still do. Run by passionate people, specialty nurseries offer a vast selection. Most often they offer small—sometimes tiny—plants and those often come at a not tiny price. Some early plant sources included Cummins Gardens in New Jersey; Forestfarm, Siskiyou Rare Plant Nursery, Del's Japanese Maples Garden Center,

Bob's parents in their Boxerwood Garden in Lexington, Virginia.

and Buchholz and Buchholz Nursery in Oregon; Kurt Bluemel, Inc. and Foxborough Nursery in Maryland; Viette Farm and Nursery in Virginia; M.A. Kristick Rare Plants in Pennsylvania; Heronswood and Fancy Fronds Nursery in Washington; New York State Fruit Testing Cooperative Association; and Camellia Forest Nursery in North Carolina. There were some favorite drive-to nurseries as well, such as Weston Nurseries in Massachusetts; Twombly Nursery and Logee's Greenhouses in Connecticut; and J. Verkade Nursery in New Jersey.

When I look back at the plants I ordered before 1989, a scant few are still alive, mostly trees. What happened to

them? It is horrifying and baffling to think about all those plants that have passed through my hands. Some of the plants were exceedingly small when they arrived by mail. Usually they went right into the gardens. Now I have started to up-pot them and plant the pot directly in the soil in a protected area for a month. It is probably fair to say I am rough on my plants and rough on my body, tools, and machines as well. I also do things fast. That is not intentional but is just my pace; maybe the two are related.

I must add that I am not afraid to experiment with plants that may be out of Bedrock Gardens' 5b zone for plant hardiness. I practice what Sean Hogan of Cistus Nursery coined "zonal denial." For instance, I brought back a seedling of China fir (*Cunninghamia lanceolata*) from Boxerwood in 2002 and while it never grew more than three feet tall, it is still alive far from its zone 7 to 9 range.

I wouldn't mind having back some of the plants I have lost; think how grand a forty-year-old lacebark pine (*Pinus bungeana*) would look. One survivor is the yellow Japanese maple (*Acer japonicum* now renamed *A. shirasawanum* 'Aureum') I bought on May 27, 1987, for $5.50. It was moved to its second home on the west side of the barn in 2012 and in 2017 to its third in Shrubaria, where it is no longer rubbing up against a pushy variegated aralia (*Aralia elata variegata*) and can breathe again. Moving trees, incidentally, is a sure way to retard their growth, which is not always a bad thing. It is a bitter moment when I must cut down a beautiful specimen that has outgrown its spot.

Early on I remember poring over *Low Maintenance Perennials* by Robert S. Hebb, maybe my first plant book after the *Peterson Field Guide to Wildflowers*. Then came narrative books on gardens like *Green Thoughts* by Eleanor Perenyi and *Onward and Upward in the Garden* by Katharine S. White. Now I have thirty feet of gardening books on my bookshelves.

The downside of being a plant collector is that it can turn your garden into a horticultural zoo. On the other end of the planting design continuum are many professionally designed landscapes where plants are grouped in herds. An honored design maxim is to plant in multiples. If you see nine boxwoods and five viburnums, you can be sure a landscape designer has been there. These gardens make me sad—they feel unloved—as if the landscape is a commodity like a new set of furniture. I like to plant in multiples of one. Yes, you can buy a grove of ten-to-twelve-foot-tall, balled-and-burlapped yellow Japanese maples. But where is the romance in that compared to the magic of unwrapping a little plant, planting it, keeping your eye on it, moving it around, and growing it to be big enough to climb for pruning? I'll take the comfortable familiarity of aging together.

The exuberant Ping Garden, parallel to the Allée, includes, from left to right, golden lace (*Patrinia scabiosifolia*), castor bean (*Ricinus communis* 'Carmencita') with large palmate leaves, the airy *Eupatorium capillifolium* 'Elegant Feather', the pink fruits of prickly ash (*Zanthoxylum simulans*), another castor bean, and a red blooming canna.

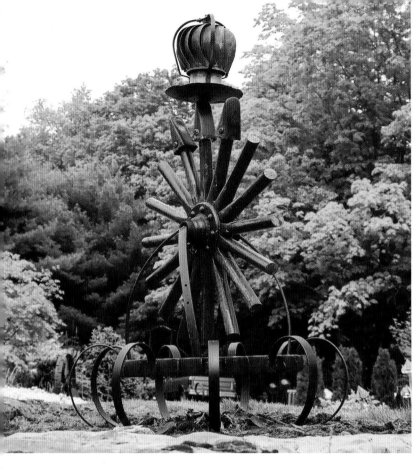
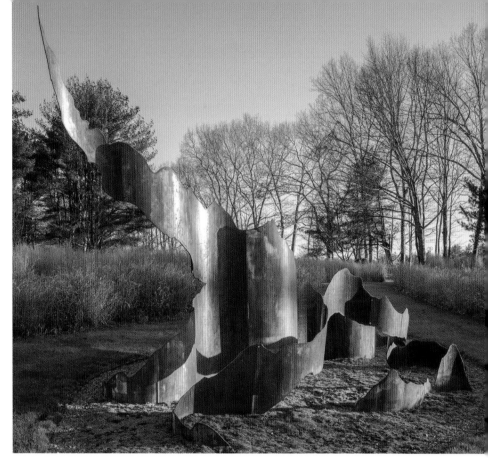
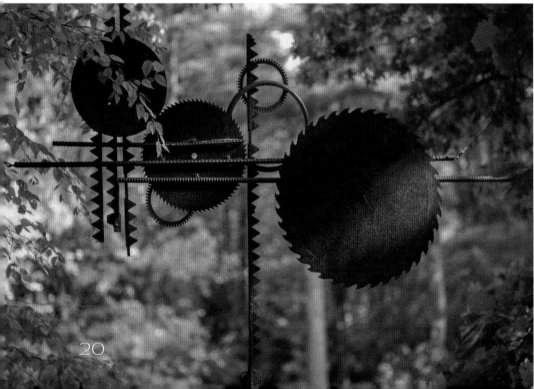
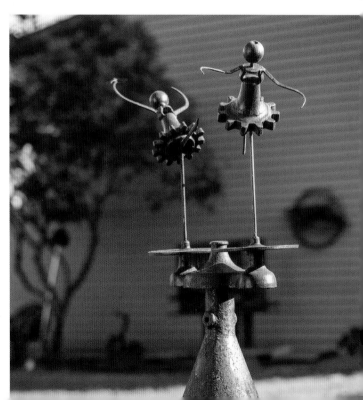

Art in the Garden

Art, plants, and what makes people tick have been consistent interests in my life. I began making sculptures for Bedrock Gardens when it became established enough to need them. Garden design can be experienced as sculptures of landscapes and plants, like the GrassAcre or the Pate. But garden sculpture made from metal, wood, and other materials catches your eye in a different way; it makes you slow down and look more closely, maybe makes you smile. These pieces can serve as anchors or focal points, bring color and intrigue, and distinguish a spot in the garden in a way that plants often cannot do on their own. The Buddha and the Halo are good examples.

As we got to know the property, we began to see traces of former inhabitants. Some were obvious, like barbed wire half enveloped by trees running along some parts of the stone walls or a rusted cultivator under the barn. Some were more subtle, like the faint writing on the inside of a stall noting the date and number of something. Behind the barn there was a mound in the woods with pieces of metal sticking out of the soil: plow parts, worn-down shovels, calf waterers, saw blades, and more. These relics felt like my soulmates, testifying to work.

My collection began to grow—horse hames, electrical insulators, cow stanchions, broken shovels, metal shoe lasts, and disc harrows. I hired a local welder to weld some together for me, and sculptures began to form—such as a couple holding hands, her pregnant belly represented by a tine from a dump rake. I was hooked on the magic of making something into something else.

Finding raw materials is similar to plant hunting, now that I think about it. I began a focused, passion-driven, decades-long hunt for interesting metal. Most often this was farm and machine equipment, but my attention was caught by anything with an interesting shape, such as the meat grinder my mother would clamp onto the counter. I also collected many round objects, such as wheels, gears, disc brakes, and hubcaps to name a few. Hunting has led to many escapades, like the time Bob and I drove to Vermont following a lead on a collection of farm equipment. The property owner was accommodating and pointed to the woods where trees were growing through the machinery. Luckily we had brought the chain saw, but it was not long before the molten bolts we had cut with the torch started a small fire. I ran to the house for some water and it all worked out.

It is easy to see abandoned equipment lining stone walls on former farmland, especially in winter, and I had no trouble inquiring about them. In the late 1990s and early 2000s, scrap metal became valuable and headed to China. Landowners were reluctant to give or sell their scrap metal to me cheaply, so I followed up every personal referral. On the flip side, I frequented metal recycling places where this material occasionally appeared, and I could cherrypick the most interesting pieces along with many other treasures.

Clockwise from the top left: An Unnamed Sculpture made from a roof ventilator, three bulldozer teeth, a 100-year-old wooden wagon wheel and teeth from a spring tooth harrow, marries the old and the new. *Syncopeaks* is made from air compressor tanks that were sliced into strips and welded in a concave-convex pattern. One in a series of ballerinas. *Razor's Edge* is an assemblage of circles with teeth that proved so dangerous it started a trend of hanging art from trees.

Gradually I assembled a sizable collection including disc harrows, plows, sleighs, wheels from horsedrawn carts, parts from the Mount Washington Cog Railway, hood ornaments, gears, leaf-springs, organ pipes, floor grates, and tractor seats. And folks began telling me about properties they or others were going to sell. In 2013, I decided to stop acquiring new material and use what I had, since it was piled so thickly it was hard to know what was on the bottom.

Along the way I began to set aside some of my small "precious" pieces, storing them in the house in a spackle bucket. They would be insignificant incorporated in a sculpture and were at risk of being lost in my heap of small pieces. I was happy to remember that particular bucket when looking for a way to dress up our new bathroom at the Welcome Court. These sculptures now have their own little gallery attached to an old board I found in the barn. This reminds me of the course the Metal Folk took to arrive at their own gallery at The Wave.

Most often the pieces of metal drive the creation. I use the barn floor as my canvas, laying out the pieces, sometimes working on more than one sculpture at a time if I have gotten stuck. Then I draw the sculpture's design on paper or take a photo, dimension it, and date and sign each one. I make myself smile sometimes when I complete a piece, begin another beside it, look over and pirate a piece of the finished work. I like the unexpected, which sometimes comes from the challenges of assembling dissimilar metals. And sometimes I can be disappointed if a sculpture turns out just how I had imagined it—where is the fun in that? For me collecting the material and designing the sculpture are the most meaningful parts of the process. So it is not surprising that I am happy to have the sculptures begin another life in someone else's garden. However, some, like *The Family from Hell*, *Guardians of an Unhinged World*, *Razor's Edge*, and *Syncopeaks* that I wouldn't part with and are now part of our gift to the Friends of Bedrock Gardens.

The garden incorporates about two hundred pieces of sculpture that I have fabricated, predominantly out of metal. When I say "I have fabricated," I mean others have made them with my close supervision. I have the luxury of a small welding studio near the house that is outfitted with all the equipment needed to realize my ideas. I have relied on the patient problem-solving talents of a half dozen welders over the years. They are not put off by the challenges of combining metals in the heat and the cold. I have many more ideas than can be completed in the hours I can pay a welder, which is a good problem to have. It has been a wonderful collaboration.

I have always felt an affinity with African, Native American, and Asian cultures, and it is no wonder that their aesthetics turn up in my work. Jungian psychology has an apt name for this—the collective unconscious. It is the part of the mind derived from ancestral memory rather than of an individual. I enjoy this circularity from the individual to humankind.

The journeys my metal pieces take are also very satisfying. What was discarded by others is treasured by me and

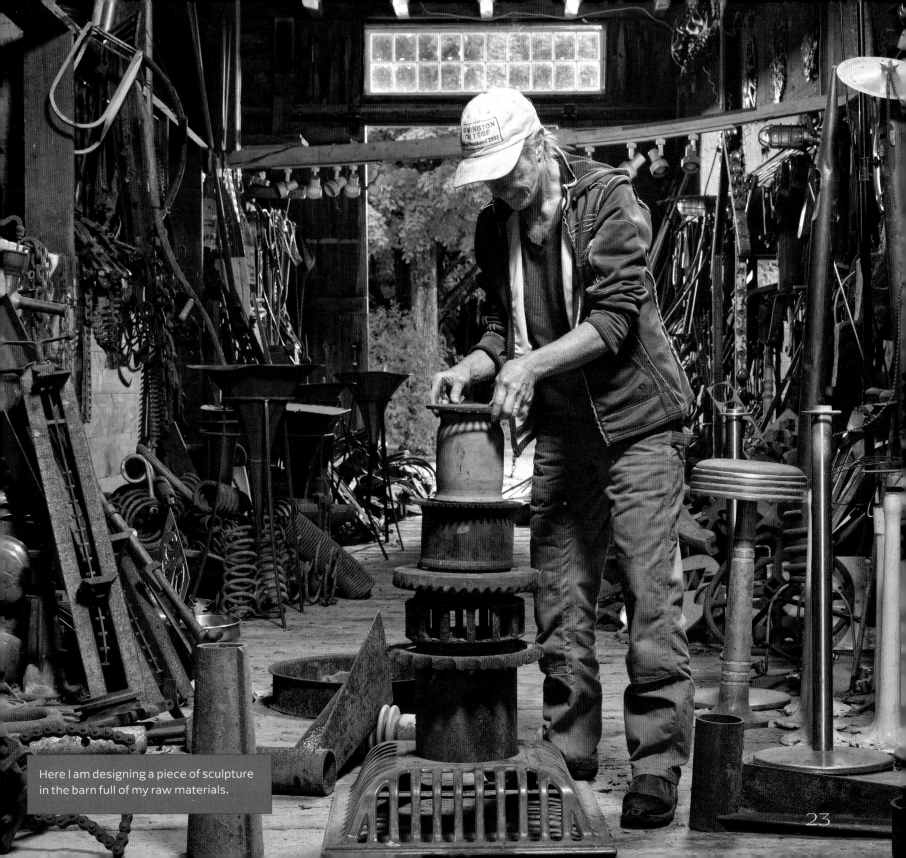

Here I am designing a piece of sculpture in the barn full of my raw materials.

Pawn Broker's three round elements are from an automatic calf waterer.

Groucho has the famous comedian's eyebrows and mustache.

Fire Wood Water Totem is an assemblage of beautifully shaped implements showcasing the fire hose on the top along with pieces associated with lumbering, farming, railroads, and water control.

Tanker evolved out of a 275-gallon oil tank, which was a gift from a neighbor. I cut it into sections and recombined the pieces. There is something so inviting about those curves.

To make this sculpture, I used pieces from old wood stoves' cast-iron doors, which hold memories for so many of us.

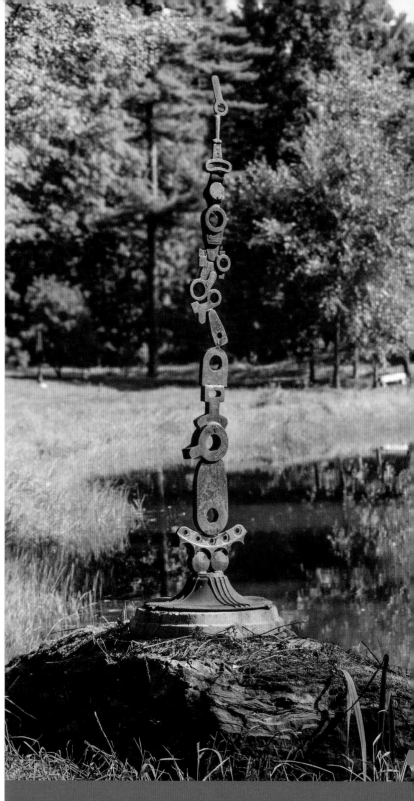

The pieces in *Bits* gathered themselves up in a doodle-like totem that resides on a rock in the pond.

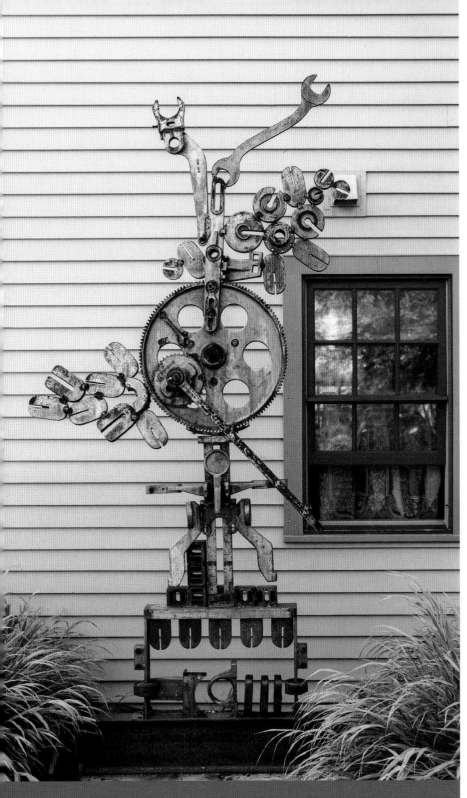

When I found a large pile of metal pieces related by shapes and paint color, I challenged myself to use them all in one piece and created *Time Machine*. The lever on the lower right is the one piece that moves.

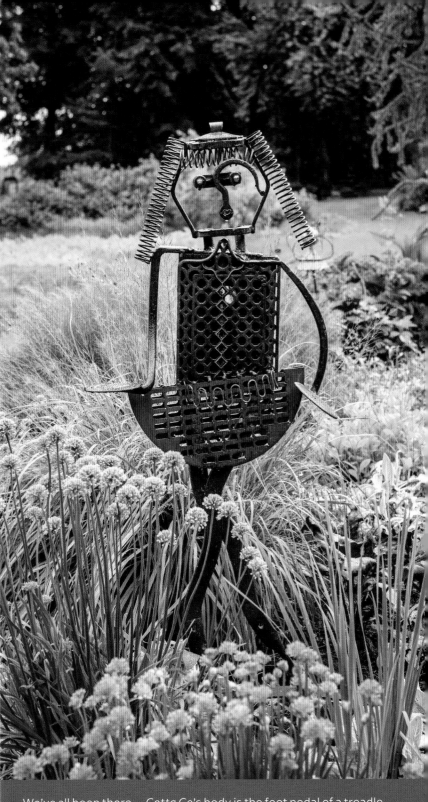

We've all been there—*Gotta Go*'s body is the foot pedal of a treadle sewing machine and her arms are footrests for a buckboard buggy. Some folks call her a waitress.

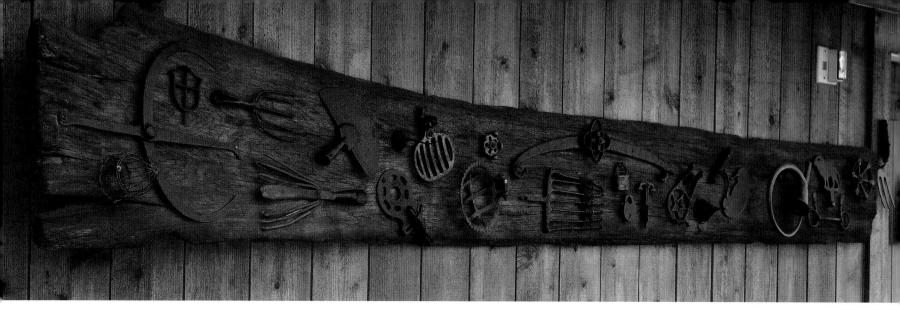

made into something others might value. I feel connected to the people who have repaired them. It feels fitting that machines that have worked the land return to the land, rust covered, the color of dirt. I also feel a certain pride in saving mementos of New England's agricultural past, pieces that may not interest a farm museum.

In 1996, a friend and I started a company called Fine Garden Art and Ornaments. We sold architectural salvage we imported from England as well as my own pieces. This led to participation in many garden-art shows from Maryland to Maine. The most arduous was probably the annual garden antique show at the New York Botanical Garden. We were not a good fit there, but we participated for four years and enjoyed being among the rich and famous. We did not enjoy stopping abruptly on the Taconic Parkway, causing the heavy pieces in the U-Haul to crash into the back of our truck's cab. It was a relief to retire from these shows and hauling the work around, and we decided to let people shop at Bedrock Gardens. In 2017, we happily closed the business after a very satisfying run. When I look back in my photo albums, I realize how many pieces I have sold over the twenty years, yet, the creating of art continues.

Naming parts of the garden

I name different sections of the garden to make it easier to communicate to others, such as "Bob, I got the tractor stuck at…" I remember looking at old maps where fields and intersections had names: the Bottom Field, Gerry's Pasture, and Palmer's Corner. Some areas on our property were easy to name: Pea Path for the pea stone lining it, and Swaleway for the shallow channel there. Others were heavily lobbied for. I liked Baxis for the back axis and wrote it on sticky notes stuck all over the kitchen cabinets, hoping it would seep into Bob's consciousness. In the case of the Wiggle Waggle we had months of back and forth, even soliciting other people's support of our own favorites. Mine was Slip Stream, by the way. In other cases the

Left: The *Precious Pieces* collage includes eel forks, a cast iron horse bit, a horn from a Model T, valve handles and parts from a calf waterer, to name a few. It hangs on the wall of the bathroom at the Welcome Court.

Right: The cobble-lined walkway of the Straight and Narrow Garden connects the dots: from the Parterre on the lower right and the Swaleway Garden, which lies at the end of the walkway. The bottom image shows the space maturing into a room.

names have changed. ConeTown was once Scott's Folly in honor of our overworked neighbor who kept promising to come over and clear it but never did.

Connect the dots

In the 2000s, multiple islands of cultivation began to emerge on the property. The garden evolved eventually to connect these dots and became what I confidently describe as a journey. When I give talks on garden design I urge others to use this concept to give coherence to a garden, even a journey as small as a walk around your house. A garden needs somewhere to go, a way to get there and things to see along the way. That is my principle of garden design in a nutshell.

These islands, or dots, of gardens arose in part because I had to figure out what to do with plant divisions. When beginning gardeners divide a plant that they have babied along, they feel like their investment has matured and produced interest with the passage of time. Eventually these divisions spawn new beds, which also double as nurseries.

It became clear that populating all the beds with the same divisions of robustly spreading perennials like phlox or daylilies was an error. They looked so homogenized that I put the divisions in spackle buckets by the road with a large plywood sign labeled "Free." When that became a chore, I just tossed them into the compost pile. Occasionally I shop from the compost pile.

The Zipper

For his fiftieth birthday in 1992, I gave Bob a golf cart christened the Zipper in honor of his email moniker, Zipity. No longer would we have to hike back and forth for more fuel for the chainsaw, to collect the proper tool, or to get a cold drink. On a small scale it felt like what barbed wire did for cattle ranching in the Midwest. It unlocked the possibilities of the back forty. My garden gestures started out small and ended up big, and the Zipper played a part. But nothing rivaled Bob's and my partnership.

Lumbering

When we bought the property, it had one deed for fourteen acres and another deed for eighteen acres. The parcels were separated by a stone wall. In 1993, we purchased an adjacent four acres, which are now the site of the parking lot and Welcome Court. The eighteen-acre parcel included the house and barn. I had never set foot on the other parcel at the time of purchase and did not for years afterward. It was a sapling, pine tree, sumac, and puckerbrush thicket with acres of poison ivy. Why go there?

This changed in 1990, when we decided to lumber it. At that time wood chips brought a better price than logs, so along with the tree-cutting equipment came a monster-sized chipper. Trails were cut through the woods, providing access for the skidder to haul out its bouquet of seventy-foot trees. There are still scars on the big remaining pines, which acted like bumpers on either side of the path.

The loggers cleared a large staging area for wood processing where the skidder, chipper, and a forty-foot trailer converged. This formed the area we now call the Nexus. It took me years to appreciate what this glade in the woods, born of necessity, had to teach me. Thinking as a landscape designer walking through a client's woods, I would have been reluctant to suggest they remove forty trees in the middle of their forest to carve out a piece of the sky. But when you are in that clearing, the tall trees are the walls, the earth is the ground plane, and the sky is the ceiling. With building blocks of that scale you can almost never go too large. Since making this connection I have felt freer to think bigger with space.

The most remarkable effect of the logging was the access it gave us to our "back forty" acres. I began killing the poison ivy on the skidder roads, then on the sides of the roads and then deeper into the woods. We were not even aware there was a

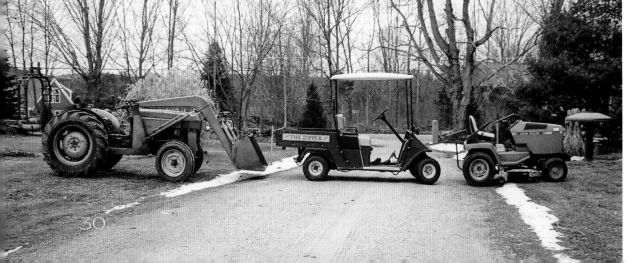

Left: Our fleet in 2002. The tractor is ours, the Zipper is Bob's, and the mower is mine.

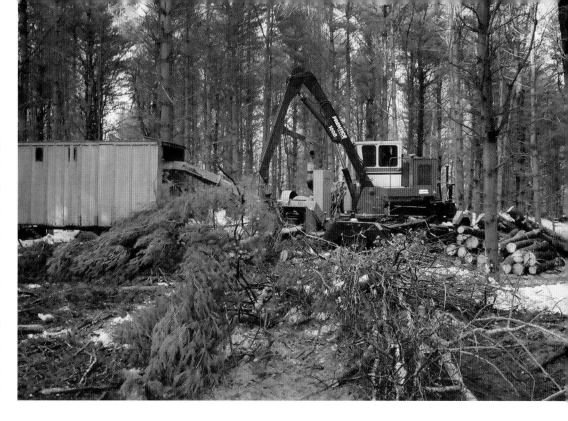

spring on the property until we were talking to Annie Piper's son-in-law who lived across the road. He remembered cows using it as a watering hole. He walked us down along the stone wall toward Route 125 where we found a spring-fed pool about twelve-by-twenty feet across and three feet deep. One edge was overhung by a large rock just begging for a sculpture of Narcissus. This is the only naturally occurring water on the property, sadly a stone's throw from the busy highway. We have created all the other water features.

With the logging equipment gone, we were left with a ravaged landscape, scarred trees, and rutted paths. The desolation of this scene was tempered by the excitement of essentially acquiring fourteen acres of newly accessible land. Making large slash piles every hundred feet gave us a chance to get a feel for this gift. I even discovered a patch of pink lady's slippers.

Curiously, since 2010, new species of invasives have moved in. They might have been growing in the neighborhood in the 1980s but had not spread here. I assume they came by car up Route 125, or by birds and other animals. My old standbys of poison ivy, wild grape, Japanese barberry, and honeysuckle now mingle with new unwanted guests like bittersweet, Russian olive, black swallow-wort, Virginia creeper, purple loosestrife, multiflora rose, garlic mustard, winged euonymus, buckthorn, and probably some others I can't identify. I pull up by hand as many as I can, but they arrive and multiply faster than I have time for. I love riding my mower over that foot-tall Russian olive, chopping it down to the ground, but unfortunately probably strengthening its root system for a comeback. Not so long ago I was on a first-name basis with the unwanted plants—I knew where they were and could concentrate on those areas. Now they occur every five inches in the twice-yearly mown field; I mourn that former intimacy and what it meant.

Above: After clearing a patch of forest, the lumbermen set up their chipping operation. They left us with a large opening in the woods that is now the Nexus.

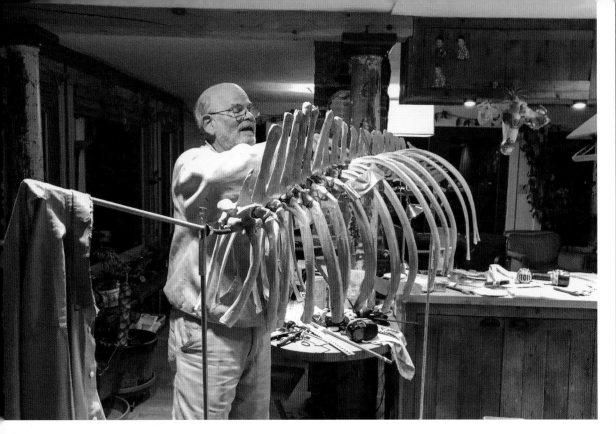

Amusing Ourselves

When you are your own client, like Bob and I, you can do whatever catches your fancy. On this page, Bob is assembling a horse skeleton. It aged for two years in a compost pile, was then boiled in water (in a horse watering trough) to remove the remaining tissue, and then soaked in hydrogen peroxide to be whitened. *Hi Ho Silva* now hangs in a grove by the Pond. On the facing page, a selfie to prove that we used the plunge pool by the Tea House at least once. Very cold. The *Acrobat* sculpture is seen in the upper left before it was relocated to the Welcome Court.

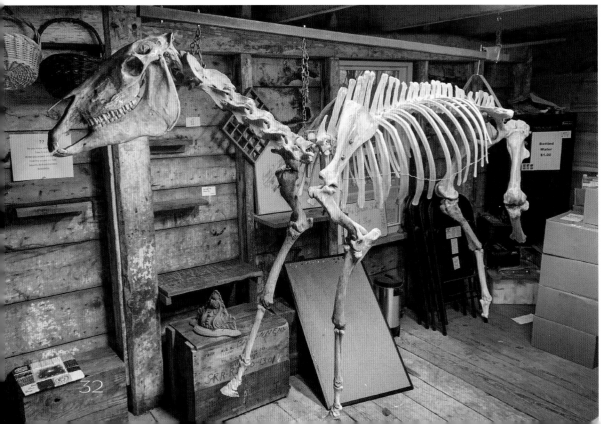

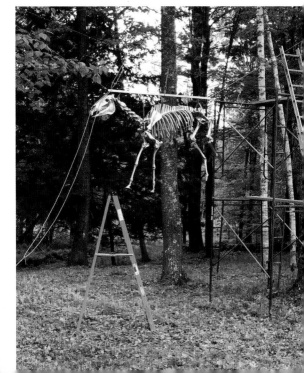

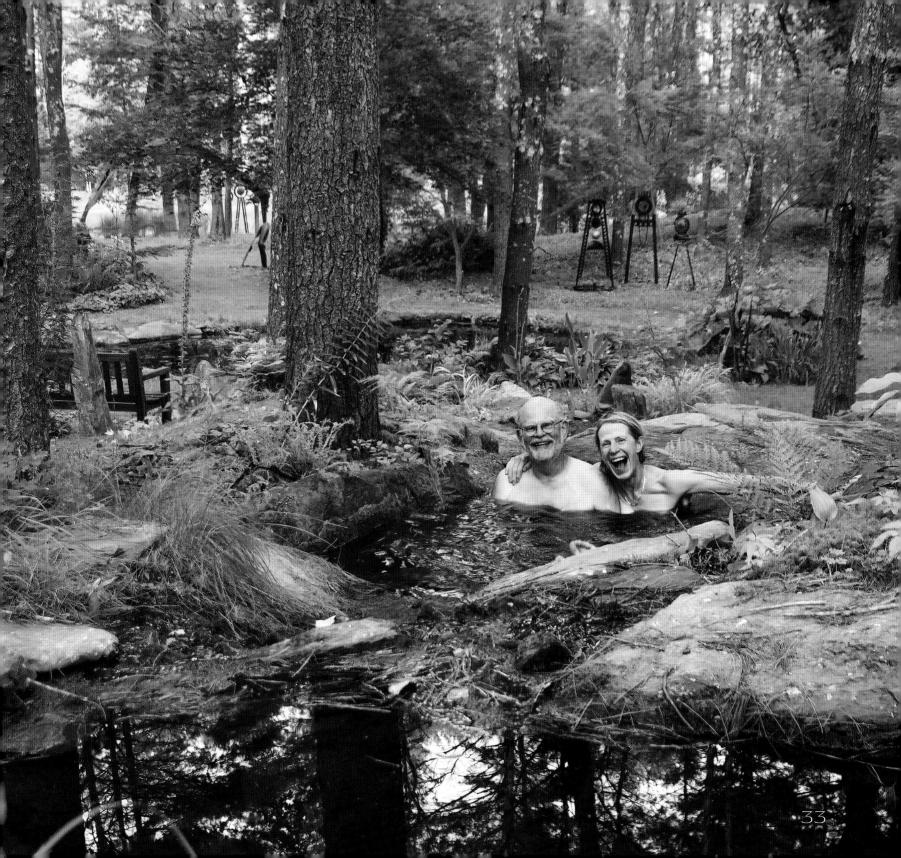

THE BLOSSOMING OF BEDROCK GARDENS

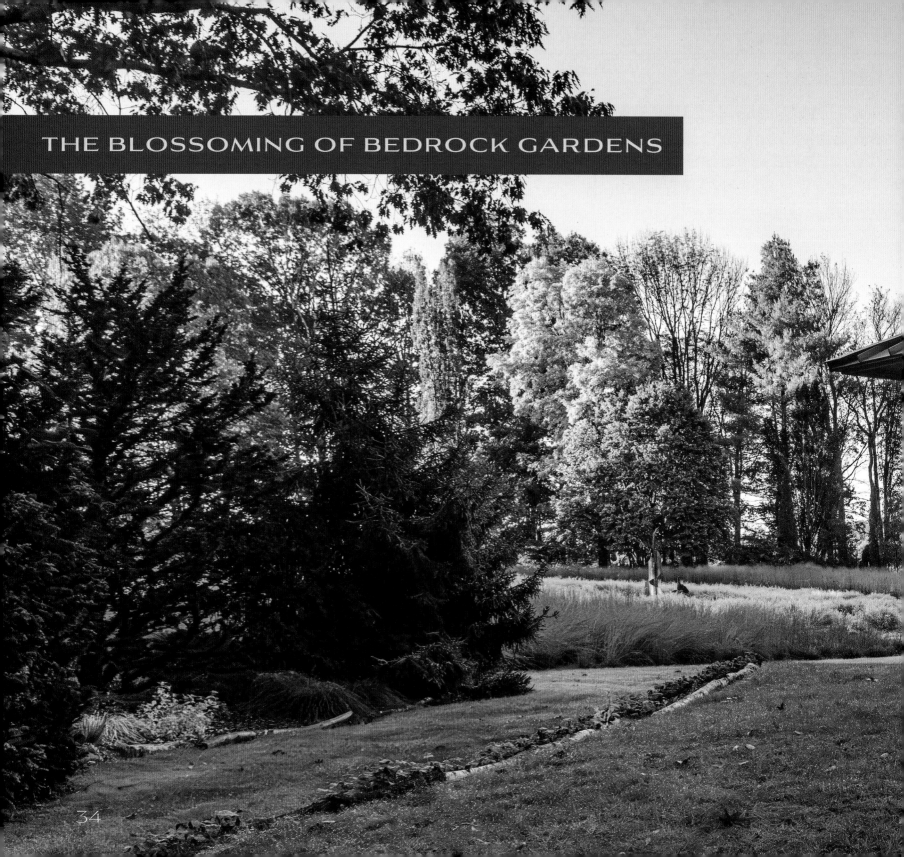

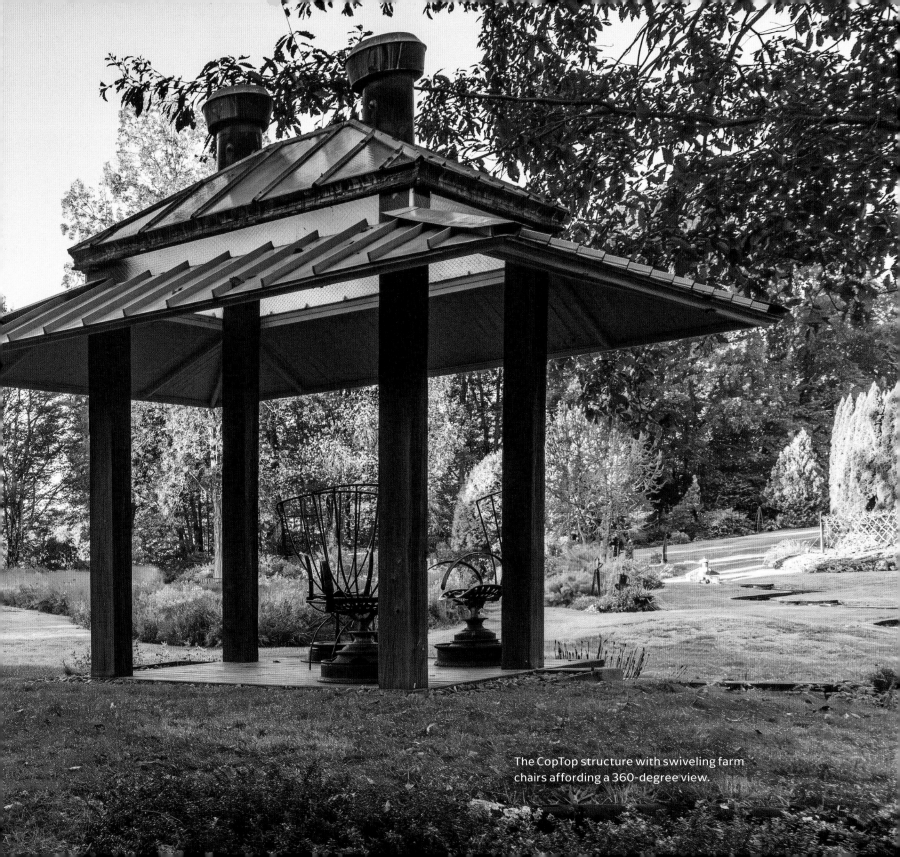

The CopTop structure with swiveling farm chairs affording a 360-degree view.

1

Welcome Court

Step back to 2014: What you once saw, driving by the present Welcome Court, was forest. Farther up the road there was a twenty-three-car parking area with a few pop-up tents lining the driveway to the barn. In 2017, I designed and had built a cute kiosk next to the driveway for the six times a year we were open, one weekend a month from May to October. Even though the kiosk was constructed to be movable, it provided a solid feeling of legitimacy and permanence—no more assembling and then knocking down the tents, or having them blow over and rip in the rain.

Visitation quickly exceeded the number of cars that our parking area could accommodate. Folks began parking on the road. Even the limiting of parking to one side of the road, to allow a fire truck or tractor trailer to go by, was clearly not going to work for our emerging public garden.

While we figured out our long-term parking solution we came up with a temporary fix. In 2018, I asked the principal of Mast Way Elementary School in Lee about using the school's parking lot for the two weekends a month that we were now open; then we could bus folks the three miles to the garden. It took her not a minute to say, "Sure." I had the same response from the owner of Live and Learn Early Learning Center when I asked if we could rent her vans for two weekends a month. "You can just use them," she said. The generosity of these two individuals bought us time while we went through the hoops of obtaining town permitting for a parking lot.

As luck would have it, the garden had yet to extend to its northernmost point between High Road and Route 125. That four-acre lot turned out to be the perfect spot for a new parking lot—as far from our neighbors and our own house as possible.

In 2019, we broke ground for the parking lot and the Welcome Court. In 2020, we cinched the kiosk on a flatbed truck and drove it down the road to its new home. The kiosk now faces a matching structure, a proper bathroom built from architectural plans generously donated by a neighbor. I topped them off with a couple of cupolas and garnished each with a handmade weathervane. The bathrooms also provided gallery space for our too-large art collection.

For the next three years we added yearly improvements as funds pooled. In 2019, our go-to stone and brick artist installed a beautiful brick entrance court edged with granite. He placed a large rock with our logo in the center between the kiosk and the bathroom. I designed a medallion-like paving pattern to encircle the rock to give it more visual weight. The next year the stone and brick artist crafted a beautiful granite retaining wall. I asked him to leave out one stone to become the Tiny Stage, inspired by the National Public Radio show *Tiny Desk Concerts*. The stage needed

Left: A rock with our logo that I gave to Bob for his birthday.

Facing page: The Welcome Court is abuzz with visitors. Notice the birthday rock, which has now been incorporated into a medallion.

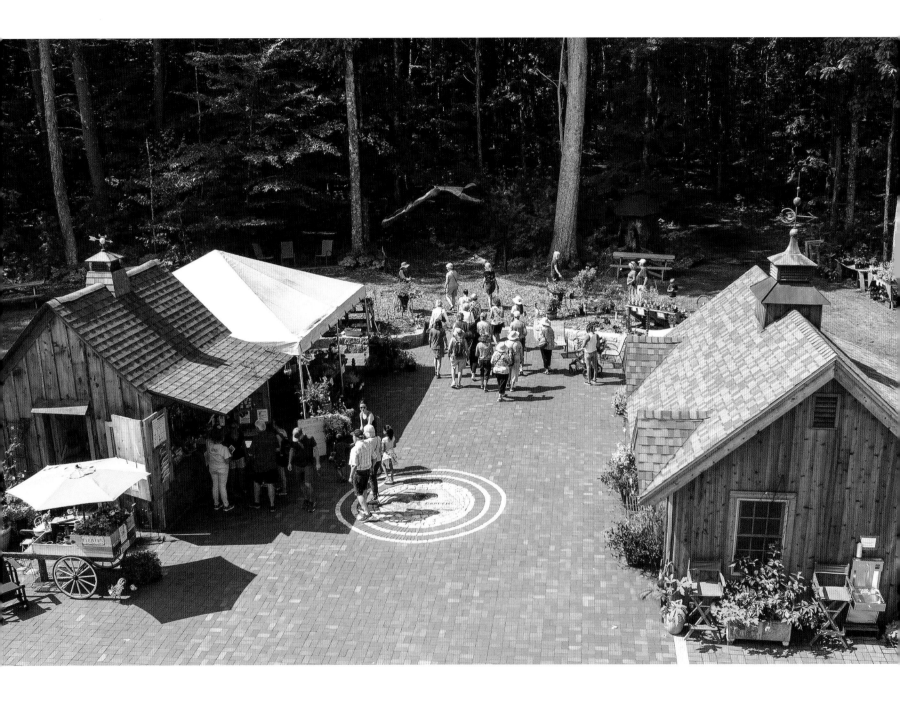

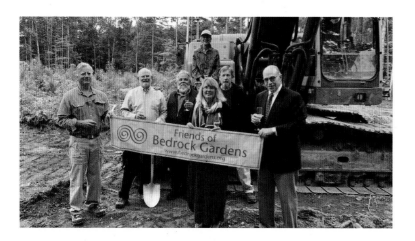

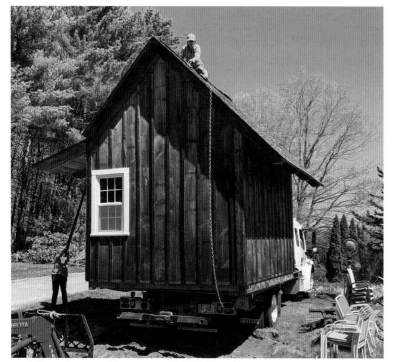

Top: Bedrock Gardens board members toast the beginning of creating the parking lot.

Bottom: Cinching the kiosk onto a flatbed to move it down the road to the parking lot.

proper illumination, so Bob ran electricity under the patio and behind the granite wall to power a small light. The Tiny Stage has become quite a hit and in 2023 all the two-week slots for exhibits were filled immediately.

To break up the large flat paving surface of the parking lot, I designed an elevated median strip that gave a leg up to the trees we were planting for shade. I also imagined it might serve as exhibit space for art installations. The first year we planted a hundred canna lilies from our collection of tubers that we dig up each year and overwinter in the basement. We added twenty castor bean plants (*Ricinus communis*), which we started from seeds harvested from the garden. They were about three inches tall when we planted them and the cannas were invisible tubers underground waiting for summer heat to emerge. This first round was unexpectedly successful, but it required a couple of months of viewing only a two-hundred-foot-long mound covered in wood chips and dotted with tiny sprigs. An exciting event-to-come rather than a blank space.

In 2021, we erected our twenty-foot-square tent nestled next to the kiosk to create a flexible retail space.

In 2022, an early adopter of the garden christened our septic field the Mesa, and it stuck. It has morphed into an outdoor classroom space sheltered by large trees and bordered by the Puppet Theater, a large sculpture I made by incorporating wood stove doors that open and close. It faces the Curiosity Garden, begun in 2022 as a narrow strip of a garden planted with curious plants that can be

viewed close-up. It is intended for children, but everyone is intrigued by the way the sensitive plant (Mimosa pudica) folds up in response to touch, as well as the shapes of the pretzel bean and snake gourd. One is never too old to be amazed.

Acrobats and acrobatics have always intrigued me. If I had kept samples of doodles from my childhood on, they would show that one theme through the years was people stacked on top of each other. As a kid I loved the after-dinner activity of tumbling. My father would lie on the living room floor with a pillow under his head and his knees bent. We kids would put our hands on his knees and our head toward his abdomen, and he would catch our shoulders and flip us around. Another stunt was to sit on his feet or balance like an airplane on our stomachs. We would also be constantly practicing handstands, headstands, and flips.

Over the years I have made a half-dozen acrobat-themed sculptures—one out of clay was a representation of our five family members on each other's shoulders. Another included a series of figures balanced on top of each other, that in turn were balancing on a large globe supported on the shoulders of an oversized male figure. That one was called *Acrobatlas*. Another was a commission by a woman who purchased a street sign bearing the name of her hometown and wanted it incorporated into a sculpture she could put in her garden.

Top: The Puppet Theater incorporates several hinged wood stove doors as well as a handful of small creatures and one weightlifter.

Bottom: The Tiny Stage features a new tableau twice a month. Notice the back lighting.

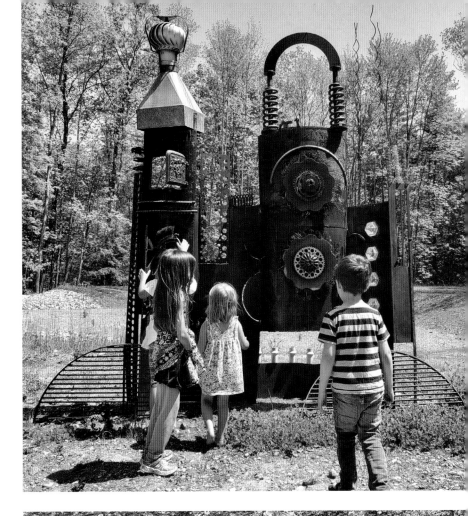

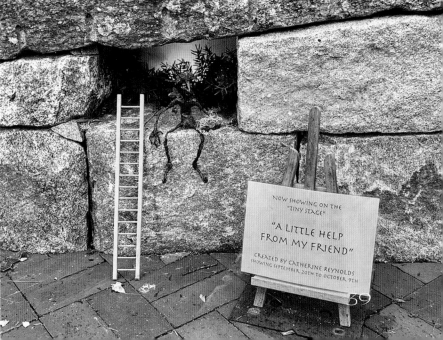

The largest sculpture, *Acrobats*, was initially installed as a gateway to Petit Pond and relocated in 2020 to mark the new entrance to the garden from the parking lot. For this piece I made a model out of sheet copper, and asked a local metal fabricator with a large shop to enlarge it ten times. No problem, he said. He created the slightly three-dimensional curves in the limbs by taking the flat cutouts to his dump, putting them on a large wooden beam and having the dump's payloader drive over them. He and I went back and forth several times refining the shapes—and then one day Bob and I brought them home in two trucks, metal limbs overhanging the sides. We bolted the pieces together by means of step ladders perched in the bucket of the tractor. It was not one week later that a phoebe started her nest in the breast of the top figure.

The time for our visiting guests to purchase this piece ended a few years into its life on the property. Now the *Acrobats*—like other pieces: *Syncopeaks* (in Grass Acre) and *Razor's Edge* (at the exit of Gothic Arbor)—have marked their spot and have become part of the visual vocabulary of the garden. Bob claimed that, every year, he got to skim 10 percent of the art I made for himself—in other words, not allowing it to be sold. I used to say everything is for sale, that I am always making more and need to free up space for new pieces. But Bob doesn't want to sell anything. This has led to some disagreements. Keeping

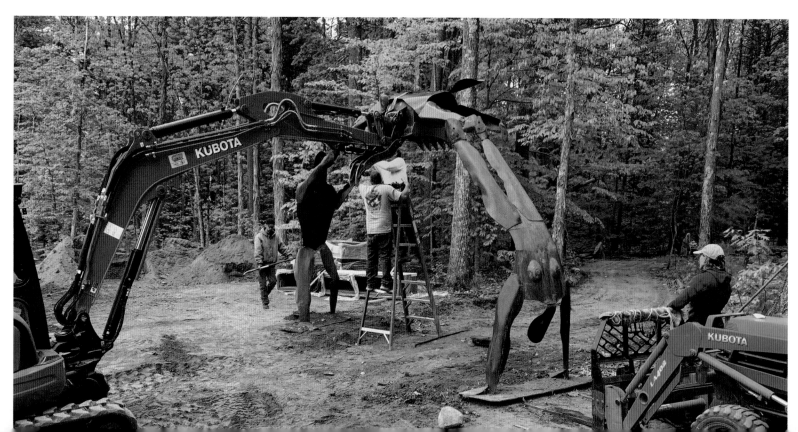

work the public can't buy seemed like a tease. But keeping the *Acrobats* we agreed on. Since 2017, when we dissolved our Fine Garden Art business, the art that remains in the garden is no longer for sale. Bob won. I continue to make smaller pieces, which the gift shop sells to support the garden.

2

Forest Bathing Path

When we created the parking lot, we had to reconfigure the journey through the garden: Now it would begin roughly where it had ended and go in the opposite direction. Instead of starting behind the barn and terminating in the most secret and special space of the Tea House, the new direct path headed straight toward the Tea House. I was alarmed!

My first move was to design the path from the parking area into the garden so it meandered, rather than being straight and goal oriented. This set the stage for a stroll.

As luck would have it this stroll occurred in a stretch of untouched woods between the parking lot and the area we call the Nexus. This area was expansive enough to create a calming feeling all its

Facing page: Reassembling the *Acrobats* after moving them from the Petit Pond to become the welcoming portal to the garden.

Above: Bob wanted a dog and got this one for his birthday.

Right: After passing through the *Acrobats*, this is where your journey through the garden begins, on the Forest Bathing Path.

own and different from any other area in the garden. This turned out to be a much more appropriate and meaningful way to enter the garden. It moved me from alarm to calm, and it even has a name: The Forest Bathing Path.

Years ago I remember reading about the practice of forest bathing. I even looked into taking a forest bathing training course in some beautiful foreign country like Switzerland or Japan. Yoshifumi Miyazaki, author of *Shinrin Yoku: The Japanese Art of Forest Bathing,* coined the term 'Forest Bathing' in 1988 based on his research. He documented how the practice supports health and relaxation through immersion in forests and other natural environments. Since then, many studies have demonstrated an array of health benefits, especially in the cardiovascular and immune systems, and in stabilizing and improving mood and cognition. Miyazaki documented what any nature lover or gardener knows, that time spent outdoors is mood altering.

My next move was to hide the Tea House as much as possible. We first disassembled and moved the *Acrobats* sculpture that had marked the entrance. Then we moved a large banana-shaped rock unearthed from excavating the parking lot to block the opening and provide seating. Finally, we moved a couple of nine-foot rhododendrons to further de-emphasize the structure and reestablish its feeling of sanctuary. We were left with a circular area we call the Nexus, where the path to the Gothic Arbor, the Bridge, Shrubaria, the Fernery, and the Forest Bathing Path all come together.

3

Nexus and Gothic Arbor

The name Nexus stuck immediately but its importance took a while to sink in. Initially, I viewed it as the crossing of several of my work roads, where I can drive the tractor without worrying about compacting the soil. But I noticed that this is where people tend to collect after walking the Forest Bathing Path. Viewing the space as a spot—and not an intersection—was a natural evolution. The way to emphasize its importance gradually suggested itself. We would suspend a twenty-eight-foot-diameter circle high above, hanging by cables from trees. We made the circle out of three-inch, gray plastic sewer pipe and elbow joints, because they are readily available, light, and durable enough to last for years. Determining the height and method of attaching the cables to the five trees is a story too long to tell here, but suffice it to say Bob did a lot of calculating. Happily, the circle also serves as a marker that helps orient people on the property.

Above: Positioning the *Ring* at the Nexus and trying out the cable attachment system. Note the cable to the left of the man in the high visibility jacket. In 2024, a storm snapped the *Ring*. A replacement is in the works.

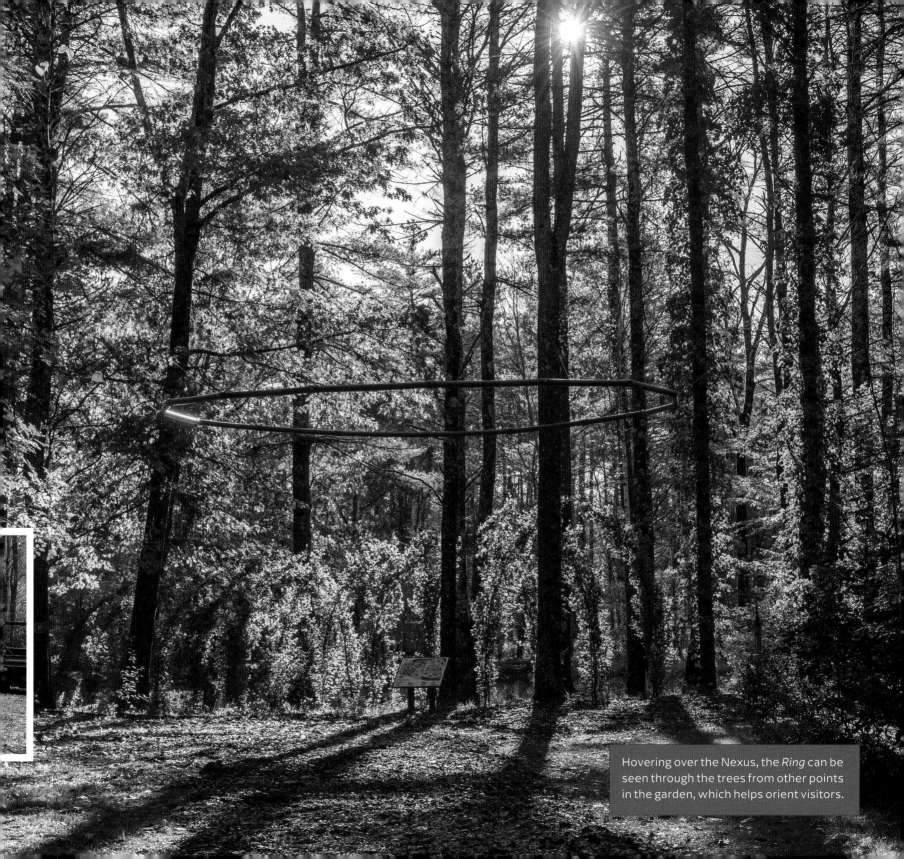

Hovering over the Nexus, the *Ring* can be seen through the trees from other points in the garden, which helps orient visitors.

Left: Fabricating the steel frame for the arches for the beech trees in the Gothic Arbor.

Bottom: The Gothic Arbor of columnar beech trees (*Fagus sylvatica* 'Dawyck Gold') viewed from the Pond towards the Nexus, with the bench as a focal point.

Facing page: The view through the Gothic Arbor from sitting on the bench.

Built in 2013, the Gothic Arbor was designed to provide a connector between the Nexus and the Pond, just as the Straight and Narrow was conceived to connect the Parterre to the Swaleway, and the Allée to connect the Spiral Garden and the Pond. In all three examples the connecting element arose months or years later. This is the beauty of having time to figure out what does not feel quite right in the flow of the garden and imagine ways of addressing it.

In the case of the Gothic Arbor the modification was a somewhat small change in the path system, but required serious effort to pull off. It meant clearing a fifteen-by-eighty-foot path though mature woods, including felling five seventy-foot-tall pine trees, cutting them up, hauling them off, having the stumps ground, and grading and seeding the area.

A friend had constructed a series of two or three Gothic arches on her property and I liked the feel of it. Most of

us can call up the feeling of awe and wonder looking up in Gothic cathedrals, such as the Washington National Cathedral in Washington, D.C.; Notre-Dame in Paris, France; and Antoni Gaudi's La Sagrada Familia in Barcelona, Spain. That feeling stays with you. While not aiming for such a lofty feeling, I wanted to create an experience not found elsewhere on the property, one with enough design heft to hold its own between two strong elements.

I doubled the size and tripled the length of my friend's arches to reflect the size of our garden and the important job the arches would perform. The arches are made of eleven welded and linked steel rods twelve feet high and seven feet apart. I learned later that in numerology the number eleven is associated with transforming the physical into the divine—was this the collective unconscious at work? We planted twenty-two golden fastigiate beeches (*Fagus sylvatica* 'Dawyck Gold'), one at both bases of each arch. Every year we tie the branches to the frame and lightly trim them. These trees are named for emerging leaves that are yellow for two weeks in the spring before turning green. Unlike their American cousins, this beech loses its leaves in the fall.

4,5

Termi and Pond

Shortly after we began cleaning up the mess from the lumbering operation of 1990 we realized there was a slight depression in the woods that suggested a potential pond. As it turns out we were able to get some modest federal support to create a wildlife pond. The funds specified that wildlife ponds need to be several hundred feet from the house and a third of the pond be a shallow area for water plants to colonize as a wildlife habitat. The sum did not cover the permitting process involved in digging a pond, which, in New Hampshire, included separate taxes for removing timber, digging the pond, and creating the dam.

 The U.S. Department of Agriculture designed the pond and determined it would capture water from the surrounding acres. There was no spring in the plan, and sadly none appeared as we watched the huge earth-moving bulldozer dig down eighteen feet at the deepest point. But at least we struck clay, which kept the water from seeping away. While we waited for the pond to fill, we busied ourselves with making a beautiful dock on redwood pilings with two built-in benches (carved with our names and the date) at the end of a ten-foot runway leading from the bank. We christened it Daddy Long Legs, as it was perched way above the water line. The bench was the new destination on our evening walk-around so we could contemplate our pond-to-be. Concealed in the runway was a trap door that could access the overflow pipe. Once, our son let himself down the pipe with a soccer ball to plug up the opening.

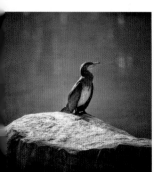

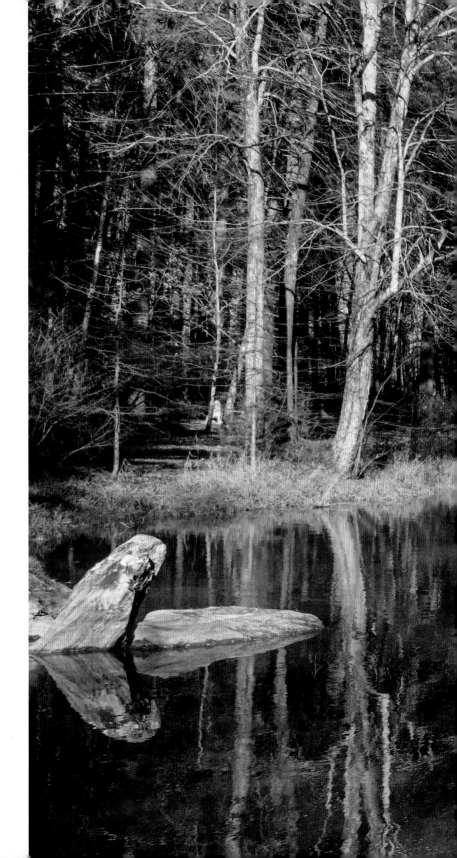

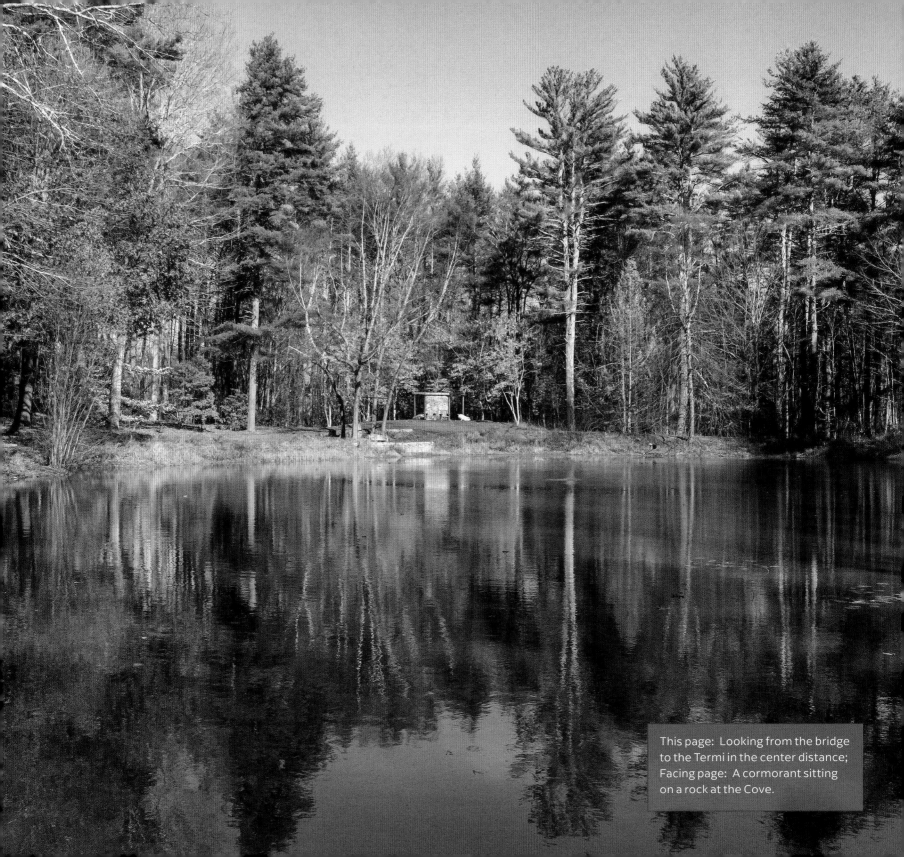

This page: Looking from the bridge to the Termi in the center distance;
Facing page: A cormorant sitting on a rock at the Cove.

Fortunately, Hurricane Bob paid us a visit in 1991, weeks after the pond's completion. It rained for days—we lost power for five—and the kids played in the slippery, muddy and ever-increasing puddle at the bottom, catching frogs that arrived by the dozens. However, we had to wait a few more years for a more reliable way to keep the pond full.

Ron Cote, our heavy equipment operator who dug the pond, suggested that we capture and divert water from the area below the barn. We cut a water-catching swale parallel with the barn that exited into a ten-inch plastic pipe running under the ground in the area that is now ConeTown. The swale sloped slightly to make use of gravity. Prior to this modification I had to mow the pond in the middle of summer. The modification helped a lot but the water level can still get low in dry years.

In summer the kids used to ride their bikes down the ramp and off the dock. In winter, they would take the antique snow blower down and clear a patch for skating. One summer our son Dylan made a "shark" out of a plywood box and lashed it to a couple of fifty-gallon heavy plastic containers. We hauled it out to the pond on the back of the Zipper and it sat out there half submerged for a couple of years.

Some of the pond's allure for swimming was lost for Bob a few years back when he discovered it was full of leeches, the only thing I have seen that repels him. Mostly we enjoy looking at the pond—the reflection of the trees and sky, the variety of birds that visit, the turtles, and the plants that mysteriously arrive. For a plant collector this unplantable half-acre safeguards a flat, open, and visually tranquil

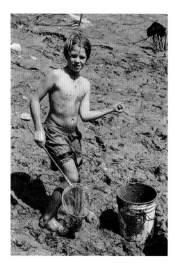
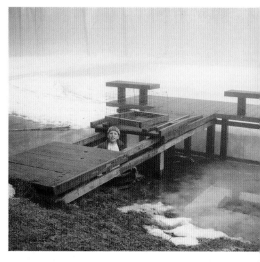
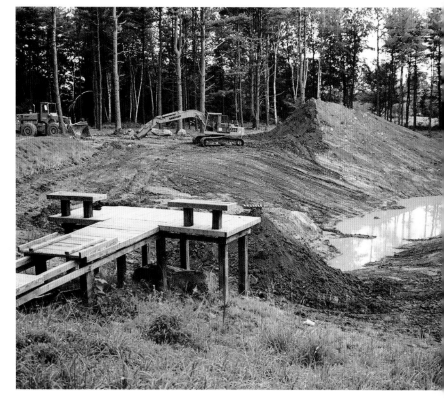

scene so important to include on a journey through a large garden.

We used the clay dirt from digging the pond to form a berm along its east side. The berm blocks headlights and maybe some noise from Route 125, I quickly planted hemlock saplings there. The topsoil from the pond site formed a small mountain on the north side. I liked the promontory it created, so while the heavy equipment was still here I had them spread out the mound to make a viewing spot. This was not a popular idea with the equipment operators, who knew the resale value of loam. Now, hidden safely under grass on what we call the Termi, our name for the terminus of the nine-hundred-foot axis, are five feet of topsoil—our savings account.

The Pond was a major destination for our evening walks—someplace to go, a dot connected by skidder trails. It is fortuitous that receiving government support for a conservation pond also requires it to be sited far from the major dwelling. This left acres between our house and the Pond, which I began to view as my fresh canvas.

The Bridge is another chapter in the saga of circulation challenges. On one of our house-exchange adventures

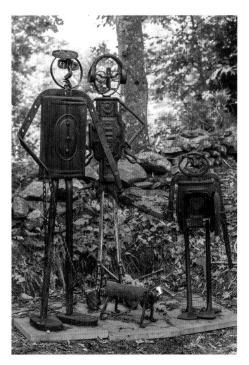

we visited artist Claude Monet's house and garden in Giverny, France. For me the house upstaged the garden but the famous bridge had staying power. We had to have one.

We sited the Bridge at the exit of the overflow pipe that runs from the Wiggle Waggle's Lotus Pool under ConeTown to the Pond. Our neighbor dug eight holes with his backhoe and we placed Sonotubes and filled them with concrete to form the footings of our Bridge. Somehow, I remembered that we had stored the slices of wood removed from the top of the Torii beams in a back corner under the barn. We laid three of the slices on the Sonotubes as floor joists forming the arch. The yin-yang synergy of the concave curve of the Torii and the arch of the Bridge, which can be seen simultaneously, pleases me even though it is too subtle for most people to pick up on their own. I like to think of it as one of the ineffable meanings a garden can carry.

Building the Bridge was sinfully fun, like eating dessert before dinner, but the problem was that it went over nothing and led nowhere. Yes, it did go over running water for a brief period in the spring when the sump pump under the liner of the Wiggle Waggle did its thing, but mostly the area under the Bridge was a patch of grass fifteen feet from the edge of the Pond. The west side of the Bridge faced an acre of dense puckerbrush full of sumac, poison ivy, and

Facing page clockwise from the top left: Dylan catching frogs, heaven for a boy; Spencer plugging the overflow pipe by inflating a soccer ball; digging the pond a little deeper.

Above: *The Family from Hell* sculpture located just west of the bridge. The figures' torsos are made from wood stove doors and the ears on Birkenstock the dog are from a retired pair of Dylan's sandals.

pine and maple trees. To create a faux stream under the Bridge we ran electricity to it, installed a recirculating pump in the Pond, and snuck a water line back to the overflow pipe behind the Bridge. Voilà, a gurgling brook. Then we spent a month clearing the puckerbrush to the west and establishing a path to the Nexus. This area first became Della Rhodia, a dell of rhododendrons, and eventually Shrubaria. Now the Bridge led somewhere. This is another example of my inclination to act now, think later.

To my eye, the Pond has always lacked something. I am not an ocean lover, but a lake or a marsh feels interesting, tranquil, and mesmerizing. So the Pond should be an enduring draw but it is not. When we first built the Pond it was a strong magnet for us. Then the dock became our go-to spot. Soon that was replaced by the thrill of the Termi structure and sitting on the thrones. Then came the Bridge and its bench, which required a long sit on our evening walks. Most recently the Dell, near the Pond, with its curved stone

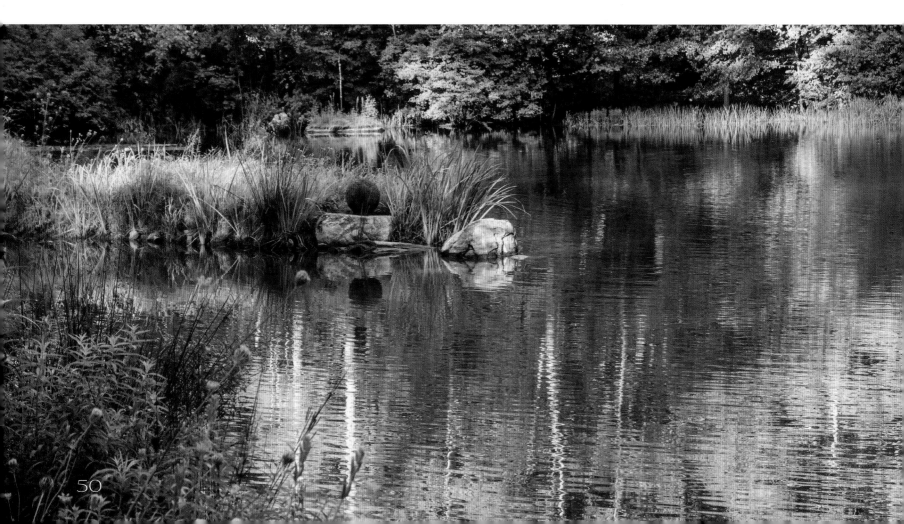

wall has become our spot to sit and swing. But what I liked the most was probably making these features.

With the new circulation pattern starting at the parking lot, the Pond is now one of the first events visitors come upon. I have always thought of it as a cow pond, muddy and without anything notable. Unfortunately, the indelible image of a beautiful pond that sticks in my mind is Beth Chatto's pond in Essex, England. It had a full garden down to the edge of the water with iris, gunnera, astilbe, ferns, shrubs and a beautiful bridge of sod. It was maybe my favorite part of her garden as I remember it many years ago. I shuddered thinking of the maintenance such a garden would require if I attempted to replicate that vision, so I turned my back on the Pond and waited for something to occur to me.

In 2020, the possibility of modifying the Pond serendipitously presented itself. I had both the talented excavator operator Brian, who had crafted the parking lot, and the availability of lovely raw material we harvested from the parking lot close by. Together we sculpted some curves, formed a cove and peninsula, and planted rocks, some so large he had to use his special trick not to tip over the machine.

The design concept for the most fun alteration—a rock that took a walk—was inspired by Andy Goldsworthy's piece, *The Wall That Went For a Walk*, in the sculpture garden at the Storm King Art Center in New York's Hudson Valley. His piece traces a beautifully crafted rock wall that snakes around many trees, enters the pond, and comes out the other side. In my version the piece begins or ends with a seven-foot, somewhat flat rock seated into the bank of the Pond. This rock is visually connected to a cluster of other large rocks, thirty feet away, by a series of boulders placed underwater, forming a shadowy line of dots only slightly visible when the Pond is full. When the Pond is at its lowest, the large, out-of-reach steppingstones are revealed. I aimed for a kinetic sculpture where the water level provides the movement, or rather water evaporation does.

The gesture that had the greatest impact was constructing a twenty-foot peninsula stretching into the Pond that created a graceful, intimate cove—a favorite of ducks, cormorants, and turtles. Altogether the Pond feels more satisfying.

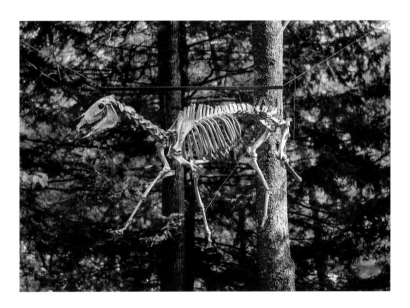

Left: The cove at the Pond looking like a shimmering pool of mercury.

Right: The *Hi Ho Silva* horse skeleton hangs from a tree on the path around the pond.

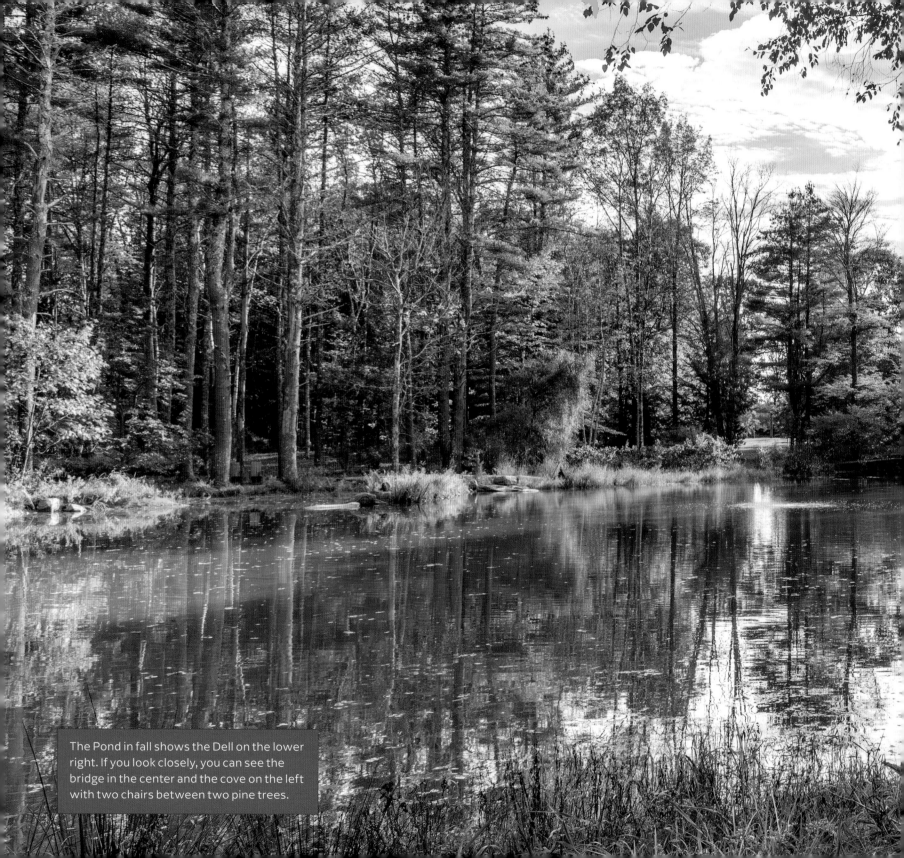

The Pond in fall shows the Dell on the lower right. If you look closely, you can see the bridge in the center and the cove on the left with two chairs between two pine trees.

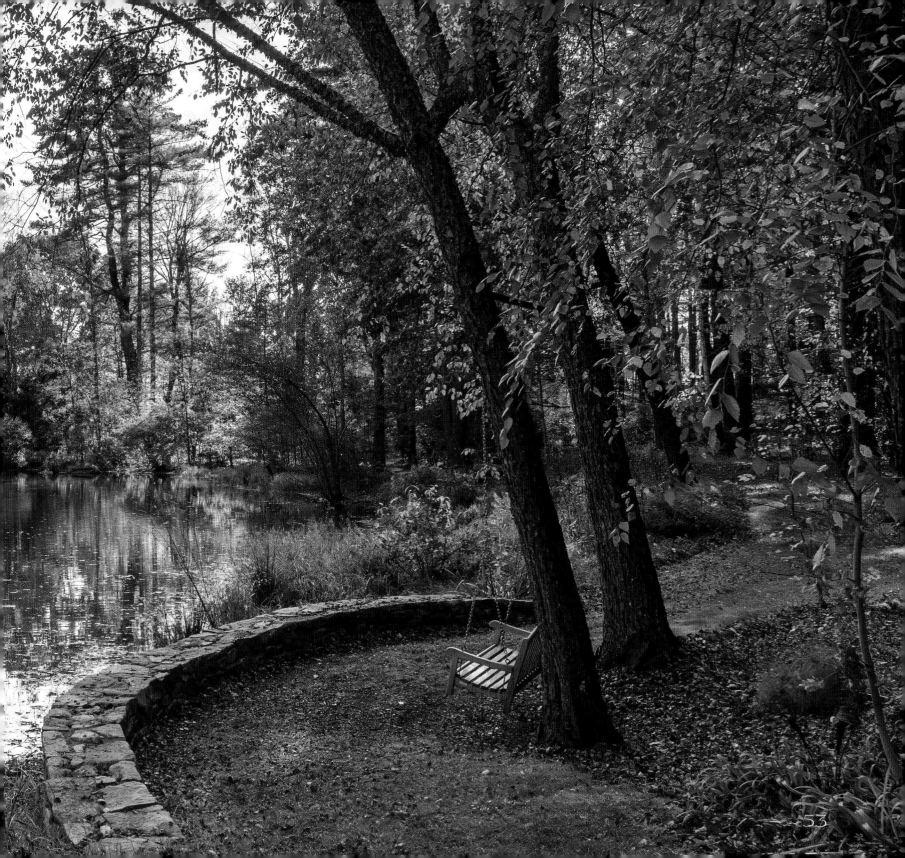

6

ALLÉE

In 1990, the Torii stood proudly within an interrupted paddock fence and functioned well as somewhere to go on the garden journey. The "how to get there" had yet to be determined in my "connect the dots" method of garden design. The Torii badly needed a context to make it serve a purpose. I always wanted to have an allée. I remember trying to shoehorn one into a corner of the property. Thank goodness I waited, because the Torii and the Allée were meant for each other—down to their double-vowel endings. Perhaps it was the interrupted paddock fence line that made a natural segue for a row of trees. The Torii would sit roughly in the middle of two rows of trees. In my mind's eye, the Torii would gradually shrink in impact as the trees took over and eventually you would come upon it as a surprise.

I spent the winter researching what tree to select for the Allée. I wrote to several knowledgeable ornamental tree people for their five top suggestions. I was looking for a small, twenty-foot, disease-free tree with three seasons of interest. Ultimately I settled on Korean mountain ash (*Sorbus alnifolia*). The December 18, 1992, entry in the Bedrock Gardens Farm Book says: "Just returned from Weston Nurseries where I tagged forty-five *Sorbus alnifolia* for our double allée. Tramped through two feet of snow with Dave Walker. Fun." What I could not see at the time, because of the snow, was that some trees were grafted on another species of mountain ash and some were grown on their

Top: The Torii straddles the line of the former paddock fence marked by the line of taller grass. On either side are the holes for the trees.

Bottom: The first step to remove the trees was to cut the tops off, leaving stark sculptural pieces.

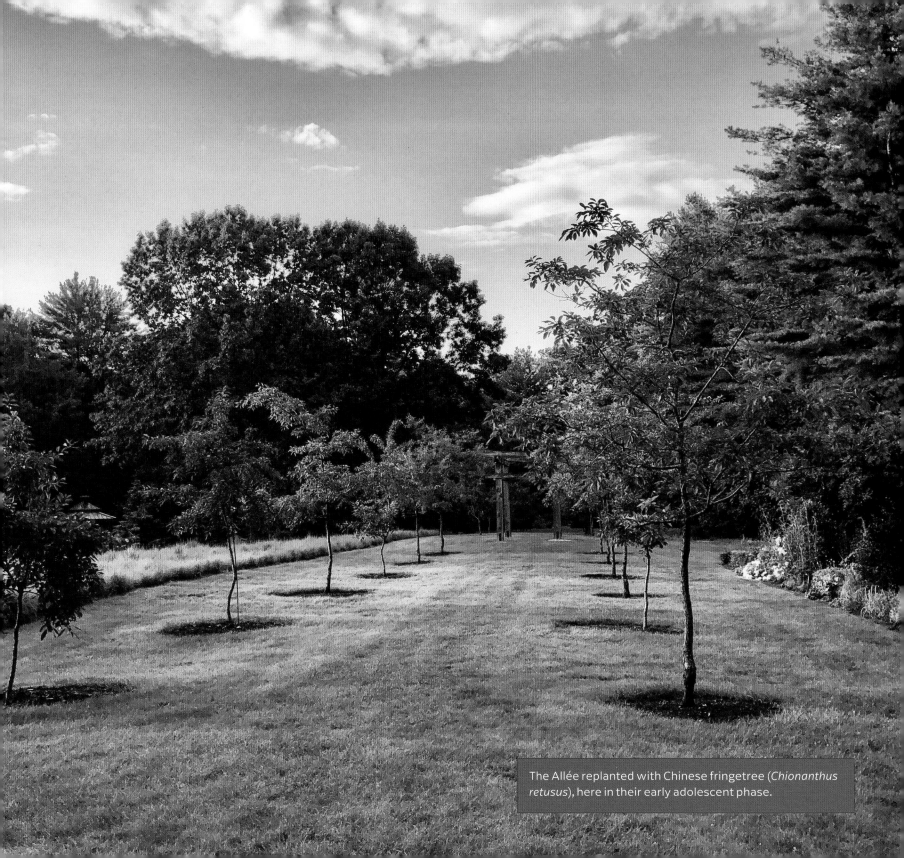

The Allée replanted with Chinese fringetree (*Chionanthus retusus*), here in their early adolescent phase.

own roots. The former sprouted bushy beards at the point of the graft, which required tedious and frequent pruning.

In my journal entry from April 18, 1993, I wrote that the holes for the trees were too large and misplaced, but the real challenge was lining them up in two straight rows. "We staked out the allée this afternoon using several methods including an isosceles triangle of string flip-flopping along. Finally, we settled on the naked eye as producing a much more accurate line than the geometry we tried." By the time the trees arrived in the spring, on a flatbed truck, in the spring we had purchased a transit. With that and a tool Bob made, we were able to move the trees as little as one inch to line the trunks up in a straight line.

Then came the nemesis, drought. The closest source of water at the time was the barn, more than 400 feet away. We ran as many hoses as we had, then extended them farther by attaching a long section of flexible black two-inch pipe to the hose, with duct tape. Altogether it stretched about an acre across the field. The quickest means of transportation was a bike. I would come home from work and pedal out there, wondering if I should water what looked like the neediest tree first or continue the zig-zag plan.

Despair began to creep in as more and more trees looked like they weren't going to make it. My October 2, 1993, journal entry says: "I clung to Bob's comment that years from now we would recall with humor all the trials that beset the installation of this beautiful double allée we would then be admiring. I suppose unless you try something big, you can't have big problems. Thank goodness the gypsy moths, which were an incredible menace last year, were on the sharp decline this year." The October 16, 1993, entry in the Bedrock Gardens Farm Book reads, "We planted the fourteen replacements of the *Sorbus alnifolia* today."

Whatever headaches these beautiful trees caused ceased fifteen years later, because we cut them down. The sad fact was that in my pursuit of a lesser-known and underused tree, I had selected a tree that would come to be regarded as invasive. They soon blanketed our woods with seedlings whose leaves turn a lovely soft orange in the fall, announcing each year how far out of my grasp they had become.

Initially, I was heartsick at the prospect of cutting them down. When I first said it out loud, I could hardly believe what came out of my mouth. Gradually the horror of spotting a seedling anywhere on our thirty acres tipped the scale. I could not wait to eliminate the source of the next generation of seeds.

In 2010, we replaced the Korean mountain ash with Chinese fringetrees (*Chionanthus retusus* 'Arnold's Pride'). They were purchased as two-foot, bare-rooted whips from Heritage Seedlings in Oregon, as opposed to the one-and-a-half or two-inch caliper mountain ash we started out with in 1993. For years the fringetrees' thin stems flopped over

Facing page: A garden medley in the Ping Garden, parallel to the Allée, punctuated by the cymbal sculpture. Some plants include the lavender meadow rue (*Thalictrum rochebrunianum*), pale pink sedum, deep pink of spirea, and orange of fire king daylily (*Hemerocallis* 'Fire King').

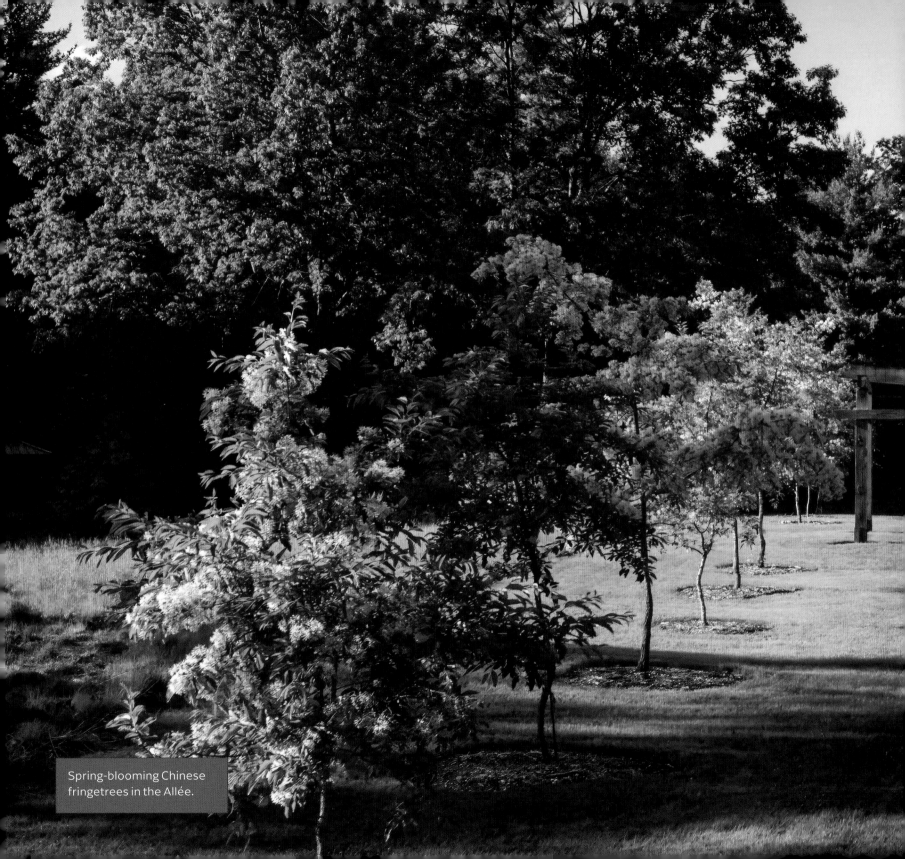

Spring-blooming Chinese fringetrees in the Allée.

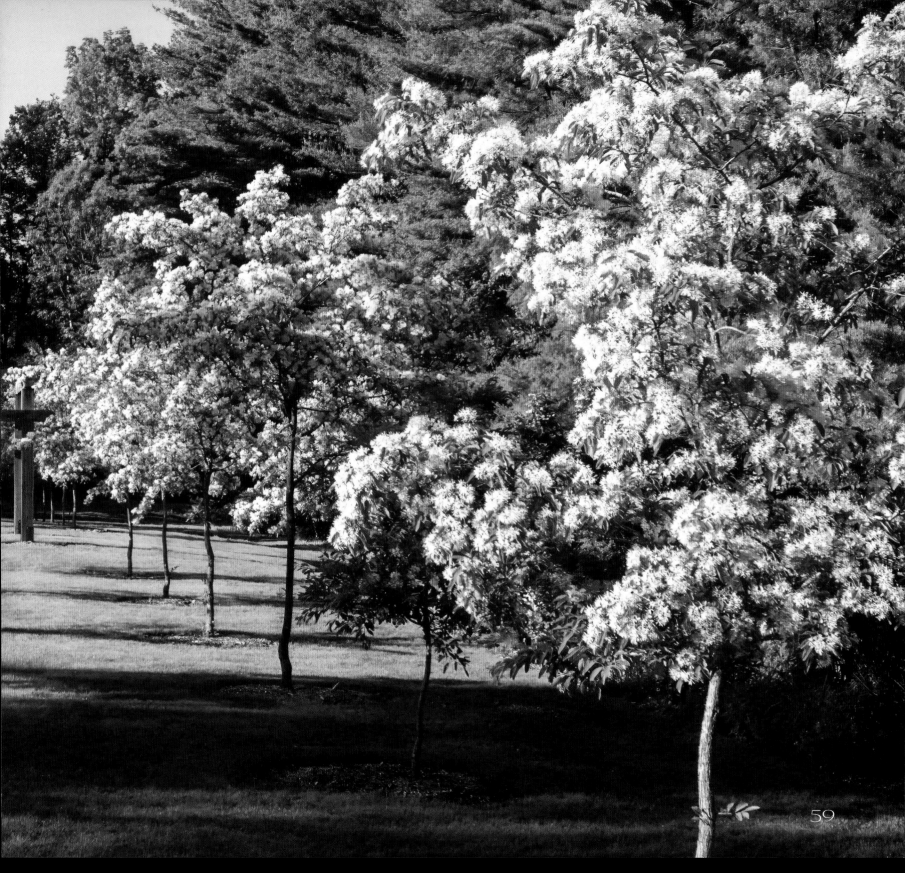

Left: Installing the *Golden Ring* at the Spiral Garden.

and required staking, and even then, the side branches flopped down as if the tree had the soul of a weeper.

The Chinese fringetrees threw some blooms early on and ten years later they began making a statement. The glossy foliage, prolific frothy white blooms, and the copious dark-blue olive-like fruit have provided a long run of interest. The Chinese fringetree is a member of the olive family, as is the ash genus. Sadly it may succumb to the emerald ash borer, which is wiping out ashes in much of the country.

When we created the Allée with the Torii at the midpoint we established a strong visual line. This became one of two major spines in the garden. We strengthened this line, or axis, clearing a visual path over the Pond by cutting down a number of large trees and removing fifteen feet of stone wall. Now, from the Termi you look through the Torii south to the golden circle hanging high in the trees at the farthest border of the property. The ring bisects the top beam of the Torii like the London Underground logo. From the ring you can turn around and look north through the Allée and Torii.

At the Termi we installed two throne-like teak chairs and hung a backdrop wall of wool, that was left over from one of our displays at the Boston Flower and Garden Show. Bob further dignified the space by adding a patio of bluestone and cobbles combined with some very unusual bricks, the product of a "failed firing" at the local brickyard decades ago. The combination of the backdrop of a grove of seven-sons trees (*Heptacodium miconioides*), chairs, the wool wall like the ermine fur adorning a king's mantel, the columns, the higher elevation of the Termi, and the long sightline creates a theatrical king-of-all-I-see feeling. I have always pictured it as a movie set for a wedding. First the party walks along the Allée, guests lining both sides, with French horns or flutes playing. Then the couple climb into a punt and are gently poled across the Pond strewn with flower petals and votive candles. Finally they ascend to sit on the thrones under a pergola wrapped in garlands of flowers.

This north-south sightline is bisected by a east-west axis at the Torii that runs east from the Landing through the Torii structure to terminate at the (now obscured) CD Tree. We strengthened this half of the sightline to the east by eliminating some pine trees that were blocking the view deeper in the woods. We then created a focal point strong enough to be seen from the Landing at the back of the barn, roughly eight hundred feet away.

Initially, we wrapped a medium-sized pine trunk in a four-foot band of aluminum foil. The tin foil-wrapped tree evolved into a more elegant reflective surface of 250 CDs screwed on with tiny springs. I was aiming for the magical luminescence of the watery green color of the CD, much the same color as the deck prisms. No go. When the sun hits the CDs at the right angle, they flash red, cobalt blue and yellow in a garish carnival fashion. We took great pleasure to discover them brightly illuminated at about 5 p.m. on the summer solstice.

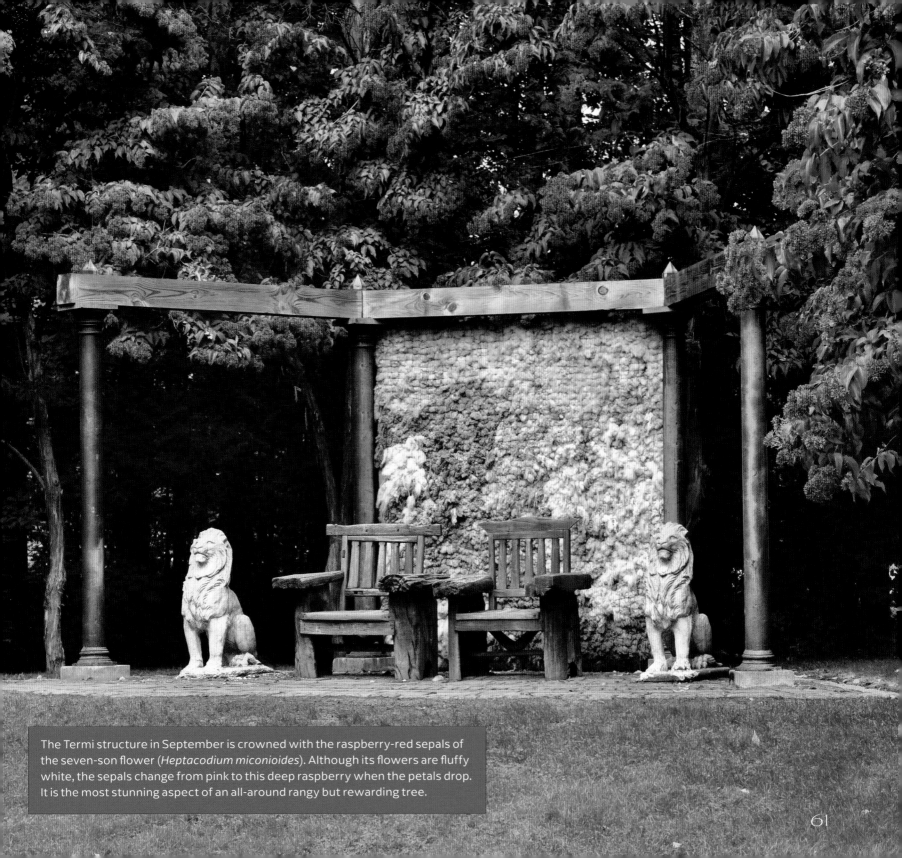

The Termi structure in September is crowned with the raspberry-red sepals of the seven-son flower (*Heptacodium miconioides*). Although its flowers are fluffy white, the sepals change from pink to this deep raspberry when the petals drop. It is the most stunning aspect of an all-around rangy but rewarding tree.

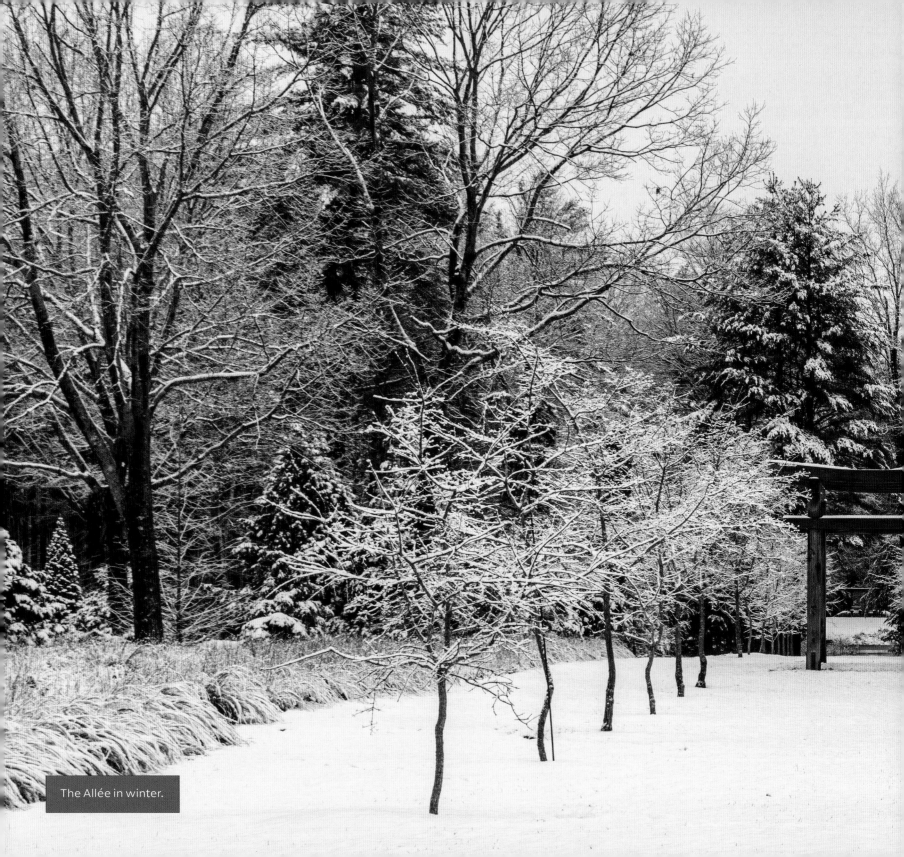
The Allée in winter.

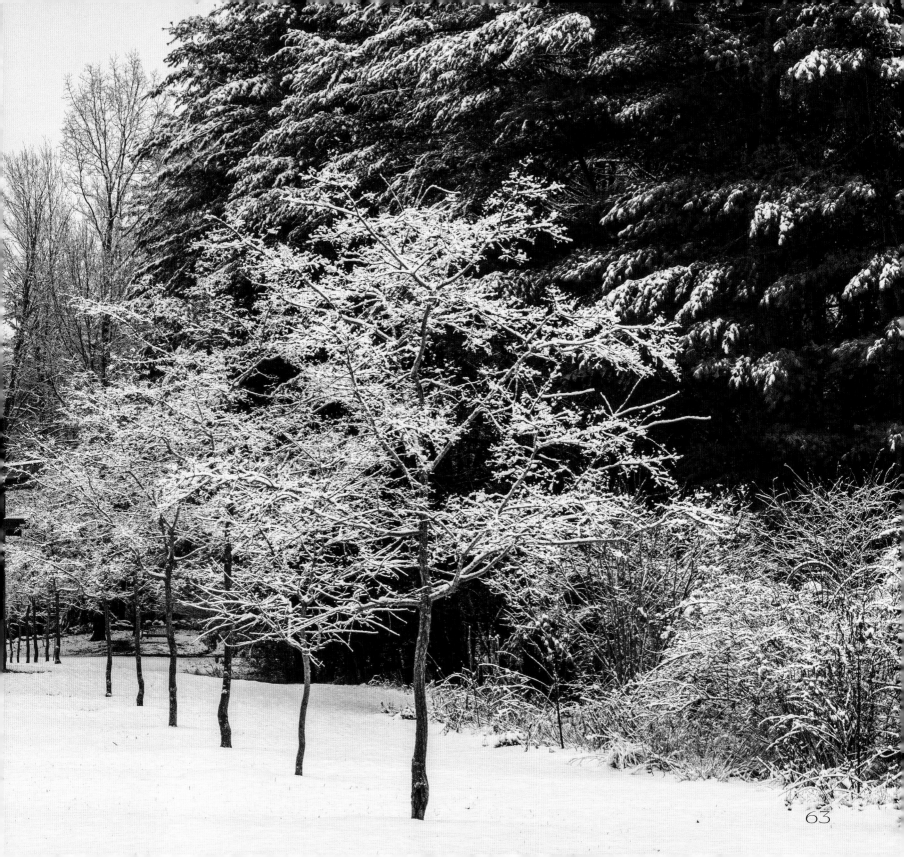

Left: Assembling the *Inukshuk*.

As the garden aged, the sightline to the CD Tree became crowded by an irregular row of Japanese scholar trees (*Styphnolobium japonicum*) planted in front of it. We grew these trees from seeds—they were the only success to come out of a seed propagation course we took at the Arnold Arboretum's Dana Greenhouses. I was happy and proud to have a spot to plant the four-inch darlings. I had given no thought to their negative impact on that focal point. So it goes, when you have a large garden. Things sneak up on you.

I'm reminded of a passage from *Funny Weather: Art in an Emergency* by Olivia Laing (published by W.W. Norton & Company in 2020): "Gardening situates you in a different kind of time, the antithesis of the agitating present of social media. Time becomes circular, not chronological; minutes stretch into hours; some actions don't bear fruit for decades. The gardener is not immune to attrition and loss but is daily confronted by the ongoing good news of fecundity. A peony returns, alien pink shoots thrusting from bare soil. The fennel self-seeds; there is an abundance of cosmos out of nowhere."

As luck would have it, in 2021, a friend offered me an antique millstone she had planned to use in her garden, but could not make it work. I re-experienced the thrill I had felt when Ron Cote gave us the two pieces of curved granite curbing that gave birth to the Parterre. Pure luxury. After casting around for ways to use it, the place found me—much like the placement of the Torii in the middle of the paddock.

I always thought using millstones as stepping stones was a waste of a beautiful sculpture. I had seen it done repeatedly and assumed they were so plentiful at the time that they were getting repurposed. Well, they are not plentiful now. I knew I wanted to install this millstone upright and elevated to give it a place of honor.

Over the past thirty years I have accumulated pieces of granite and stone that spoke to me. When Fletcher Granite Company in Milford, New Hampshire, was closing, we scavenged their yard and came home with three large pieces of different types of cut granite, all with patterns of drill marks. Each was a piece of sculpture all by itself. One was a two-foot-by-six-foot-by-six-inch slab of black granite that would work perfectly for the new Baxis structure, replacing the CD Tree as the terminus of the east-west axis.

We placed the black rectangle on top of two large old granite posts like a table and then pinned the millstone vertically on top of that. When it was done a friend said it reminded him of an Inuit figure. Sure enough it does, so we called it by its Inuit name, *Inukshuk*, which means to act in the capacity of a human.

7

Dark Woods

There are two ways to arrive at the Baxis: Walk through the majestic formal Allée and when you arrive at the Torii, take a sharp left. Or you can take the inauspicious looking path through the Dark Woods, so easy to mistake that I made a signpost with its name.

This was one of several secondary paths that form spurs off the main route. It struck me that this patch of bedraggled untended pines could serve as a counterpoint to the rest of the garden that was rapidly becoming gentrified. I called it a palate refresher between the Pond and the gussied-up Baxis event. The latter was in full sun and the Dark Woods was in shade. The Baxis is hot; in the Dark Woods, you felt instantly cooler.

Before long, Bob started populating the area with loitering figures of upside-down tree crotches lounging against the straggly pines. Maybe it is not such a surprise when I remember his father constructing one of these figures as a sculpture on his Boxerwood property. The figures began proliferating as the materials became available, some very large and others shrunken. I joined in making site-specific sculptures, carrying along the theme of spookiness and something-is-not-quite-right-here. I hung some up in the trees, and then Bob caged horse bones and strung them up. I brought home a piece of driftwood from Whidbey Island in Washington and set it on a pedestal; Bob added a red glass eye. Now the pine trees are dying, adding to the feeling of decay but introducing lots of light. Things are always changing.

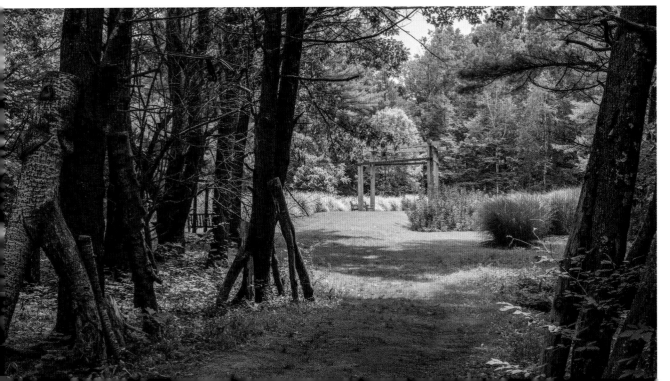

Top: *Quetzalcoatl*, a piece inspired by the Aztec and Mayan creator god, suspended in the trees and looking fiercely confident.

Left: The Dark Woods leading to the Baxis structure illustrates their relationship, going from dark to light, *au naturel* to managed.

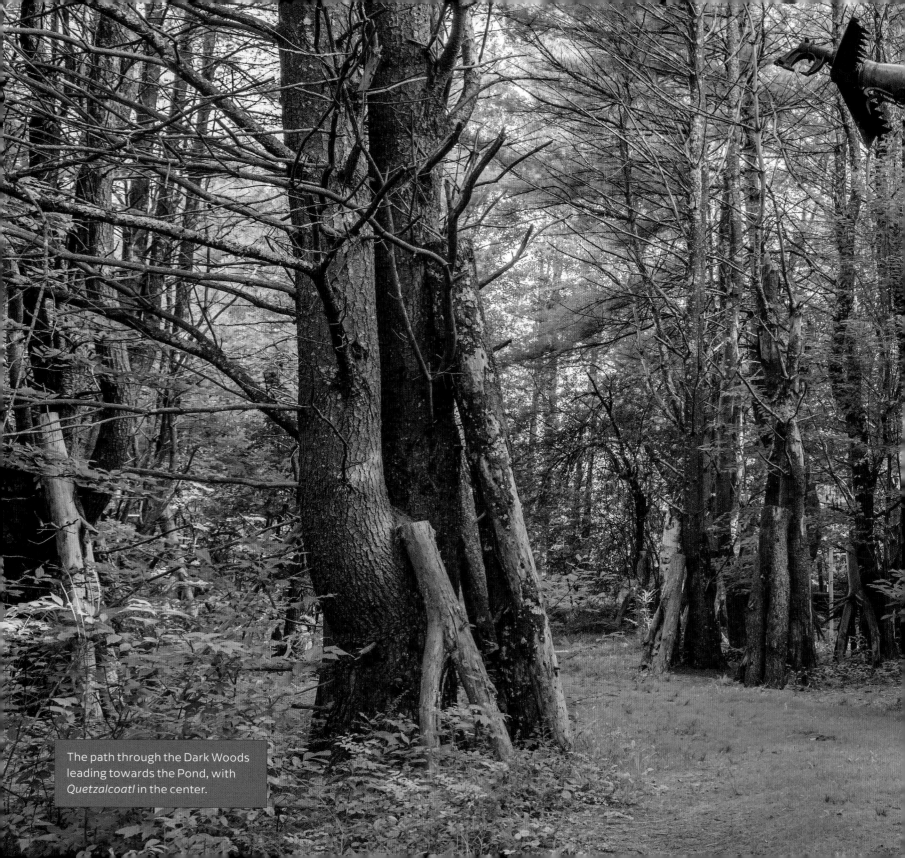

The path through the Dark Woods leading towards the Pond, with *Quetzalcoatl* in the center.

A sampling of some personalities and attitudes of the residents.

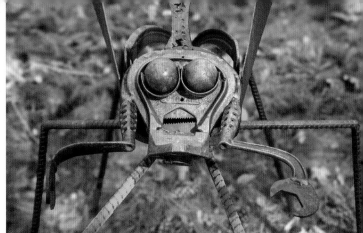
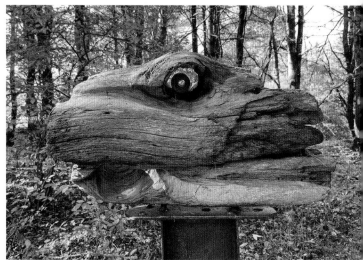

Top to bottom: A bug with razor-sharp teeth and beady caster eyes; driftwood from Whidbey Island that found a new home; the *Red-Eyed Bug* with car antennae and brake light eyes.

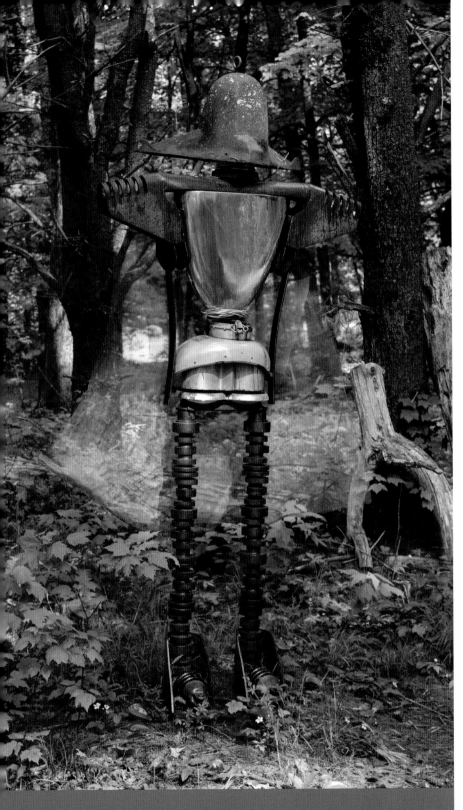

Darth Vader with an upended corner stall feeder for a head, wasp waist, and camshaft legs.

More personalities and attitudes of Dark Woods residents.

8

BAXIS

In 1999, we blasted bedrock to construct the family-room addition to our house and were presented with another opportunity to repurpose material from construction. If you are light on your feet, rubble like this can feel like an unbelievable gift. The sloping area between the Torii and the edge of the woods lacked character. Suddenly the two joined up, a problem and the solution. Many, many loads of blasted rock and subsoil were dumped in a line parallel to the Allée. These were leveled, and subsoil was added as it became available to us. We now had a berm, level with, and parallel to, the Allée.

Whatever structure we erected on this back berm had to be of a scale to compete with the hefty pine trees around it. We settled on a twelve-foot-high pergola we dubbed the Baxis, the "back axis." Without Bob's firm grasp of math and engineering, we never would have ended up with a structure that looks square from the Landing but is a rhombus. This shape was required to accommodate the path that runs through it south to north that is not at right angles to the east-west path. To date, only one person, in my presence, has noticed the Baxis's rhomboid shape: landscape architect Stuart Dawson.

The runway feeling of the Baxis was soon softened with the addition of a row of variegated fountain grass (*Miscanthus sinensis* 'Variegatus') on the east side and a series of rows of different species on the west. These

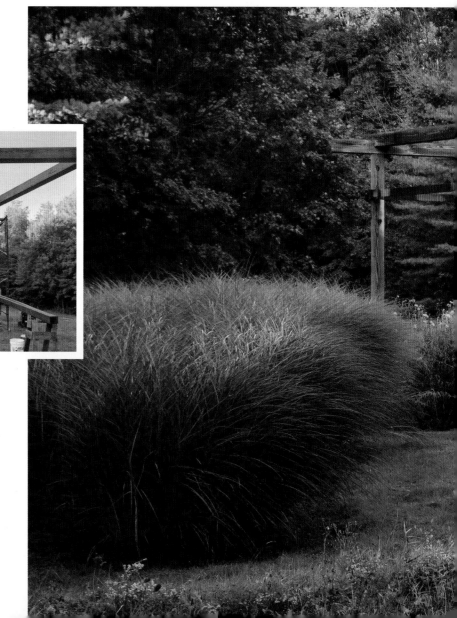

Above: Bob engineers the Baxis.

Right: The Baxis as seen from the Belvedere.

began with purple smoke bush (*Cotinus coggygria*), interplanted with Maximilian sunflower (*Helianthus maximiliani*), then morning light maiden grass (*Miscanthus sinensis* 'Morning Light'), and finally sparkleberry winterberry (*Ilex verticillata X serrata* 'Sparkleberry'). I have always been drawn to the look of agriculture, the neat rows of crops, blocks of different colors—a crazy quilt when viewed from an airplane.

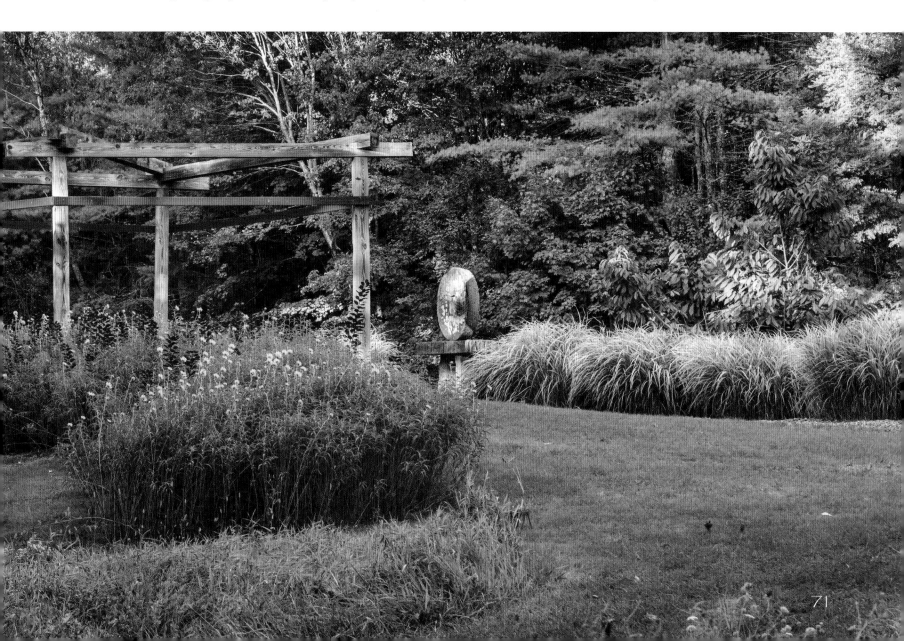

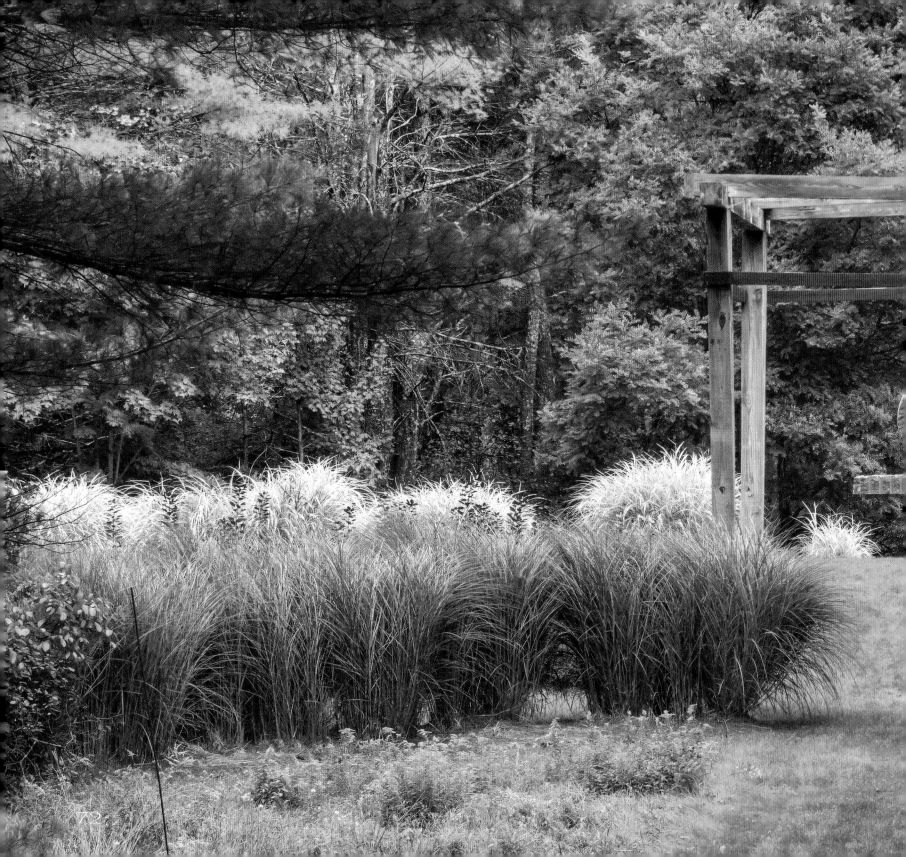

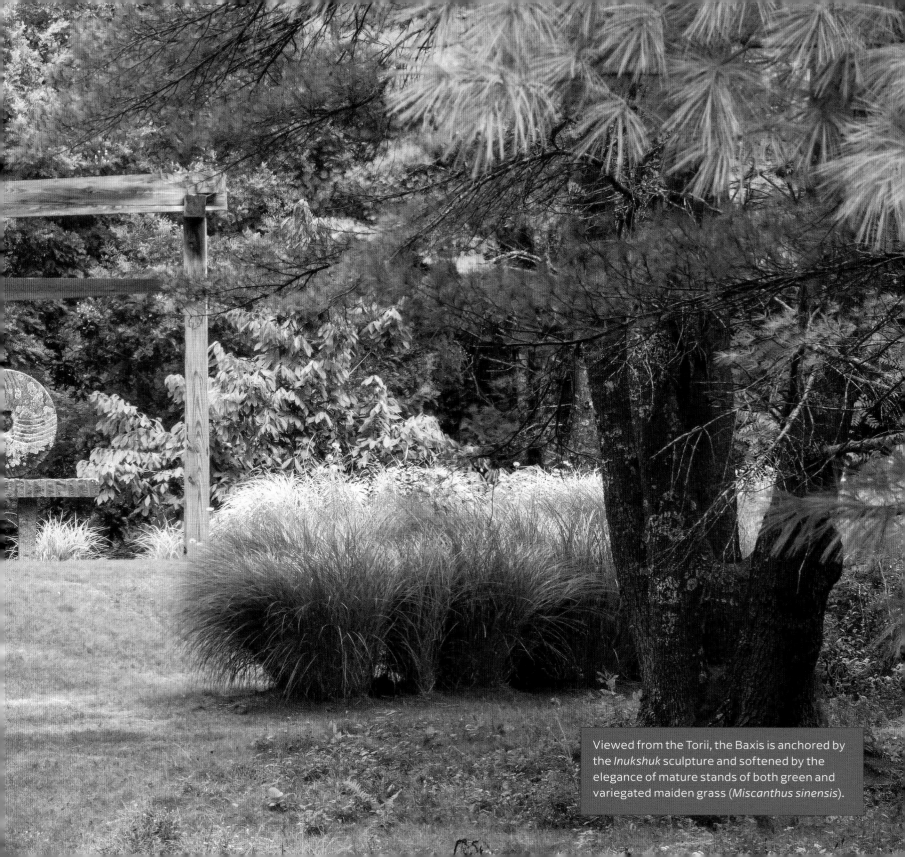

Viewed from the Torii, the Baxis is anchored by the *Inukshuk* sculpture and softened by the elegance of mature stands of both green and variegated maiden grass (*Miscanthus sinensis*).

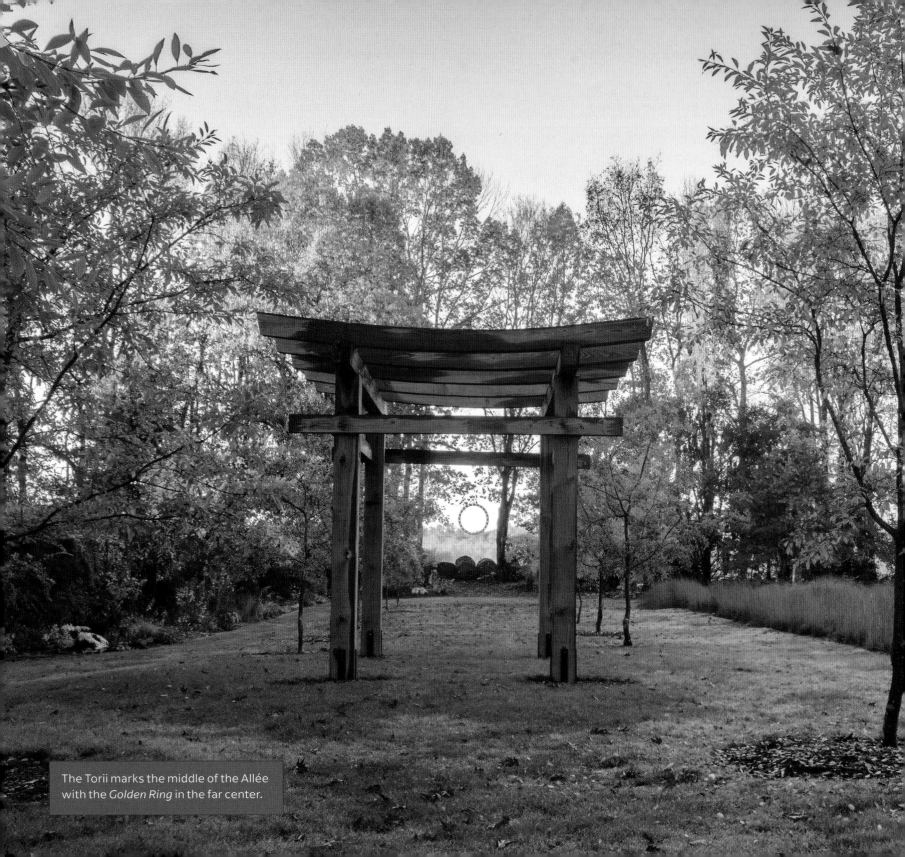

The Torii marks the middle of the Allée with the *Golden Ring* in the far center.

9

Torii

One of the first embellishments to the patio by the house was a plan to add a pergola over it for shade. In anticipation we poured four footings, two of which remain concealed under the bricks of the patio. The carpenter we hired to build the pergola came up with the wonderful idea of a torii, taken from a book on Asian structures. A Torii is a traditional Japanese gate most commonly found at the entrance of, or within, a Shinto shrine, where it symbolically marks the transition from the mundane to the sacred. It can be found singly, or in multiples, including a famous single red torii in the water. Its shape is somewhat like the Greek letter pi. Ours would be a rectangle with five gracefully concave top members. I was still in the model-making phase at Radcliffe, so I made a model of it. When I was satisfied with the elegance of the proportions we ordered the lumber. We settled on rot-resistant Douglas fir.

When the wood finally arrived, Bob was at work and I was the only one home. I could see, as the truck pulled up, that the dimensions we had chosen were way out of scale with the house and the shed. This would have been immediately apparent if I had included them in the model as well. The beams were moved out of sight until we figured out what to do next.

Fortunately, a solution for our Torii presented itself: a spot in the back paddock seemed to call its name. It was on a rise an acre away from the barn. A year and a half later, we took down the section of fence that ran right

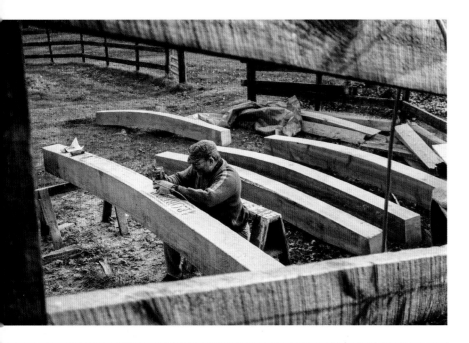

through the spot and erected the Torii. It stood parallel to the broad side of the barn and had enough prominence and proper placement to have a conversation with the barn.

Our carpenter determined the curve of the top members by bending a fourteen-foot length of clapboard and marking its natural curve. A wood carver scribed the names of our five family members on the bottom side of the crossbeams. It is always interesting to see who notices this; most don't. I remember hearing the director of a botanical garden say most visitors to a garden take in 20 degrees of the landscape out of a possible 180, and it is children who look up and down. There is a sculpture under the water by the bridge in front of the CopTop and it is invariably the children who notice it.

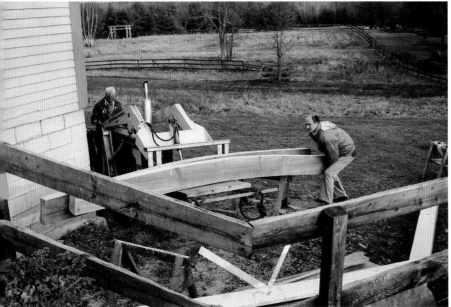

Top: Carving elegant lettering on the five beams for five family members.

Bottom: The finished beams are being moved to the partially finished frame seen in the distance in the upper left.

Facing page: The Torii is seen through the Garish Garden, framed by an Asian pear tree with a patch of dusty rose Joe Pye weed (*Eutrochium maculatum*) in the middle ground.

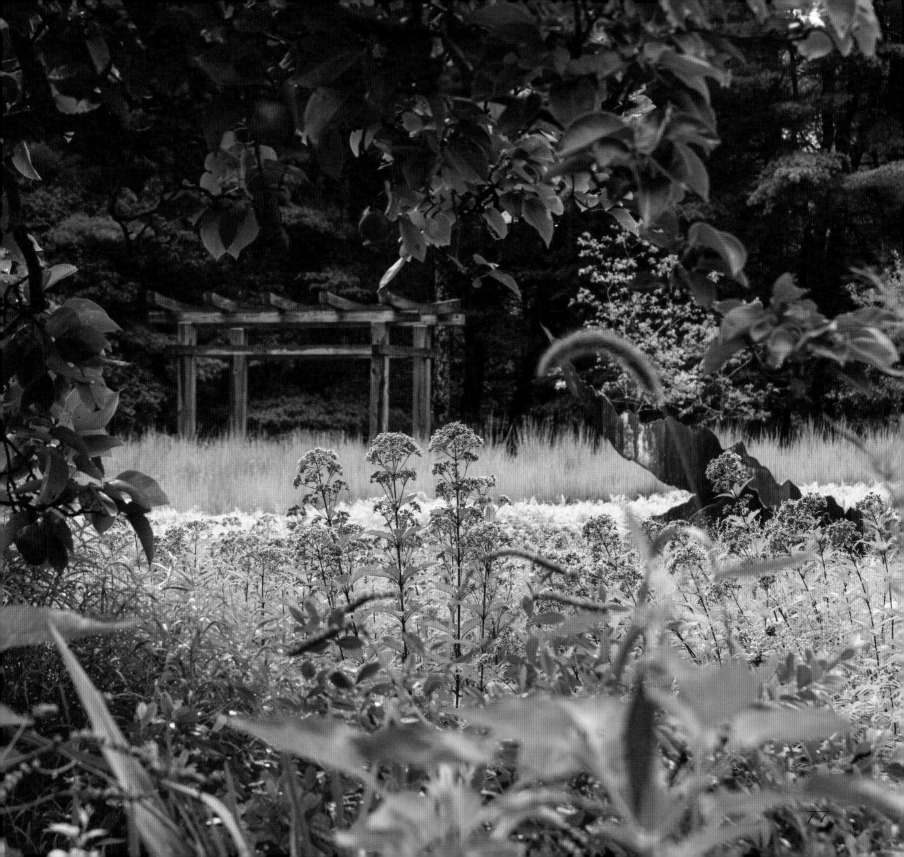

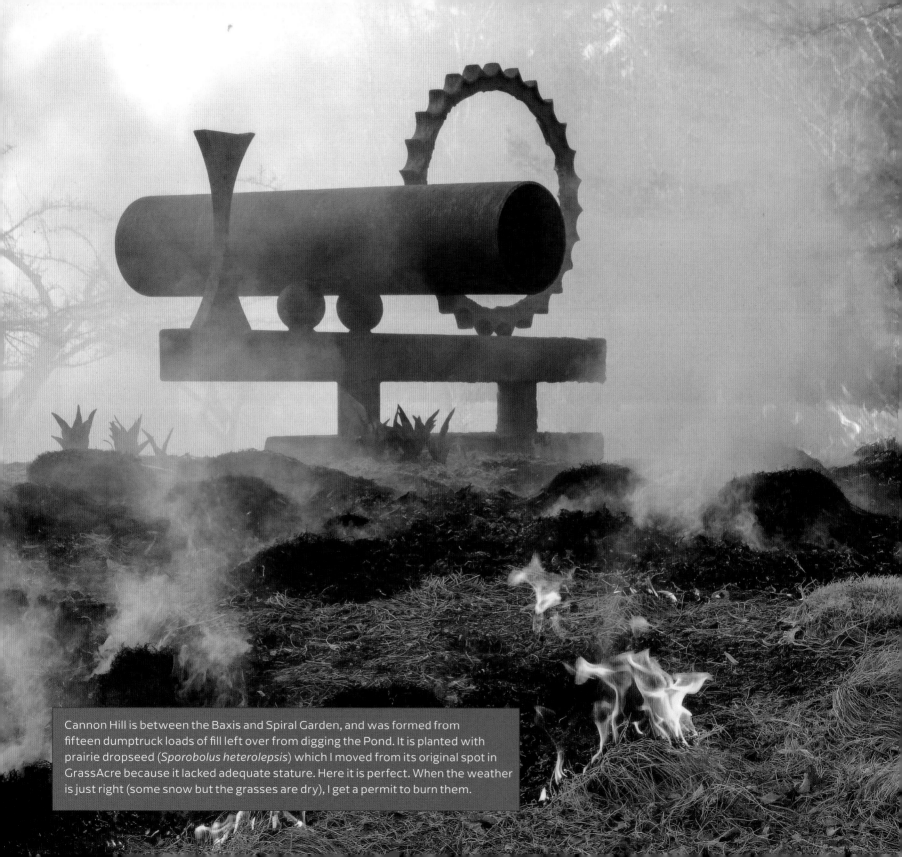

Cannon Hill is between the Baxis and Spiral Garden, and was formed from fifteen dumptruck loads of fill left over from digging the Pond. It is planted with prairie dropseed (*Sporobolus heterolepsis*) which I moved from its original spot in GrassAcre because it lacked adequate stature. Here it is perfect. When the weather is just right (some snow but the grasses are dry), I get a permit to burn them.

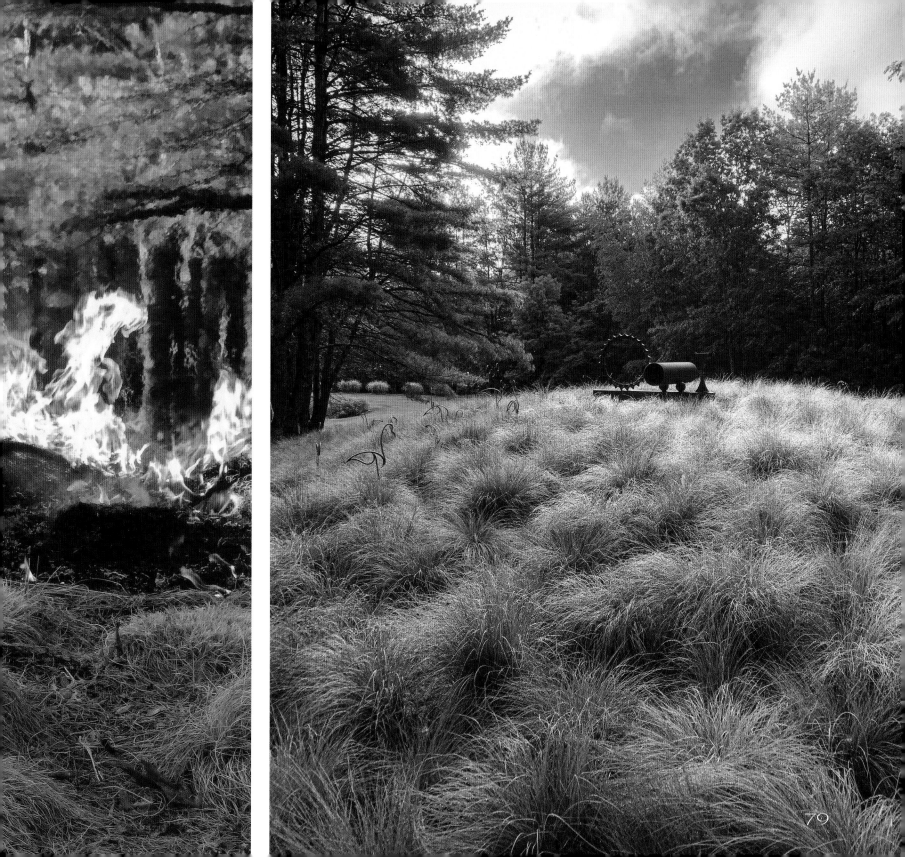

79

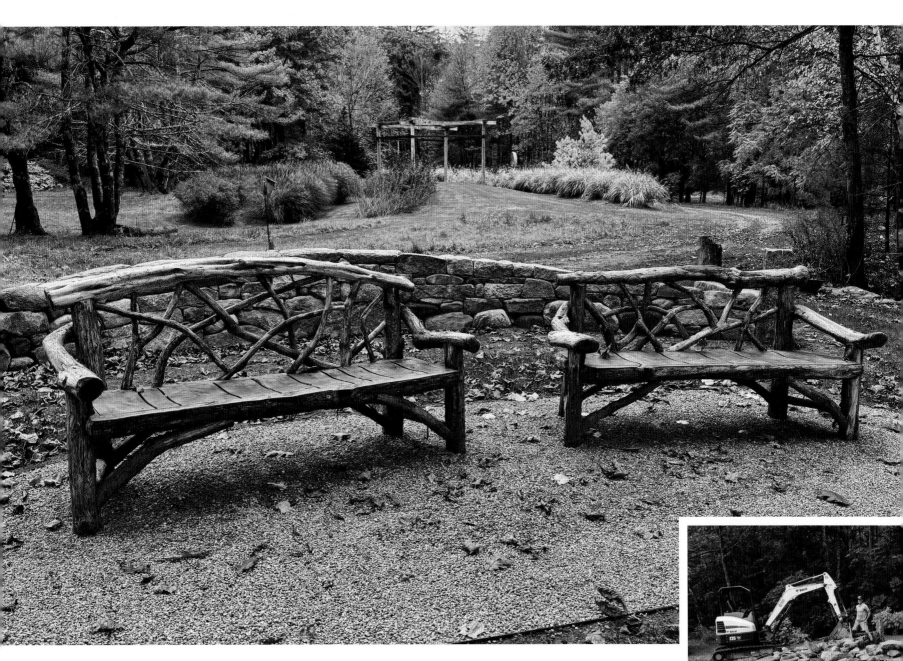

Above: The Belvedere, looking north, showing its relationship with the Baxis.

Right: Building the Eyebrow Wall, which has one finished face as seen below, but requires a sturdy back.

Facing page: The view from the Belvedere south onto a beautiful, protected field.

10

BELVEDERE AND EYEBROW WALL

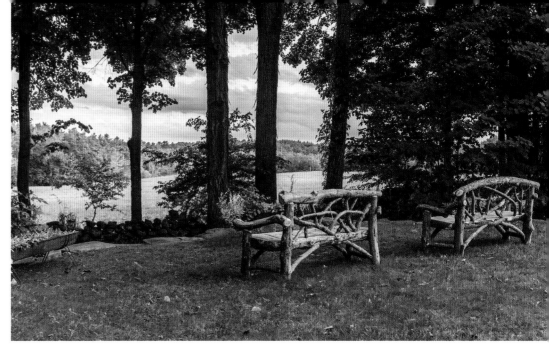

Mid-October, when the garden closes to the public until the following May, is our opportunity to make big noisy messes and not worry about tearing up the ground. In 2021, our skilled excavator operator and I spent the better part of a week constructing a belvedere, a structure designed to command a view. My reason? After thirty years, this area had become a bloated, utilitarian, brush pile condo for woodchucks. It looked too "back of the house" in the expanding gentrification zone of the garden. We also happened to have a big pile of large squarish rocks left over from blasting for the parking area. The "free" rocks, the brush-pile eyesore, and a talented excavator operator were a perfect combination. I was on the ground and he was way up in his excavator, which had a thumb. He would twirl and flip the boulders. We would try one out, discard it, and keep trying until we found a fit we liked. Then he would back fill it with gravel and pound on it with the bucket to stabilize it. Onward we went, course by course, in the rain and sun, communicating in sign language. When we were done, the eight-foot-high and thirty-foot-long wall had consumed most of the rocks. You can't have more fun than that.

This spot, coming late in the development of the garden, is the only feature that looks out to the wider world. Since I designed the garden as a personal retreat, the other views are all internal. This view is out to a field that our neighbor took considerable trouble to put under a conservation easement thirty years ago. Combined, this property and several others form a couple of hundred acres of continuous green space, a precious thing in an ever-developing Route 125 corridor.

When the Belvedere was finished and two rustic but classy cedar benches were placed at the edge, it became an instant go-to spot. But I knew in my bones something was not right. It felt like the energy of the spot was leaking away. It needed to be contained, gathered up somehow to feel complete. A couple of years later in 2023, I solved the dilemma with what I call the Eyebrow Wall, a low, arching rock wall rising from eighteen inches on either end to three feet in the middle. The Eyebrow Wall curved behind the benches like a stiff collar with soil backing it, fanning out like a spreading cape. Much better.

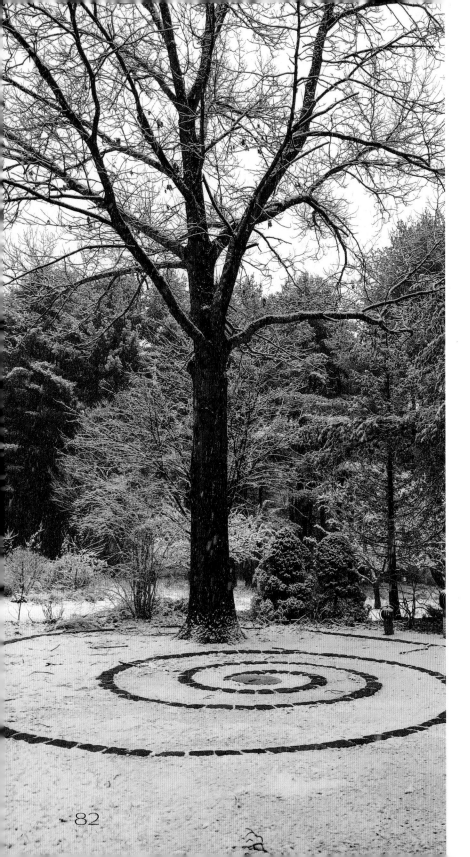

11

Spiral Garden

The inspiration for the Spiral Garden began when I purchased a jumbo roof ventilator at a flea market. I had been collecting ventilators for some time, liking how reliably they would spin. For a period of years I was focused on trying to make sculptures that move; I had modest success and the ventilators were my fallback. With the addition of the jumbo ventilator, I realized I had enough graduated sizes to make them into a sculpture. I had once used street culverts in a Boston Flower Show exhibit and knew they would complement the ventilators perfectly. The swirls of the culvert spoke to the fins and twirling action of the ventilators, which gave rise to the idea of repeating the swirl on the ground plane in cobbles—giving the garden its name.

The area was initially covered in moss, which I had introduced by making a slurry of ground moss, yogurt and water, sloshing it around and waiting a year for it to knit together. Over the years I have added the ashes of my best friend, my father, and my mother as well as my daughter-in-law's placenta under their respective columns. This garden is so well loved that, like the fur of the Velveteen Rabbit, the moss was soon worn off and the soil became hard and compacted. In 2022, the dirt was removed with an air spade and replaced with beige stone-dust and pea stone, which, in addition to providing a more durable surface,

Left: The Spiral Garden with its confectioner's sugar-like dusting of snow.

Right inset: Spencer setting the Belgian block spiral. The roof ventilators preceded the spiral on the ground.

Far right: A closeup of the roof ventilators on their culvert bases bathed in early morning light.

brings more light to the area. The nearby bench under the *Golden Ring* anchors the spot further as the endpoint of the Termi-Torii axis as well as having a clear sightline to the *Syncopeaks* sculpture in the middle of GrassAcre all the way to the CopTop.

The Spiral Garden is marked on the north side by a beautifully worn rock I call the Hex Rock. A guy delivering a dump load of loam noticed all the standing rocks in the garden. He invited me to visit his place in Kensington, New Hampshire, to see his collection. His assortment of large equipment and land-shaping jobs had netted him a large variety of beautiful, water-sculpted boulders. When he asked me if I would like one, I put aside my more often demurring self and pointed to the Hex Rock. I was beside myself. He even delivered it. We sited it to be on a visual sightline with a bench located behind the barn. When viewed from the bench, the ridges in the rock look somewhat like the letter X. Remember that a prominent feature usually benefits from having a name.

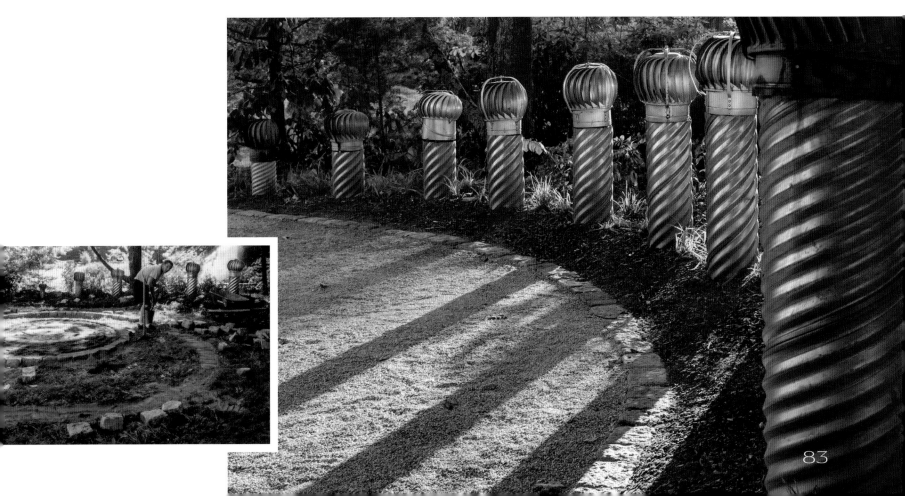

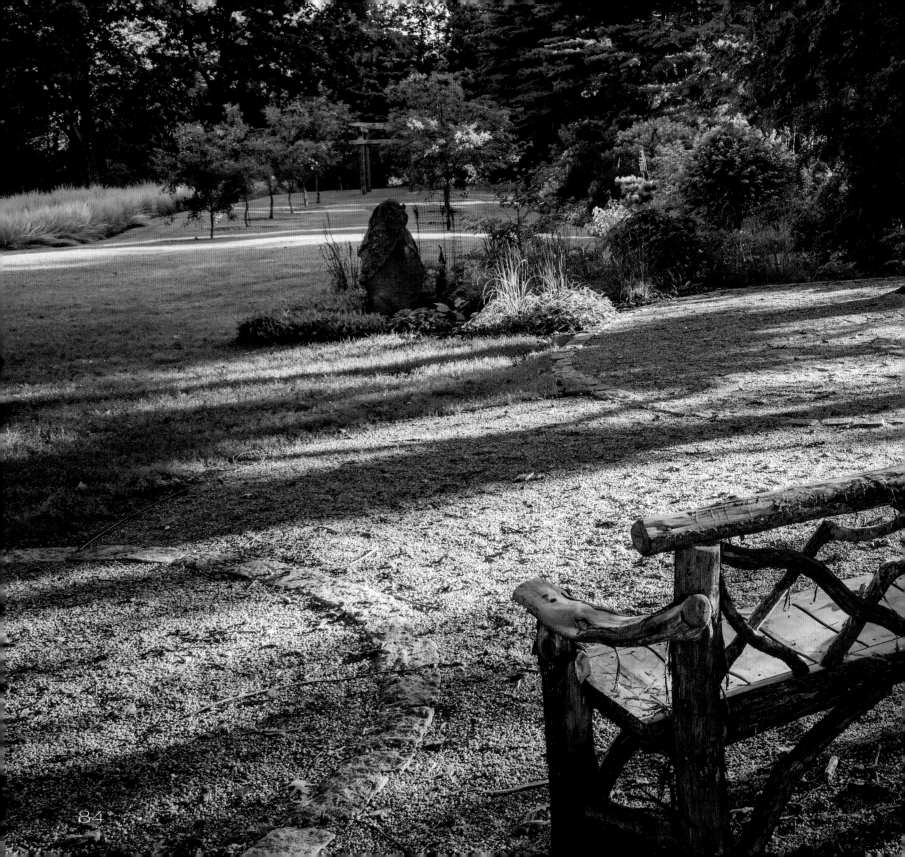

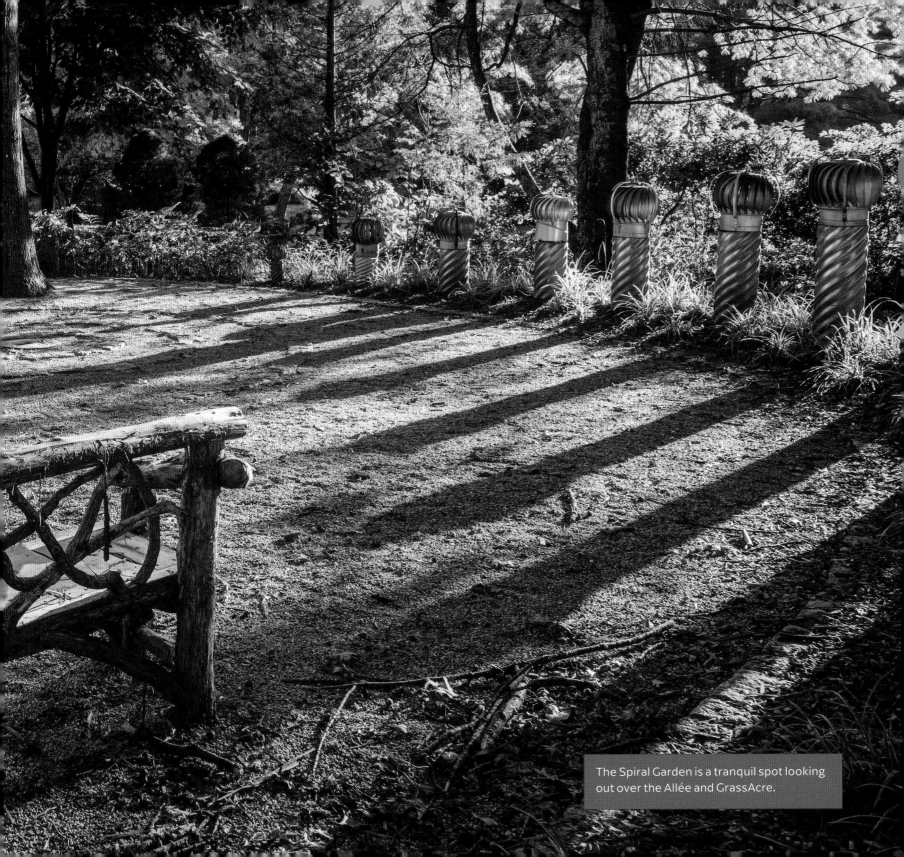

The Spiral Garden is a tranquil spot looking out over the Allée and GrassAcre.

12

Funnel Gardens

These long borders of trees, perennials, and shrubs emerged early in the evolution of the garden in the 1990s. They were narrow beds sitting on one side of the mowed field on the north, and along the stone wall on the south. I created them by spreading a thick layer of manure on top of a great expanse of cardboard and newspaper. Since the bed parallel to the GrassAcre is narrow, I filled it with a variety of fastigiate trees that would not outgrow their spot too quickly: Red Obelisk beech (*Fagus sylvatica* 'Red Obelisk'); 'Wredei' golden elm (*Ulmus x hollandica* 'Wredei'); and Degroot's Spire arborvitae (*Thuja occidentalis* 'Degroot's Spire'). Two other trees are important anchors for the beds and seen to best advantage when sitting on the CopTop. One is the lovely yellow-leaved 'Frisia' Golden Locust (*Robinia pseudoacacia* 'Frisia')—a tree with a troublesome habit of suckering that is outweighed, in my opinion, by its lacy leaf texture and yellow color that holds all season long. The other

Above: The Hex Rock, with the Spiral Garden in the shadows.

Facing page top: This is a snippet of the Funnel Gardens. This area includes a blue and yellow themed collection of trees, shrubs, perennials, and bulbs keeping company with the *Three Cymbals* sculpture.

Facing page bottom: Looking through the narrow bed of the Funnel Gardens toward the Pate with its wavy hedge in the far distance.

is the 'Heronswood Globe' katsura tree (*Cercidiphyllum japonicum* 'Heronswood Globe'), a naturally occurring, elegant, globe-shaped selection of a tree that otherwise can become large and rangy, getting as wide as it is tall. It has lovely apricot-orange fall color and a sweet cotton candy-like odor to the leaves as they senesce. The maturity and variety of the trees in this garden, their textures and colors, make looking back from the barn one of the more satisfying vignettes in the garden.

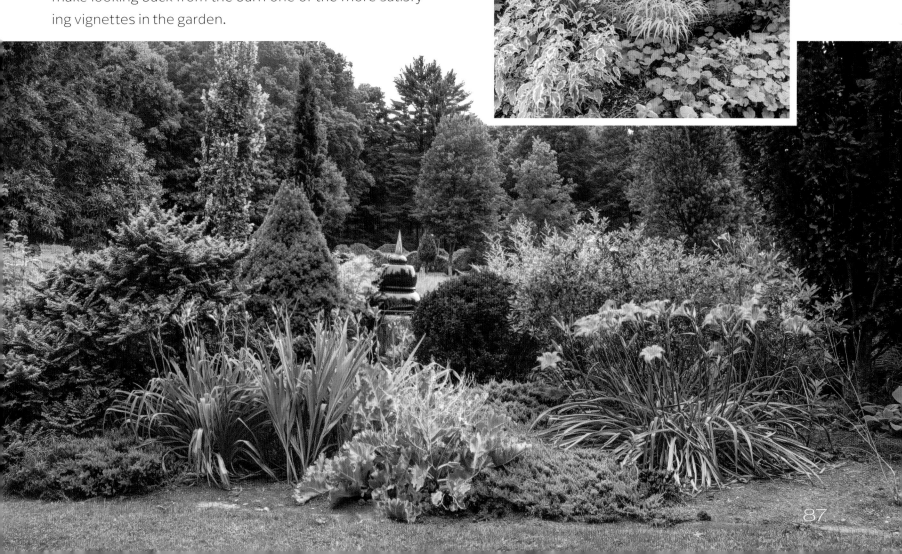

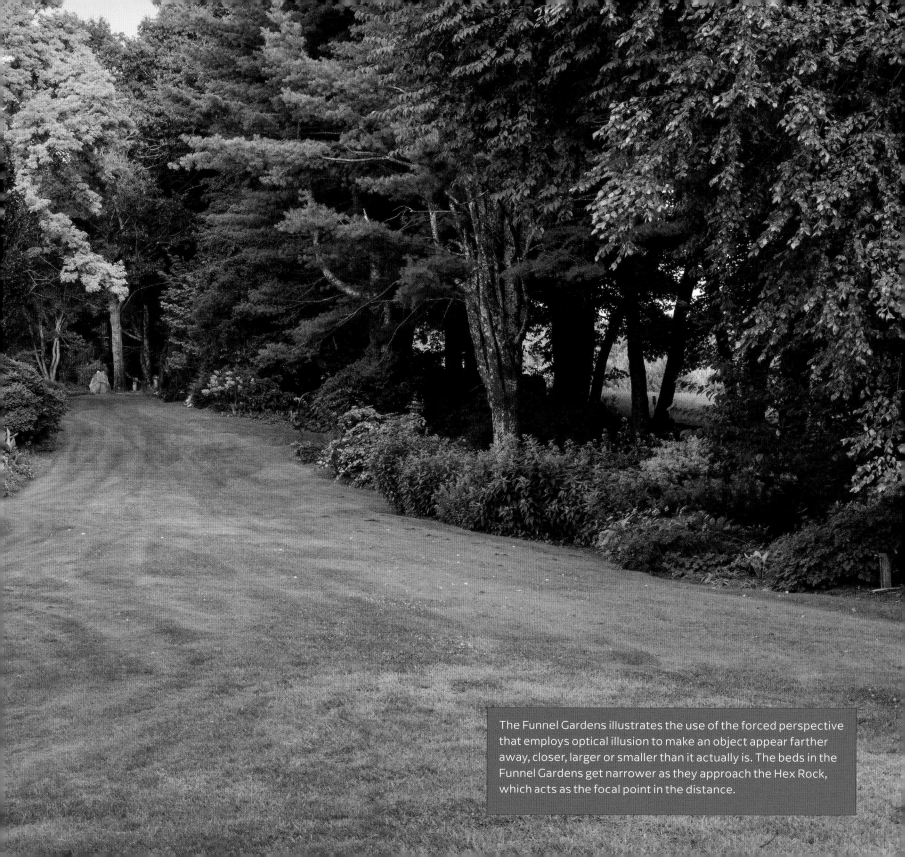

The Funnel Gardens illustrates the use of the forced perspective that employs optical illusion to make an object appear farther away, closer, larger or smaller than it actually is. The beds in the Funnel Gardens get narrower as they approach the Hex Rock, which acts as the focal point in the distance.

13

The Swaleway

One bed, the Swaleway, arose because it was a shady environment where I could grow spring wildflowers. Originally it was a thicket of saplings and underbrush growing along a stone-wall boundary. I gradually cleared it out, leaving a basswood, maple, and a pine to grow under an enormous oak and maple. I added a gently curving pea-stone path and installed a swinging bench. Voilà, we had a "thing to do along the way" swing in the shade, hidden from sight between two large trees and looking out to all the gardens in the sun.

Several cairns mark this garden. They were my first effort at garden sculpture, inspired by a hike one summer with the kids on Franconia Ridge in New Hampshire's White Mountains. A section of the trail lies above the tree line and the peaks are frequently fogged over. At those times, one's life depends on these rock piles marking a path through a landscape of shale and gravel. We made our cairns with our Leyland tractor and rocks collected from the property. In the beginning they called for much admiring from our perch on the swinging bench.

Top: Some spring bloomers include white and pink Japanese wood poppy (*Glaucidium palmatum*), Asian mayapple (*Sinopodophyllum hexandrum*) with emerging mottled leaves and upright pink blooms, the shiny spoon-like leaves of European ginger (*Asarum europaeum*), and the white dots of the flowering sweet-woodruff (*Galium odoratum*).

Bottom: A favorite cairn. Plants include budded Japanese woodland peony (*Paeonia obovata*) in the forefront, purple perennial sweet pea (*Lathyrus vernus*), wild blue phlox blooming to the right (*Phlox divaricata*), the pink of an early blooming species peony (*Paeonia mairei*), and red barrenwort (*Epimedium x rubrum*) to the left of the cairn.

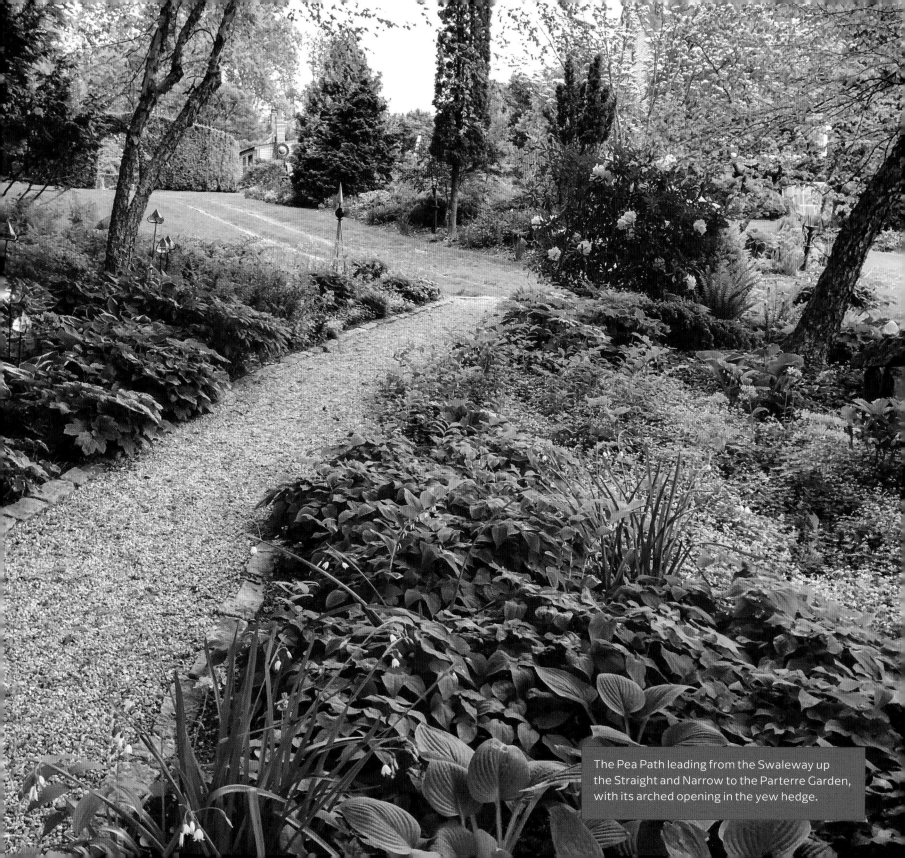

The Pea Path leading from the Swaleway up the Straight and Narrow to the Parterre Garden, with its arched opening in the yew hedge.

The upper part of this garden is full of spring-blooming plants, which enjoy plenty of light before the trees leaf out. Henbane (*Scopolia carniolica*) with its diminutive dark maroon flowers is the first, joined by hellebores, dwarf masterwort (*Hacquetia epipactis*), chloranthus (*Chloranthus japonicus*), Asian mayapples, twinleaf (*Jeffersonia diphylla*), perennial sweet pea (*Lathyrus vernus*), Japanese wood poppy (*Glaucidium palmatum*), and many more.

The wet spot at the bottom of the incline gave this garden its name. In spring, a constantly moving rivulet of water runs from the bottom of the GrassAcre through a culvert, headed for the neighbors. This water figured into the USDA calculations of filling the pond; however, it heads in the opposite direction.

In this garden I experimented with a different garden-making approach: garden design by removal. I left the existing vegetation, removed a few plants like Canada goldenrod (*Solidago canadensis*) and added others like David phlox (*Phlox paniculata* 'David') for white; perennial sunflower (*Heliopsis helianthoides* var. *Scabra* 'Sommersonne') for yellow; and queen of the prairie meadowsweet (*Filipendula rubra*) for pink. Combinations need occasional tweaking but this garden requires the least maintenance of any I have designed.

Top: A massive cairn, testing the limits of our tractor, is nestled in a bed of textures including, from the left, white plumes of the giant fleece flower (*Persicaria polymorpha*), the thread leaves of a euphorbia, bold rugose leaves of rodgersia (*Rodgersia aesculifolia*), and the thin palmate leaves of the shredded umbrella plant (*Syneilesis aconitfolia*), with its diminutive flowers blooming on stalks rising above to create another layer of interest. The robust Geranium 'Biokova' forms the middle layer.

Bottom: The *Four Seasons/Elements* sculpture carved from a thick plank of mahogany, marks this end of the garden. Totem-like structures are so easy to use in a garden and mahogany is so easy to carve.

14

Straight and Narrow

I try to design spaces that feel different from one another. The Swaleway is a shady spring garden with its hidden swing lookout point, while the Parterre is a formal garden enclosed by a tall, dark green yew hedge. To connect them I created the Straight and Narrow. This is simply two rows of cobbles four feet apart with a grass strip between them running parallel to the hedgerow on the south stone wall boundary. We then created a two-foot-high berm on the other side and introduced some trees and shrubs. As the plant material on the berm matured, it created a sense of enclosure and made this area a garden experience on its own. The stunning Jane Abbott azaleas (*Rhododendron* 'Jane Abbott') are still increasing twenty-five years later, as is the handsome, very slow growing dwarf Hinoki cypress 'Nana Gracilis' (*Chamaecyparis obtusa* 'Nana Gracilis'), which I dug from my mother's elegant tiny backyard garden in Portsmouth, New Hampshire, when she sold her building in 1986.

Above: The newly laid cobble path of the Straight and Narrow connects the Parterre with the Swaleway in front of the pine tree in the upper middle.

Left: The sculpture *Sentinel* presides next to the entrance of the Parterre on the lower left.

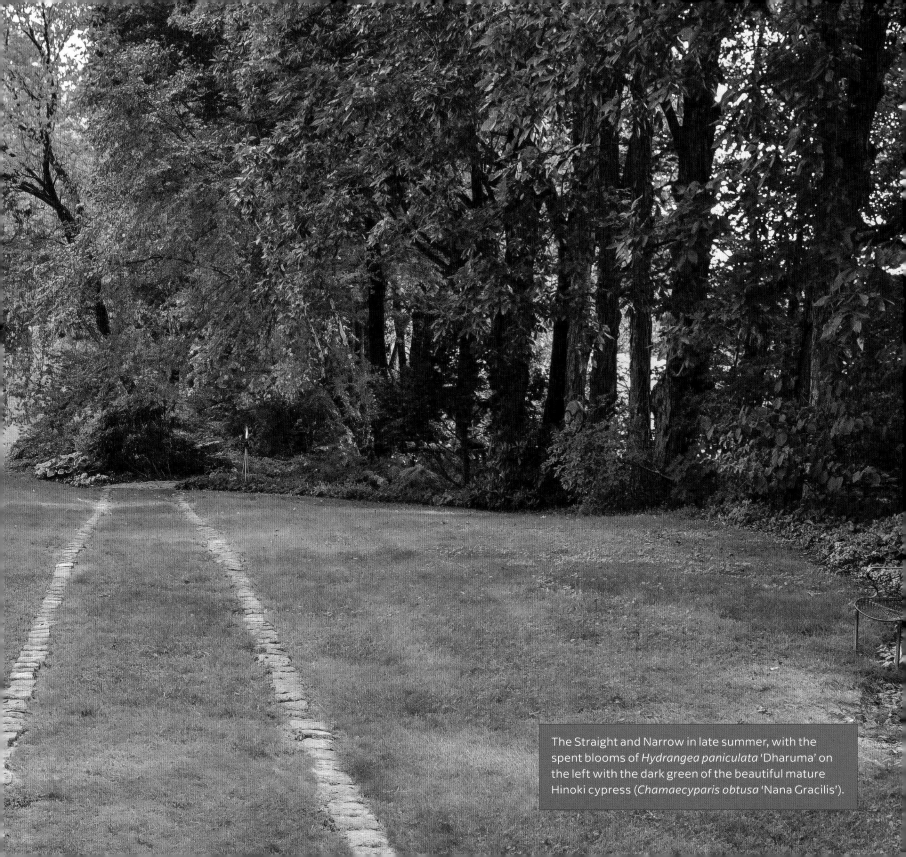

The Straight and Narrow in late summer, with the spent blooms of *Hydrangea paniculata* 'Dharuma' on the left with the dark green of the beautiful mature Hinoki cypress (*Chamaecyparis obtusa* 'Nana Gracilis').

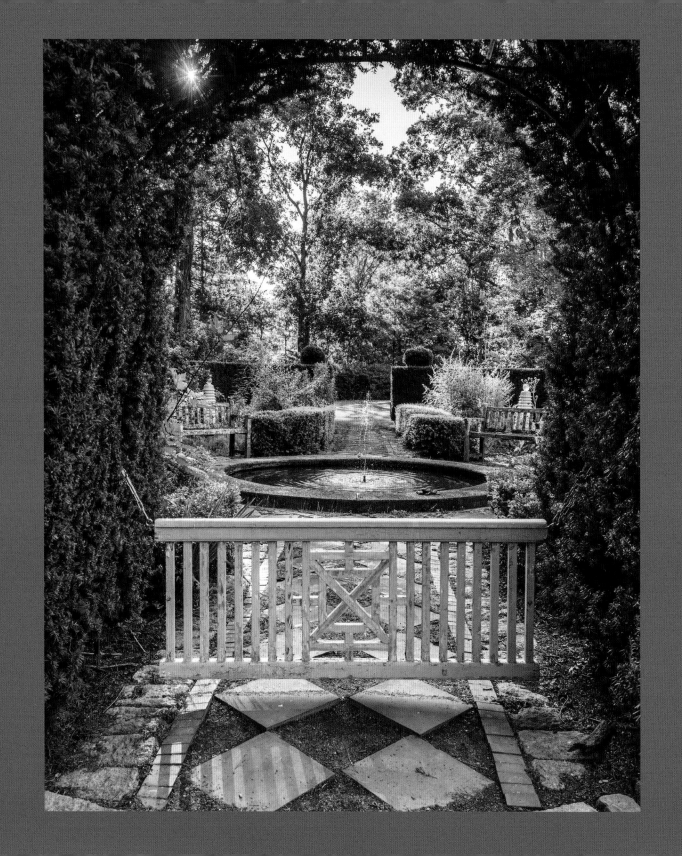

15

Parterre

This garden evolved in a bassackward way as opposed to following a design map from the onset. Ten years after creating the sweet vegetable garden I had dreamed of having for so long, we ripped it out. The tail that wagged this dog was two six-foot pieces of curved granite curbing that Ron Cote gave us. I can't tell you what a thrill these pieces were. We made a garden in their honor, which required dismantling the vegetable garden, pulling up the fence, transplanting the fruit trees, and renting a Bobcat tractor to raise the grade so we could use the curbing as a step up. Call me fickle, trading my vegetable patch for the sex appeal of two pieces of arched granite curbing.

We have joked that the garden should be named after Ron, who has so generously helped us over the years. Along with the curbing, he lent us rubber-lined tongs to hook onto the tractor bucket that allowed us to pinch and pick up pieces of granite without causing scratches. There were so many other invaluable presents like a rock drill, several industrial pumps, and a dozen lifting slings we did not even know we needed but now cannot do without. Ron would size up a job and give an almost immediate verbal estimate followed by a handshake and no paperwork.

The garden that emerged we call the Parterre. According to Ephraim Chambers's *Cyclopaedia,* published in 1728, "A parterre is a part of a formal garden constructed on a level substrate, consisting of symmetrical patterns, made up by plant beds, plats, low hedges or coloured gravels, which are separated and connected by paths." This one is enclosed by an evergreen hedge with a smaller hedge-lined path traversing it. The hedge on the west end is armpit height, gradually rising to form an arch on the east end that you can walk through. The path splits around a small round pool with a jet fountain. I had read somewhere that I could expect the hedge to take twelve years to fill the arch, and it has. All but the two Hicks yews (*Taxus x media* 'Hicksii') forming the arch are *Taxus x media* 'Hatfieldii' yews. The internal hedge is holly (*Ilex crenata* 'Green Lustre').

To provide a little insight into my creative process: After placing the curbing I went directly to the nursery, bought

Right: Looking at the Parterre garden from the east.
Facing Page: Looking west through the yew hedge arch.

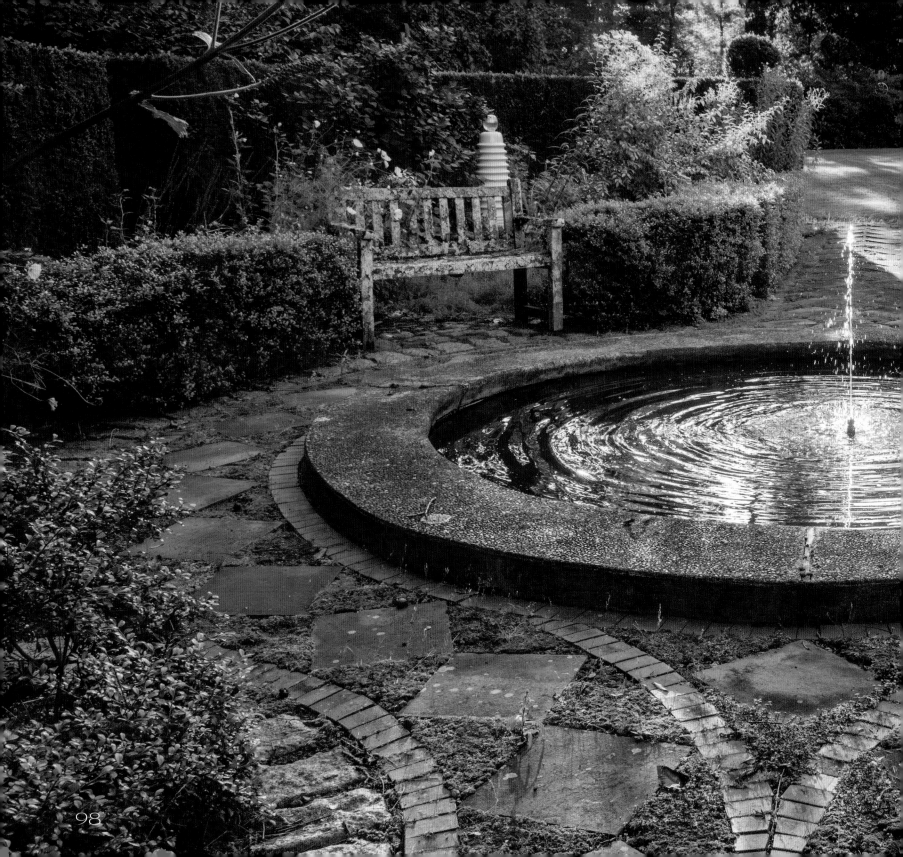

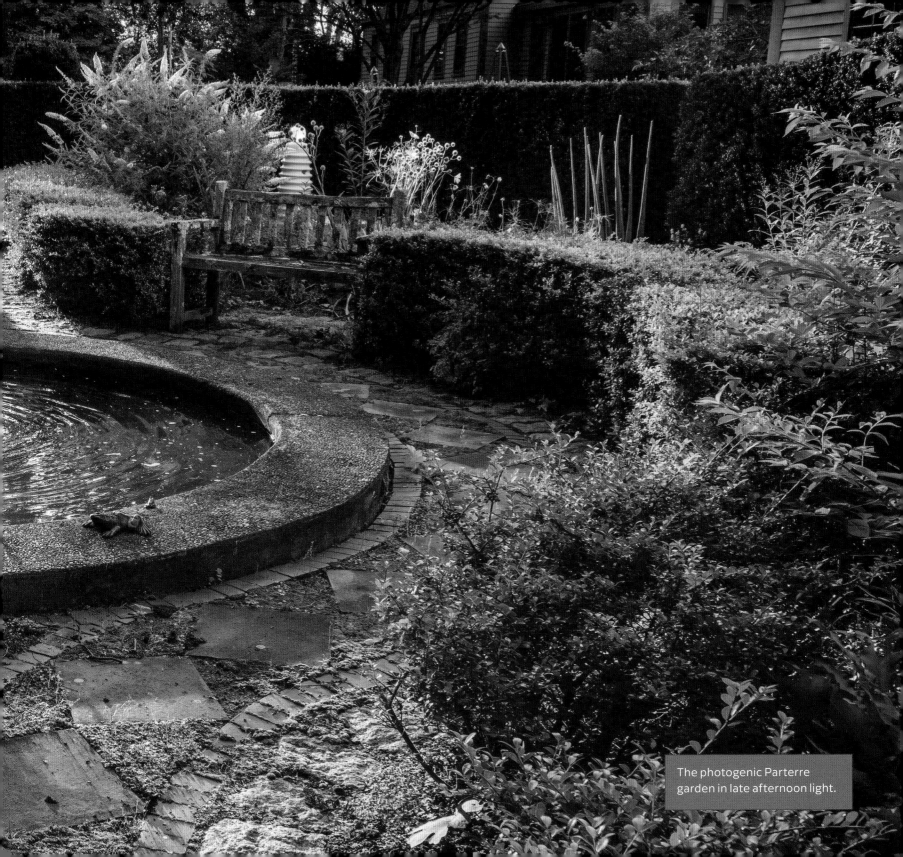

The photogenic Parterre garden in late afternoon light.

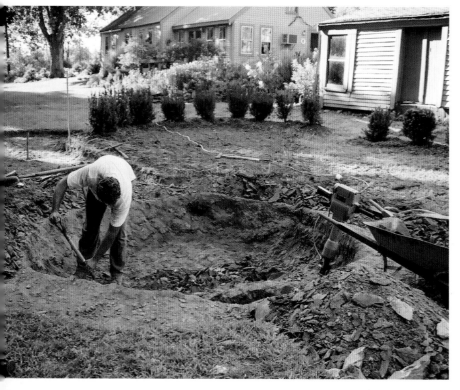

forty yew plants and started planting them. One of my mottos is, "Act now, think later." Another is, "If anything is worth doing, it is worth doing fast." Bob's modus operandi is to mull things over, consult some people, sleep on it, and think some more.

I located the pool in a spot that turned out to have ledge about nine inches down. This was the first of two times we had to rent a jackhammer. The ledge was a punky shale material that came off in sheets, making it difficult to gather up into a wheelbarrow. But lifting and repositioning that jackhammer took the most effort during a stinking hot week in August.

The pool is about three feet deep and lined with rubber. For a change we hired someone to form the exposed aggregate concrete coping. An electrical cable runs under the coping to power the fountain and the heater, which keeps the water from freezing in winter.

We cut the diamond-pattern paving by hand out of one-foot-by-four-foot bluestone stair treads, and cut bricks in half and laid them on edge to make the border of the path.

The curving shape of the yew hedge requires precision when trimming and as you might have guessed that is Bob's department. Each year he would erect scaffolding around the perimeter and string lines across to the other side making sure the heights matched.

In 2004, we gave the hedge a ten-year cut, something I made up after I heard about a twenty-year cut in

Top: Bob levels the vegetable garden seen on page 6.
Bottom: Digging the Parterre pool with our rented jackhammer.

lumbering. We usually wrap the hedge in deer fence in winter, but didn't have to for a few years: it looked like they already had browsed and left a see-through hedge.

Somehow seeing the naked branch scaffolding of the hedge gave Bob the idea to create an infrastructure—a rebar tripod supporting an angled iron rail. Now he could rest the hedge clippers on the frame and just follow the rail around.

I have tried several planting schemes for the interior of the garden. In 2013, I tried creating a white garden, capitalizing on the highest drama I can achieve against the dark green yew background. White also holds up well in the shoulder times of the day and is a standout on a moonlit night.

Since 2023, the Parterre is open for visitors to gaze at but not to walk through, as we carve out our personal space from the parts of the garden that are open to the public.

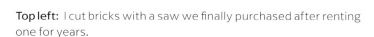

Top left: I cut bricks with a saw we finally purchased after renting one for years.

Top right: Bob begins the paving with the partially completed pool in the upper left.

Right: The emerging pattern of the Parterre garden as seen from the roof of the Welding Studio.

101

Frothy white summer blooms in the Parterre garden.

16

Barn Garden, Metal Folk, the Wave, and the Guinea Hens

One day I was flipping through an unlikely catalog, I think possibly from Pottery Barn, and a robot figure caught my eye. Soon I was on a roll of fabricating Metal Folk. What was exciting and captivating initially became a skipping record. After a while, all I could see in my pile of supplies were pieces of Metal Folk. I was making lots and selling few. They were piling up everywhere like the dividing brooms in the Disney version of *The Sorcerer's Apprentice*. I slowed down and tried to stop. I positioned them awkwardly on a board next to the house and I was still running out of room.

To provide crowd control for the Metal Folk, we built the Wave. Ever since I had ripped out a white rose (*Rosa rugosa* 'Blanc Double de Coubert') border in front of the Emerald Green arborvitaes (*Thuja occidentalis* 'Smaragd') on the Ha-Ha Wall, the hedge alone began to feel not exactly menacing but at least overly imposing and slightly unfriendly. And, it was getting bigger and bigger. Transition plants between tall plants and the ground plane are called facer plants and are used to create a softening buffer zone. Without the rose facer border, the area between the hedge and the east side of the barn became a tunnel-like pass-through, as there was nothing to see or cause you to linger.

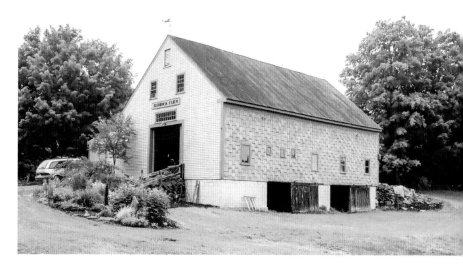

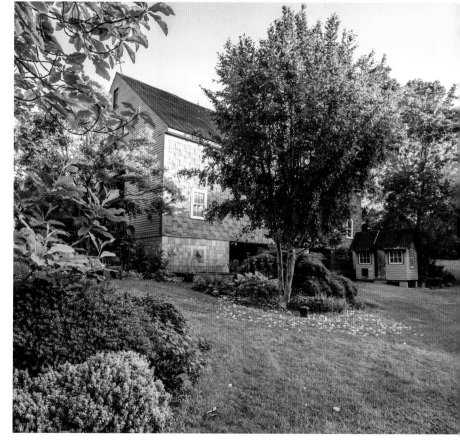

Top: The Barn Garden after we removed the paddock fencing.

Bottom: The Barn Garden showing the Dragon Fountain in the center left and the Coop in the center right with the stunning stewartia tree (*Stewartia pseudo camellia*) in the middle on a carpet of its spent blooms.

This became the perfect stage for my expressive Metal Folk. When they were lined up in front of the hedge, it became their big, heavy, folding velvet stage curtain. After placing them individually on posts four feet apart and set in a vertical wave pattern, the Metal Folk could properly introduce themselves with space around them to breathe. I have thought about writing up the personal history of each one in a little accompanying booklet, like the American Girl doll series, which still seems like fun. Maybe one day I, or some other writer, will take it on.

I look forward every year to designing a different color scheme of annuals and vegetables in the bed underneath them with its undulating edge.

As an aside, I have been struck by the design themes that repeat themselves in the garden—not so much by my plan as by an unconscious feeling. Looking at this combination of waves on the ground and those formed by the heights of the posts, I am reminded of the gas station model in my Design 2 class, of the swirl of roof ventilators in descending heights with the cobble spiral on the ground in the Spiral Garden, and of the undulations of the privet hedge at the Pate with its once hay-bale path curling to the top.

Across from the Metal Folk is the Coop, home to our guinea hens who have been a constant presence at Bedrock Gardens since 2011. Bob's brother raised guinea

Left: A chicken sculpture I made in honor of the Coop.

Above: The Coop is the guinea hens' home, which Bob made from recycled material we had on hand.

Facing page: Looking from the Barn Garden to the Wave in fall (left) and summer (right).

hens, who ran through his hilly property, made a racket, and looked ridiculous. That gave us the idea to try them.

So we ordered two-day-old keets at a local feed and supply store and housed them in a large cardboard box in the back room of our house for a month or two until they liberated themselves all over the room. We were instructed to train them to come home to roost by letting them all out—except a few who remained in a dog crate. They form such a tight group and would not go too far from the caged ones. This worked well, and with confidence we decided one day to let them all out. They walked down the road, never to be seen again.

Let me count the ways to lose a guinea: a fox, a hawk, a fisher cat, a racoon, a coyote, drowning, and walking away. One flock would gather on our outdoor sofa, ruining it with their poop while pecking furiously at the picture

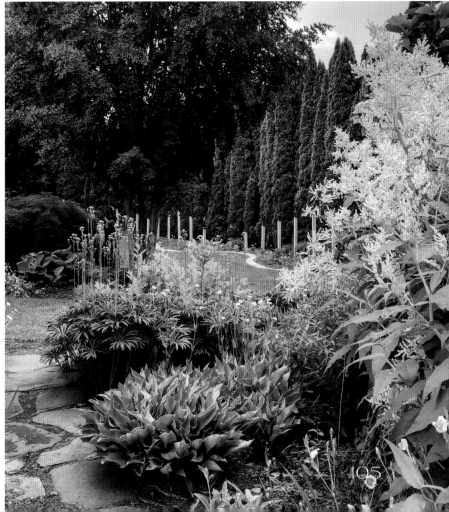

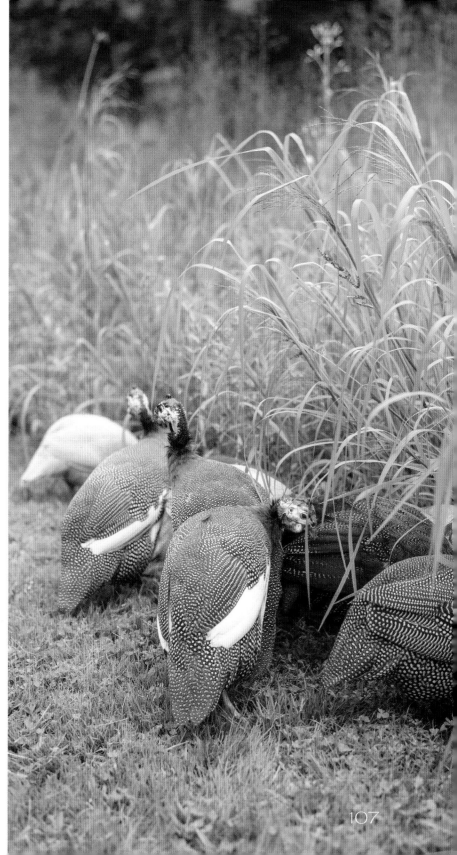

window. A recent group—the first ever to do this—viciously attacked my hosta plants, masticating them to the point where I was praying for a visit from the hawk. Every year we start in early spring with between nine and two dozen guineas, and we usually end up with one or two by the time next spring rolls around.

They start laying eggs in a wanton manner, dropping them anywhere. At some point in their lifecycle, one of the females "goes broody" and all the other females coordinate their laying into one very hard-to-find spot. Being outside on the ground all night is a vulnerable spot for a guinea, particularly a white one, so I should add going broody as another way to lose a guinea.

Left: Morning sun highlighting the arborvitae hedge of the Wave. A volunteer alternate-leaved dogwood on the left is in full fruit.

Above: A closeup of the Dragon Fountain.

Right: A group of guinea hens is called a "confusion", which is quite apt.

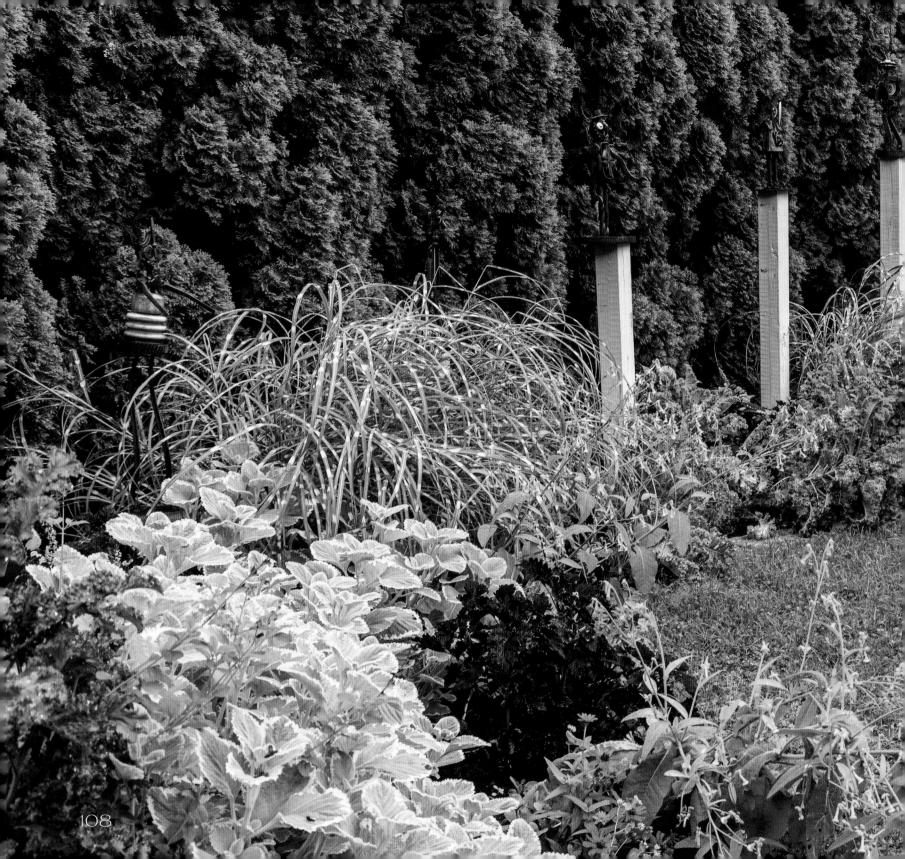

The color combination of annuals planted at the Wave changes every year.

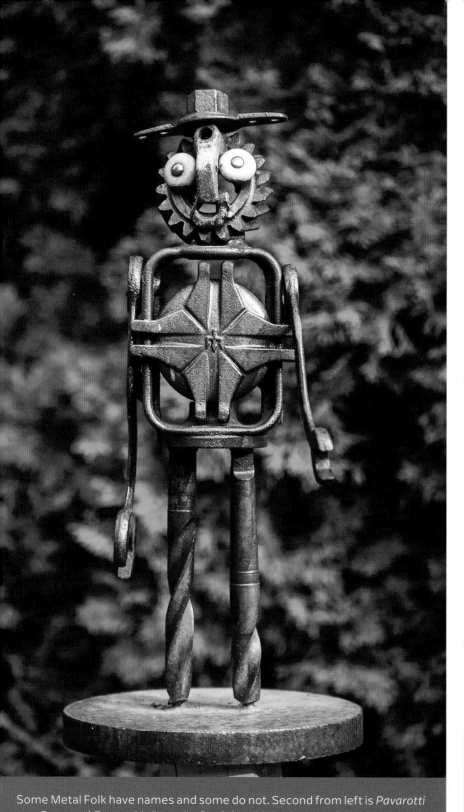
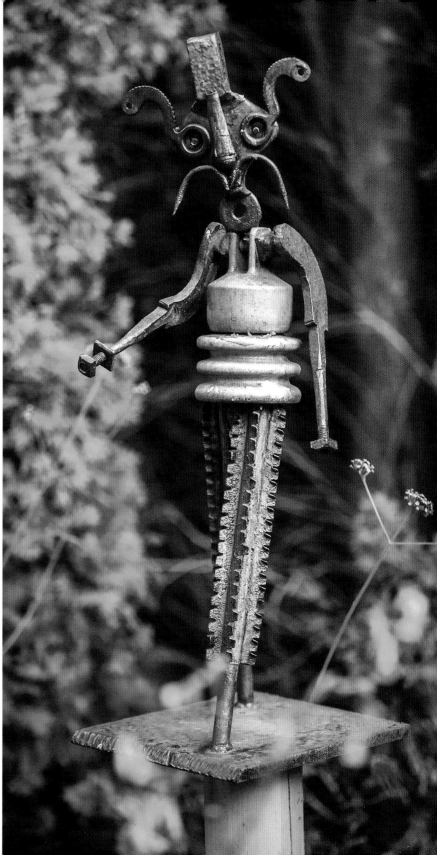

Some Metal Folk have names and some do not. Second from left is *Pavarotti as a Satyr* and *Esmeralda* is on the far right, although most visitors see this piece as a Hasidic Jew.

17, 18

LANDING AND ROCK GARDEN

Even before I completed my studies at Radcliffe in 1996, I was already feeling that I was playing catch-up and wondered how to insert large bold elements in a garden that had already headed in a certain direction. It wasn't as hard as I thought. Some gestures suggested themselves immediately and others gradually rose to the surface. We made the first large addition in 1995: the Ha-Ha Wall between the Barn Garden with its guinea coop and the Belgian Fence. The Ha-Ha Wall's name arose on the spur of the moment and unfortunately it stuck. Unfortunate since it is inaccurate—it is not a wall sunken from view acting like a fence, which magically contains sheep and cows in a lovely bucolic setting. Our wall's purpose was otherwise: to eliminate yet another mowing challenge.

To make the wall, an excavator cut the steep slope behind the barn to fashion a cliff. With one person operating the excavator, equipped with a thumb on the bucket, and the other person on the ground gesturing, the two of them created a one-hundred-foot stone wall about three-and-a-half-feet high. Ron Cote donated the rocks he had hauled from a highway blasting site in Raymond, New Hampshire, a few towns over. One and a half days later the wall was done. I quickly planted a row of the above-mentioned arborvitae on top of the wall, further invalidating its name.

You get what you pay for: in this case a wall with no foundation or drainage. Large flat rocks lean against the slope, like a face rock, begging to be the first to fall out. I filled the holes with hens and chicks (*Sempervivum tectorum*), fleshy rosette plants that like growing in crevices. They slowly spread, a fitting mortar, but were soon overtaken by a diminutive so-called annual: a trailing snapdragon (*Asarina procumbens*) with its sticky sage-green leaves and pale ever-blooming flowers draping like bunting over the rocks.

Right: The Rock Garden in summer with the white blooms of *Viburnum plicatum* f. *tomentosum* 'Mariesii' on the upper left, purple and white Siberian iris in the forefront and a pink blooming allium (*Allium* 'Summer Pink') in the upper middle. The sculpture *Tango* is in keeping with the scale of the surrounding plants.

Facing page: Chairs made from farm detritus—a hay feeder, tractor seats, and a spring tooth harrow—are placed to create a feeling of safe harbor as one looks out onto the large landscape.

We repair some part of the wall every few years, but considering it was thrown together, we are not complaining.

On the northern extension of the Ha-Ha Wall was another bank—one steeper than what the Ha-Ha Wall had eliminated. I would mow it by pointing the mower straight downhill and then going all the way around to get to the top again. I even mowed it sideways, skooching on the uphill side of the seat, leaning into the hill. I never have tipped over—it might even be impossible to do—but I have worried.

The reason the bank was so steep was plain to see: bedrock. It lay close to the surface, buried enough that I could clear it with my mower blades but exposed enough to have attractive patches of lichens showing. One fall I

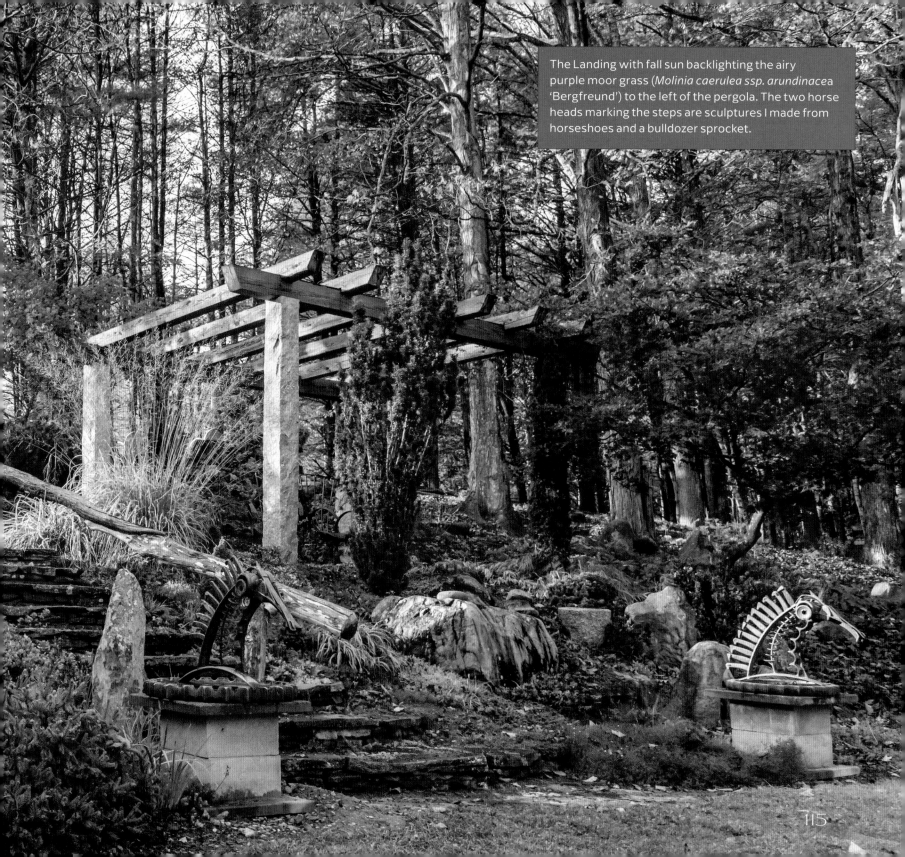

The Landing with fall sun backlighting the airy purple moor grass (*Molinia caerulea ssp. arundinacea* 'Bergfreund') to the left of the pergola. The two horse heads marking the steps are sculptures I made from horseshoes and a bulldozer sprocket.

impulsively took a shovel to the ledge to see what I could expose. I had done this before in the lawn by the house that now features the radar dome pergola. This was part of my long drawn-out process of making friends with my bedrock. As I dug into it I found that the ledge ran at a right angle to the ground for a foot or two. I dug down as deeply as I could, pitching the soil over the bank. This allowed me to form a landing in front of the ledge, about eight feet by fifteen feet. I added a layer of stone dust, edged it in granite blocks, brought over a couple of chairs, and voilà, our new go-to spot on our evening stroll.

Having established the validity of the Landing as a proper garden feature, we decided to do it up right in 1998. Although we had garden structures with wooden and metal uprights, we had none with stone. So we settled on granite posts from Fletcher Granite in Milford, New Hampshire, which quarries its stone on-site. The two uphill posts are nine feet tall and sit in a bit of concrete on top of the ledge; the downhill ones in the bank of fill are twelve feet tall with three feet in concrete.

Ron left us his large backhoe with an extendable arm that telescoped out from the body of the beast, which we parked uphill of the Landing. Bob wrapped a canvas fire-hose-covered chain around the top of the granite post and lifted. I was on the ground guiding it in place.

The excavator arm positioned the uphill posts with ease. To reach the downhill posts we needed the extender. Bob is very good at operating instruments, from tweezers to backhoes, but this one was new to him. As he extended the

arm the twelve-foot granite post swung widely, recklessly pushing me aside and slipping slightly on its purchase. He quickly learned that the control required just a little tap, not a throttle pull. This was not the last time I contemplated being crushed by some small misstep in one of our endeavors. Bob, on the other hand, worried most about tipping forward on the backhoe, which would have finished us both.

A tiny-leaved Boston ivy (*Parthenocissus tricuspidata* 'Lowii') winds up the granite posts onto the wooden beams. When we replaced the beams years later, I just peeled off the ivy and draped it over the fresh beams.

The pergola complete, Bob laid a proper stone patio underfoot and built stairs leading down to it, our secret cul-de-sac. It was some years later, when the path system had evolved, that we needed stairs down to connect the Landing to the CopTop. This was our first experience hiring a stonemason. It was heavenly and cut a few years off the project. I mowed a wide grass path through the field leading from our new gracious set of stone steps. Both the top and the bottom stairs are punctuated with a pair of large animal heads placed on pedestals—antelope and horse—which I fabricated from pieces of farm equipment. I am partial to using garden art to create drama at an entrance in a landscape.

The bank from which the Landing was carved immediately became a rock garden. The area was small enough so I could keep my eye on the diminutive plants, and large enough to incorporate enough large boulders from the property to establish its own identity apart from the Landing. Lying on an incline provides a wide but close-up opportunity to view the plants intimately.

It is such fun to have gardens with organizing principles such as the yellow and blue color combination in one of the Funnel gardens, white in the Parterre and spring ephemerals in the Swaleway—and add to these the miniature and alpine plants in the Rock Garden. They provide an endless focus for plant hunting.

Facing page top: The view from where GrassAcre will be looking west. The Landing will be sited to the right of the parked truck, and the Ha-Ha Wall to the left of that.

Facing page bottom: The completed Ha-Ha Wall, which took a day and a half to build by two guys with an excavator.

Right: With the pergola completed, we are now connecting the Landing with the rest of the garden with a set of stairs.

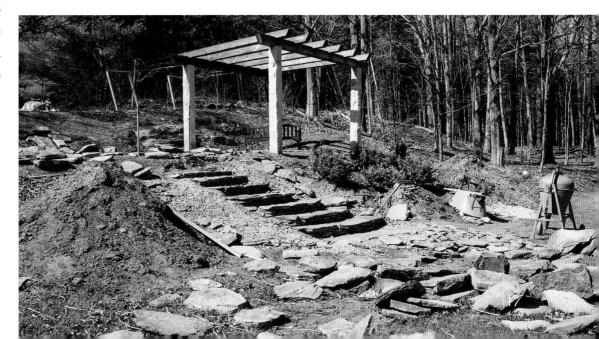

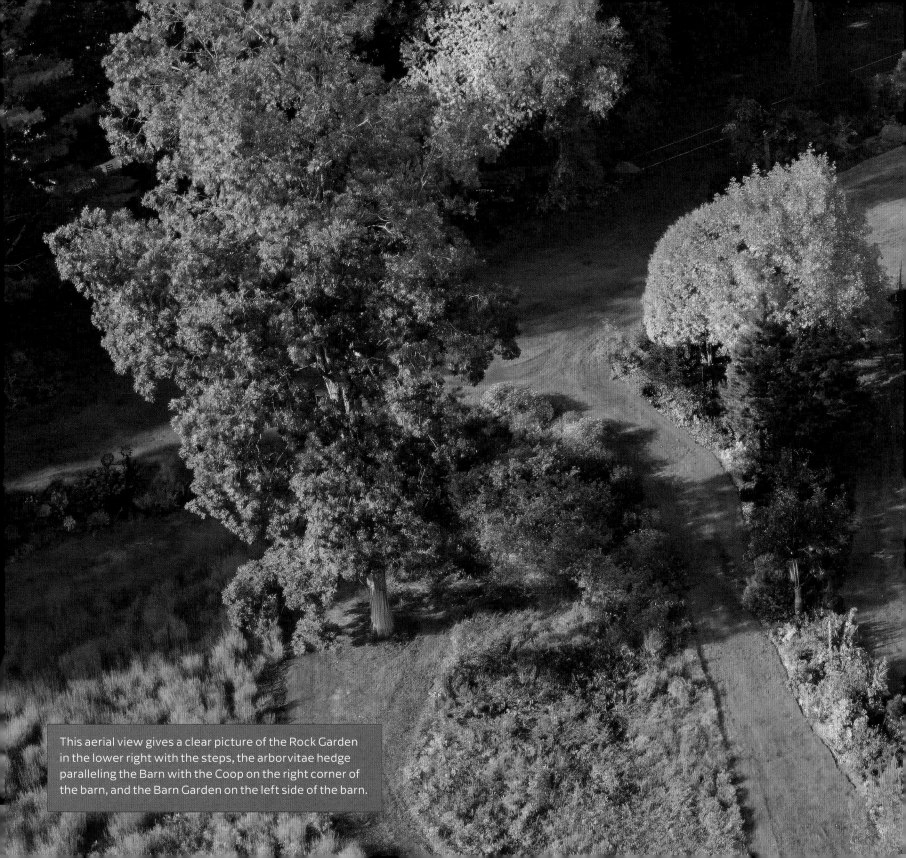

This aerial view gives a clear picture of the Rock Garden in the lower right with the steps, the arborvitae hedge paralleling the Barn with the Coop on the right corner of the barn, and the Barn Garden on the left side of the barn.

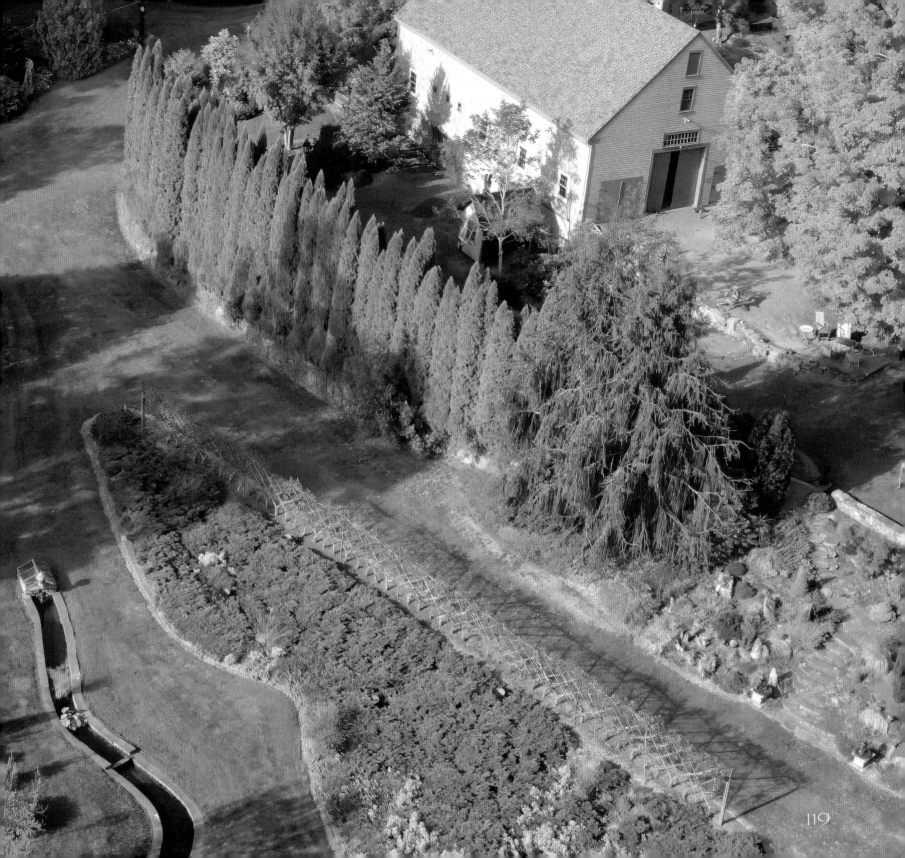

19

BELGIAN FENCE

Adding structure to the garden was not restricted to hardscaping. After the Ha-Ha Wall, which was built in just over a day, I wanted to define the area between it and the Wiggle Waggle. I came up with the idea of an espaliered fence, something visually permeable but psychologically containing. Besides—they always say the real reason always follows "besides"—I wanted to have one of every suitable element in the garden and I didn't yet have an espaliered fence.

I remembered reading years ago about a nursery specializing in growing starter espalier material in the form of whips that could be sent in the mail. To my surprise it was still in business—Henry Leuthardt Nurseries on Long Island, a fourth-generation nursery. The design I wanted is called a Belgian Fence, which features overlapping Y forms with diamond-shaped openings between the branches. We chose apples because the nursery had them in the volume we needed and even then we had to have eleven varieties to fill the order. These were grafted saplings about three feet tall. The graft is a union between the rootstock and the desired top variety. The advantage for us was that the first Y had already been formed.

Bob built the scaffold with posts strung with three rows of wire. When it was done and planted, I quickly decided it

Left: The Belgian Fence creates one side of a green corridor and the Ha-Ha Wall the other. The watchful horse head sculpture stands guard.

Facing page top left: The size of the *Tango* sculpture suits the Rock Garden.

Top right: Bob plants the apple trees to form the Belgian Fence. You can see the Ha-Ha Wall and arborvitae hedge on the lower left.

Bottom right: Espaliered apple trees form the Belgian Fence.

needed to be fifty feet longer, which was more easily accomplished than some of my other changes of mind. Voles regularly chew on the trunks despite their being wrapped with hardware cloth and we must replace a few every so often. I always hoped the branches would self-graft, as I have observed elsewhere, but that has not been the case for us yet.

Keeping the branches in line was the first bit of maintenance. As time went on, the apples gained confidence and began to sprout water shoots, as apples do. To keep the fence airy, and not a furry hedge, it needs to be pruned three times a year beginning in March.

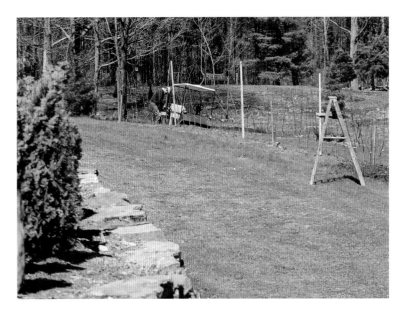

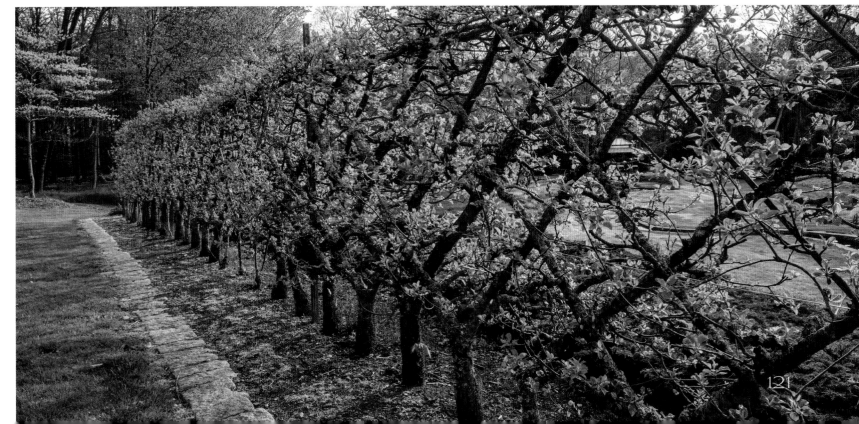

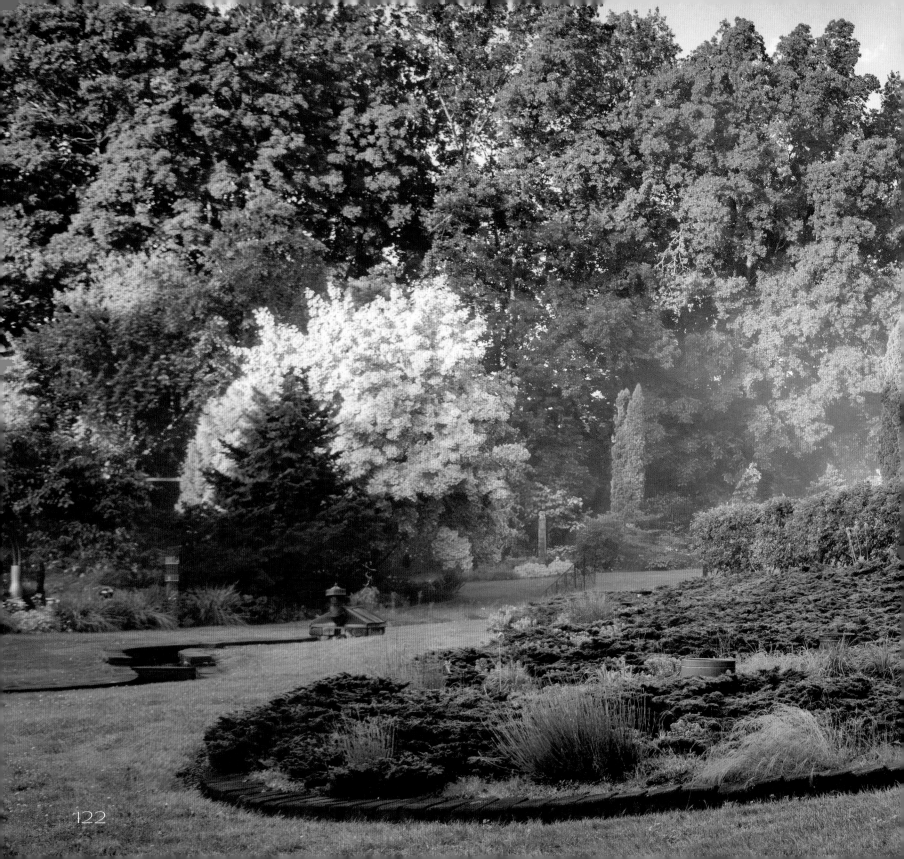

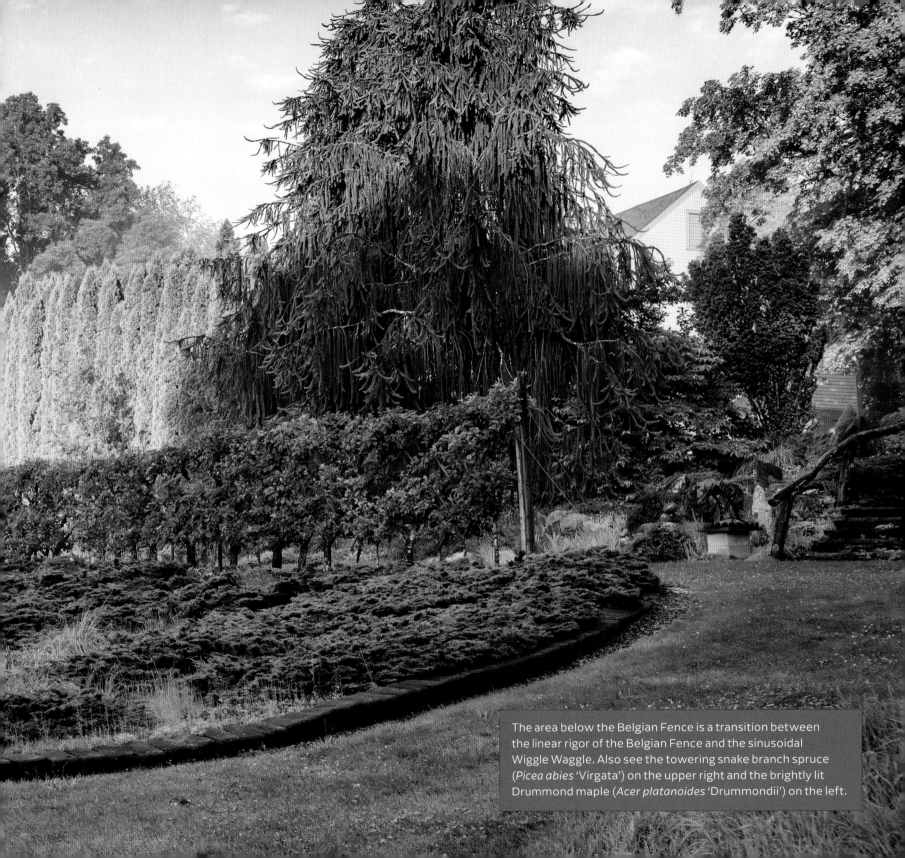

The area below the Belgian Fence is a transition between the linear rigor of the Belgian Fence and the sinusoidal Wiggle Waggle. Also see the towering snake branch spruce (*Picea abies* 'Virgata') on the upper right and the brightly lit Drummond maple (*Acer platanoides* 'Drummondii') on the left.

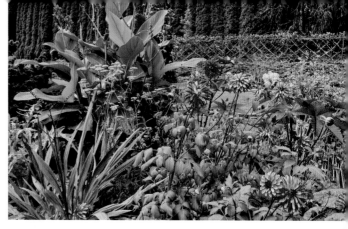

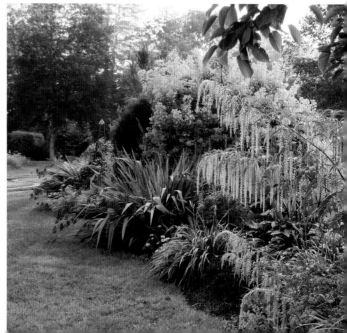

20

THE GARISH GARDEN

After the horses left in the early 1980s, a lone hickory and a dug well with a stone wellhead were the only places to rest your eye. I loved the well and its cover, and was not about to fill it in. So it became the starting point for what would become the Garish Garden.

I remember mail-ordering a Drummond Norway maple (*Acer platanoides* 'Drummondii') from Milaeger's in Racine, Wisconsin. It was the first plant to set off the historic wellhead, which, thirty years later, has disappeared under the maple's boughs. This tree turned out to be a good selection. It is a naturally rounded, medium-sized tree with wonderful green and white variegated leaves. For most of the year it lights up the spot before browning in late summer and sometimes worse, outright defoliating. Contrary to the poor reputation this species has for seeding profusely and overcoming the native vegetation in a woodland, this tree has never set seed even though I would welcome a few babies. When I give presentations about the evolution of the garden, I say, "Just keep your eye on that tree." In a matter of five slides, the garden grows up around it and the barn disappears behind a wall and tall hedge.

I introduced more plants to keep the maple company and a long narrow bed began to emerge. I also added colorful pieces of my art to bulk up the impact while my little plants put on weight. When I included a barn roof cupola that I had collected and painted in bright colors (a handy way to add year-round color to your garden), I heard from my son Dylan. "Tacky," he said. "I can't believe you did that," which gave me the idea, or maybe permission, to try and create a super tacky garden of clashing colors with a devil-may-care attitude. Those were the days of muted English gardens of pinks and blues, but also the beginning of the craze for bold tropical plants, like bananas and Castor beans, and colors like orange. I quickly hopped on and rode that wave continuing to this day.

Facing page far left: *Venturi Rex* sculpture sits in a bed of the dusty rose blooms of Matrona Sedum (*Sedum* 'Matrona'), and Variegated Peuce Masterwort (*Peucedanum ostruthium* 'Daphnis') backed by GrassAcre with the early fall coloring of the Shenandoah Switch Grass (*Panicum virgatum* 'Shenandoah') turning pink on its way to becoming mahogany colored.

Facing page right, top to bottom: The exuberance of the Garish Garden is provided here by blooming, red paddle leaved cannas, yellow golden lace (*Patrinia scabiosifolia*), and an orange dahlia; cobalt blue Gem Stems are set off in a bed of lime yellow coleus, large maroon palmate leaves of the castor bean (*Ricinus communis* 'Carmencita'), and orange of the Mexican sunflower (*Tithonia rotundifolia* 'Red Torch'); the arching branches of the flowering shrub false hemp (*Datisca cannabina*) on the right leads the way to the strappy, splayed leaves and electric red blooms of crocosmia 'Lucifer' with yellow leaved smoke bush (*Cotinus coggygria* 'Golden Spirit') in the center.

Right: The beginning of the Garish Garden about to be expanded as indicated by the green flags. The skeleton of the CopTop is in the distance.

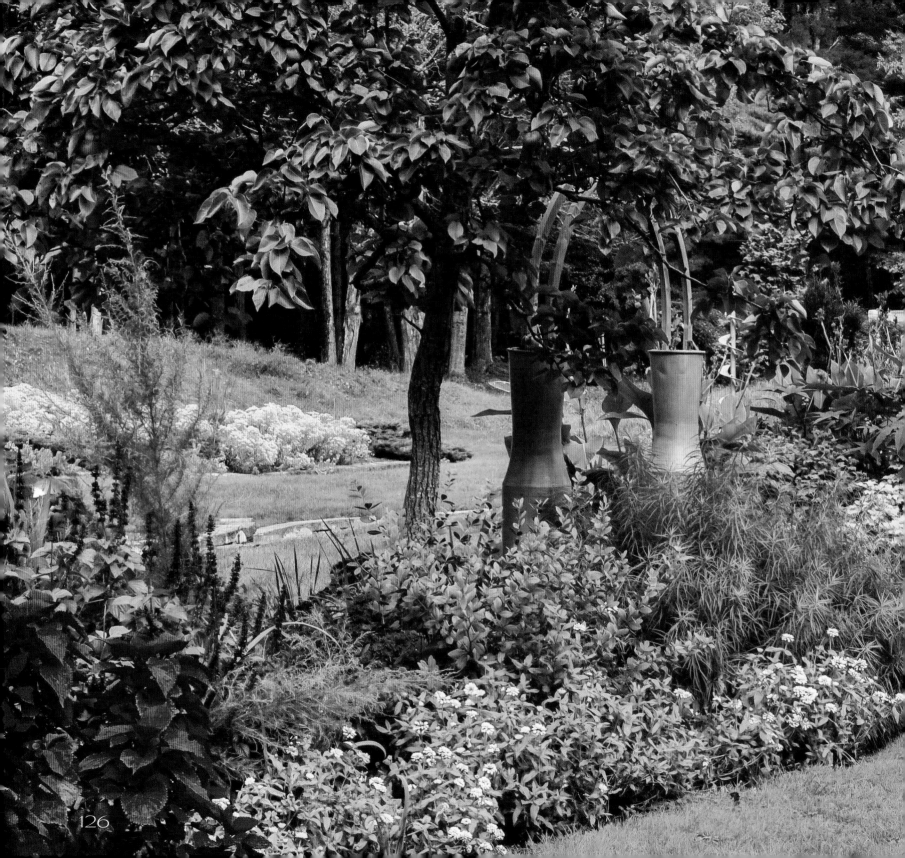

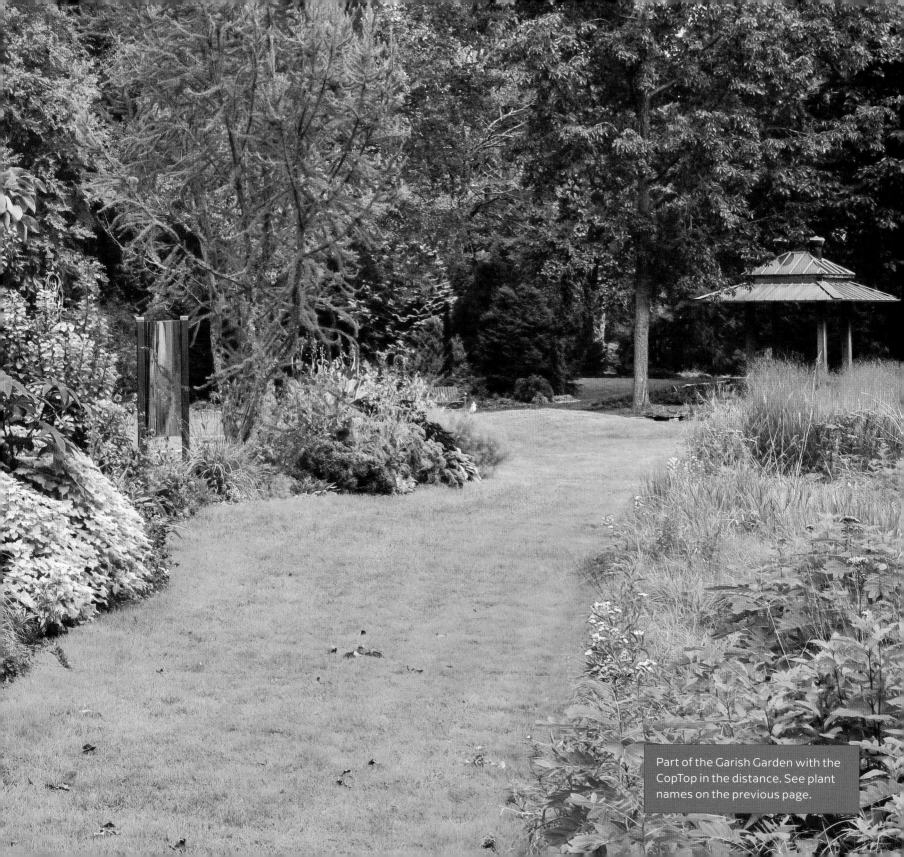

Part of the Garish Garden with the CopTop in the distance. See plant names on the previous page.

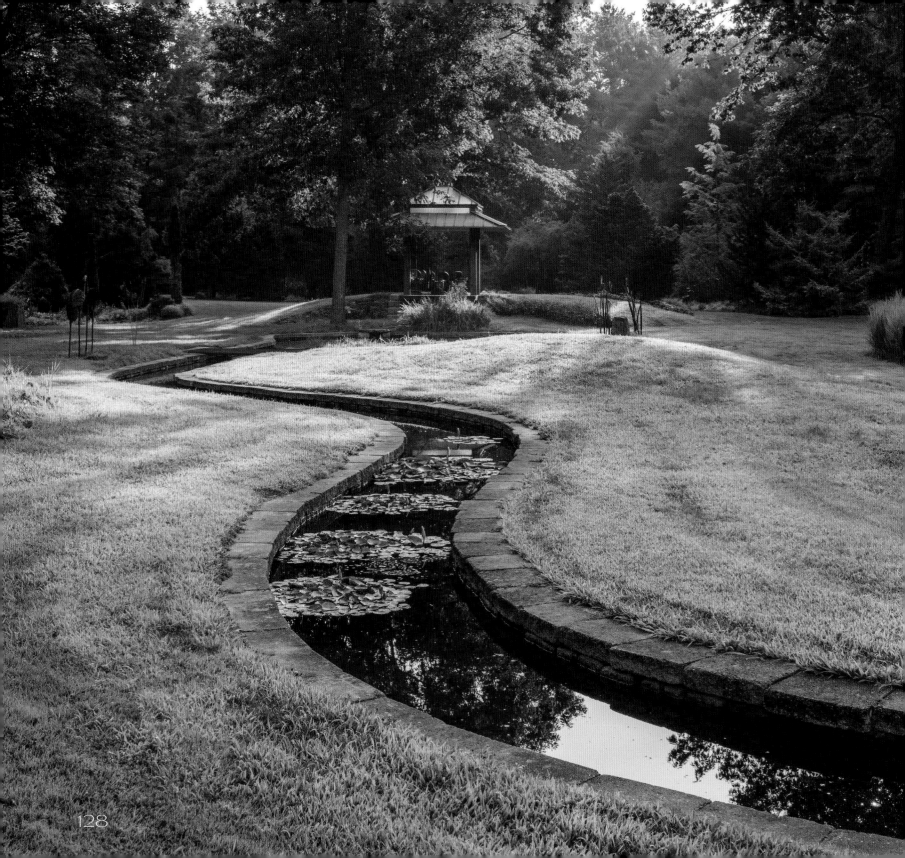

21, 23

Wiggle Waggle and CopTop

Water features require constant maintenance, we were told, and now we tell others. When I clapped onto the idea of creating a long water rill inspired by Rousham House & Gardens in England, Bob dove in and began accumulating a considerable library on the subject, pre-internet. A couple of seminars followed. Unfortunately we ignored the one piece of instruction we might have benefited from: Do not place a water feature where water would naturally collect. So you put one on top of a mound? As contrived as that sounds, it is done a lot. But we decided to put the rill or watercourse I had envisioned right where the swale had been dug to feed the pond. The overflow water from our feature would exit underground to the pond just as before.

Ron Cote rough dug the line I had delineated with orange spray paint, and we did the rest. We formed a trench with walls, installed a rubber lining, built block retaining walls and created two weirs for the water to trickle over. We repurposed an industrial copper-edged skylight that had been sitting around for years and placed it over a rectangular block-lined pool, which gives the water a logical starting point. It is now known as the Spring House.

At the other end of the two-hundred-foot watercourse, we dug a fifteen-foot-wide, four-foot-deep Lotus Pool with an overflow pipe running underground, pitched to drain to the Pond several hundred feet away. The pump that recirculates the water from the Lotus Pool back up to the Spring House is located next to the Lotus Pool (which, by the way, has never been planted with lotus, but that's another name that stuck). This project proceeded smoothly, if slowly. One difficulty early on was when the boom truck delivering the blocks for the wall got stuck in the soft dirt near the Wiggle Waggle. So from then on we moved, by hand, several tons of block onto and off of the Zipper's bed.

Making short mention of the year this took to complete, we finally turned on the hose and filled the trench with water from our well. It looked perfect—everything in place, the water so clear you could see the bottom, since it was December and too cold for algae. We were in love. The way the snow lay on the ground with just a squiggle of black open water was magical.

When spring arrived, with the snow melted and the ground thawed, we were taking our evening tour around and noticed something odd in the Lotus Pool. It was the liner floating near the surface. Somehow it got the name of "buffaloing," like the dark shiny back of a water buffalo playing in the mud. The groundwater was collecting under the liner and pushing it up like a diaphragm.

Luckily there was a work-around for this: We dug a pit for an industrial-sized sump pump to pump the groundwater from under the liner into the overflow pipe heading for the Pond. And what if the power goes off? Bob has mentioned a dedicated generator. I have said more than once that if Bob dies, the first thing I will do is fill in the Wiggle Waggle. To return to the original point, the reason you do not want to put a water

Facing page: Water lilies growing in the Wiggle Waggle with CopTop in the background.

feature where water naturally collects is because water naturally collects there. Oy vey.

Eventually what followed the Wiggle Waggle was a Wiggle Waggle viewing platform named the Croissant. Here we could admire the feature like a king and queen on our elevated promontory. That led to our wanting someplace to hang out in the garden during a thunderstorm, which gave rise to the CopTop.

The CopTop—which gets its name from its patinated copper ventilators and flashing—is a structure topped by an industrial skylight I purchased from Vermont Salvage in Manchester, New Hampshire. It perfectly matches the skylight of the Spring House at the start of the watercourse. Like retrofitting anything, the initial price of the inspirational treasure can easily be quadrupled by the time it is installed, and this was no exception. After the skylight's rehabilitation, we constructed a base of hemlock posts to support it and fabricated a steel frame for the structure to sit on.

To install it, we put it on a piece of plywood spanning the bed of our truck, backed it up the ramp of the Croissant, and with the help of two carpenters on their lunch break next door, inched it up a rail of two two-inch-by-four-inch pieces of lumber. Bob's measurements permitted the skylight to slip into place, but not without a plunk and a new crack in the glass.

Top: Digging the Lotus Pool and the trench leading to it.

Middle: Digging the trench for the water pipe to provide recirculation. The Spring House foundation and top are in the foreground.

Bottom: The pool is lined and filled, waiting to start on the edging.

Facing page: The Wiggle Waggle as it is now.

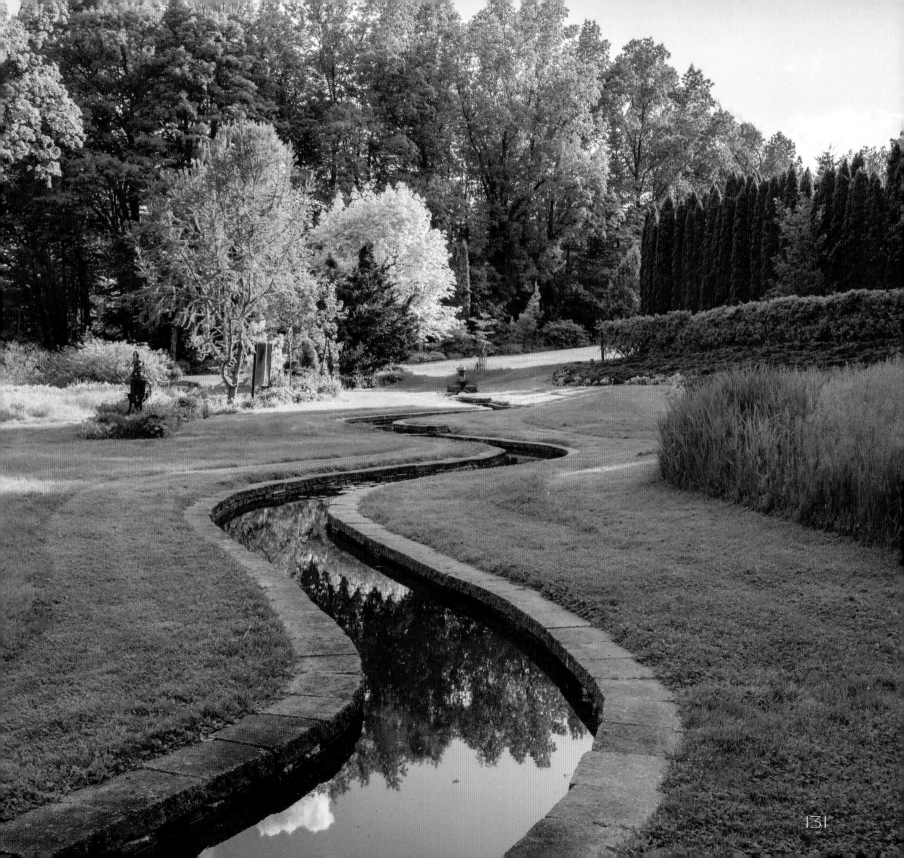

It sat for a year until we got around to fabricating the framing for the shallowly pitched roof. Then it sat for another year. Next, beadboard was screwed onto the frame, allowing us to climb on the roof to install the glass-panel surround under the skylight. The final layer of standing seam roofing took another year to accomplish, but not for want of trying. After six months of calling a roof fabricator every week, including leaving him jokes on his answering machine, Bob gave up, researched the project online and did it himself.

This was our favorite spot for years. I made the swiveling farm chairs just for this vantage place, allowing a 360-degree view taking in the Allée, GrassAcre, Garish Gardens, the Belgian Fence, the Landing, and ConeTown with the Wiggle Waggle starring the show.

Above: The top to CopTop, a vintage copper industrial skylight.

Left: A grand shagbark hickory with a bench at its base provides a place from which to view the CopTop in the distance and is fronted by a big swath of switch grass (*Panicum virgatum* 'Shenandoah').

Facing page top left: The CopTop sits on the elevated croissant-shape mound with the skylight mounted and the skirt of the roof in place, awaiting its standing seam roof.

Facing page top right: The sculpture *Innie*, made from sickle bar teeth announces itself, while the CopTop rings a soft note in the distant mist with a stretch of switch grass (*Panicum virgatum* 'Shenandoah') in between.

Facing page bottom: Large structures like the CopTop and the Torii provide a place to focus your gaze—Hakone grass (*Hakonechloa macra*) is on the left and little blue stem (*Schizachyrium scoparium*) is on the right.

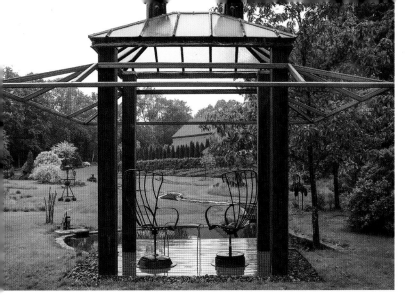

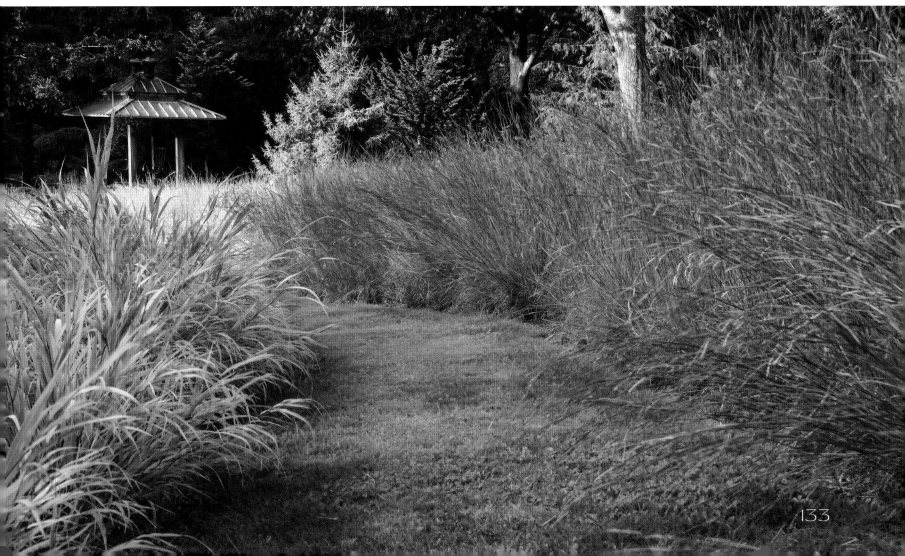

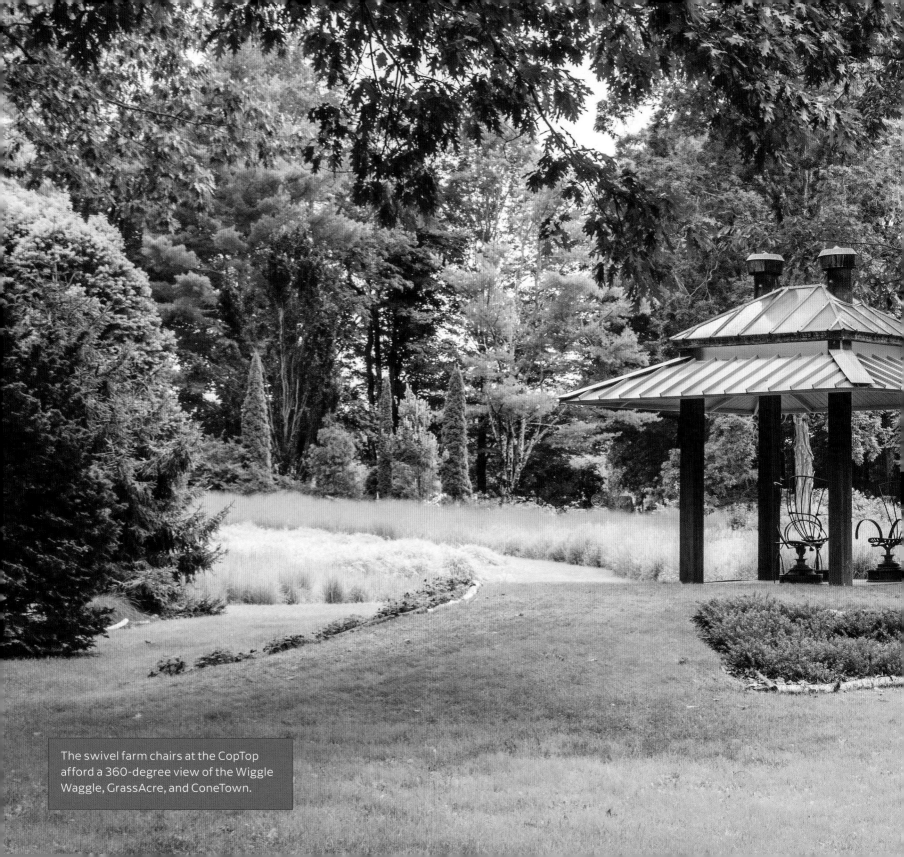

The swivel farm chairs at the CopTop afford a 360-degree view of the Wiggle Waggle, GrassAcre, and ConeTown.

22

PATE AND HIVES

We create most of our own adventures, but sometimes they are visited upon us. This was the case one February when Ron Cote called wondering if we would like some bushes he had removed from a job site. There were forty of them. Sure, I said. They sat in a pile until the ground thawed enough to plant them.

When we cleared the land, part of which would become ConeTown, we found a delicious inverted bowl-shaped promontory of thinly covered bedrock on the west side. I spent a day dumping fifty bucketloads of topsoil with our Leyland tractor while our son Spencer spread it, a skim coat of soil frosting. This was going to become an event someday and that day was when the bushes arrived. There was a slight wrinkle in not being able to identify the bushes in their leafless state but we planted them, nevertheless, in a circle around the bald mound, leaving an opening on the north and south.

Bob's literary cousin dubbed it "Sportive Wood" after a line in William Wordsworth's poem "Tintern Abbey": "These hedge-rows, hardly hedge-rows, little lines of sportive wood run wild." As it turned out they were privet, a trash shrub soon to be on the invasive list. Their lowly status freed

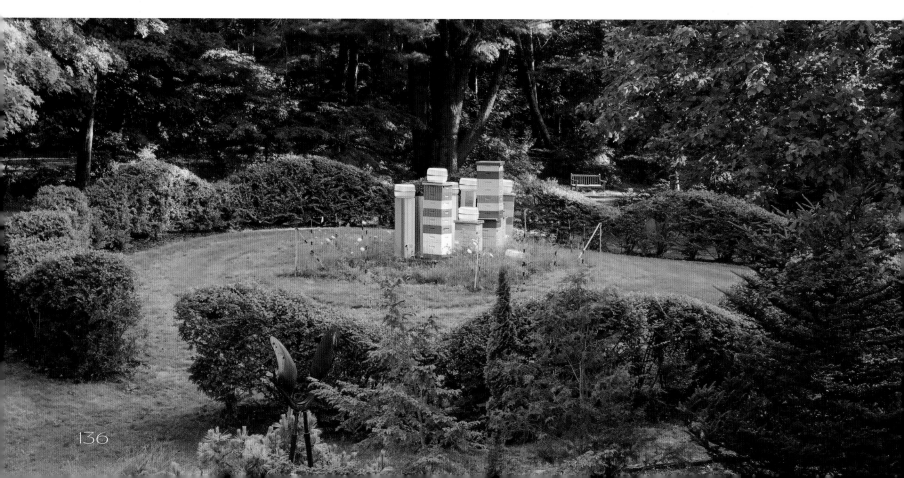

me to shape them into a wave pattern that would read like a living sculpture in a decade or so, which it now does.

A privet hedge is a high-maintenance affair. We aim for clipping three times a summer, although sometimes it could use a fourth. Initially, we used the electric hedge trimmer, running an extension cord from the barn one hundred yards away. I started but Bob took the shearing job away from me. After measuring and pounding rebar rods in at regular intervals, he determined the wave shape. Then came the gas-powered trimmer, which weighed a ton and needed to be lifted overhead in places requiring a ladder. Then Bob came up with the idea of sitting on the roof of the Zipper with the electric trimmer connected to fifty feet of extension cord as one of us slowly motored him around, doing first the outside perimeter, then the inside and finally the sides, which could be done from the ground. The name Sportive Wood fell away and the Pate, a tonsured dome, stuck.

When we visit a garden, and we have visited hundreds both in the United States and abroad, Bob and I think a lot about circulation. In some ways, it feels like *the* element that makes or breaks a garden.

Over the years we have constantly fiddled with our path system, half of which was created by the skidder paths left by the lumbering operation. We have decommissioned paths and created new ones, as in the case of the Gothic

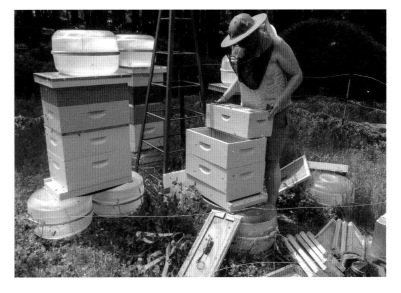

Facing page: The Pate with Hives are enclosed by the wavy hedge.

Top: A pile of light fixtures from a remodeled hospital waits to find a purpose.

Middle: Tending the bees.

Bottom: The lights have found a home and glow in the afternoon light.

Arbor and the path from the Torii to the Pond. Some paths had an exceedingly hard time getting themselves right.

The path to the Pate takes the prize. First the path ran east to west, then north to south, then just east, and now just south. Each time, we had to move plants to plug up holes and readjust the wave pattern on top of the hedge. Relics of former configurations remained for years.

In 2019, an apiarist approached us about introducing beehives on the property. She would do all the work and eventually we could sell our own honey. As it turned out the perfect place for the hives was on top of the Pate. She began with three hives, stacking up their boxes of many colors to make an instant statement.

I have puzzled over how to treat the interior of the Pate for years. In 2015, I experimented with creating a spiral of hay bales set wide enough apart for my mower to snake its way up to the top, an elevation of maybe three feet.

I continue to like the spiral idea because it slows down time and repeats the spiral theme featured elsewhere on the property. While it would take less than ten seconds to walk the short distance to the hives, a spiral also gets you there but provides a very different experience.

I was thrilled to have the main event on the Pate be a collection of colorful hives. We installed an electric fence around them, since bears are especially attracted to the larvae in the hives and sometimes a little shock on their noses will keep them away. Years ago we were gifted a couple of dozen foot-wide glass light fixtures from a hospital in Nashua, New Hampshire, which was being renovated. They were lying in the metal collection when our beekeeper spied them, independently decided they would look good on top of the hives and added them in 2019.

I also remembered we had four one-foot-by-four-foot wood pedestals in the barn left over from our trade shows. We color-matched the paint on the hive boxes, painted the columns in vertical stripes to contrast the horizontal of the boxes and added the glass light fixtures on the top. I wanted it to look like a cityscape of buildings. The ensemble was eye-catching. When the wooden plinths had rotted out by 2023, I so liked the effect that we switched to a more permanent solution: making columns by stacking differently colored square concrete blocks at different heights.

Facing page: Trimming the privet hedge.

Above: The hives animate a sticky snowfall.

24

GrassAcre

I remember a Radcliffe classmate visiting the garden and confidently telling me that before long, I would be doing something with the large field in the middle of the garden. I told her I had done something with it—I had left it natural, save for spraying poison ivy. I even thought she may have missed the brilliance of the design, the important counterpoint it offered.

Well it turns out she was right—I couldn't keep my hands off that field. I used the meadow theme to create one of the most cockamamie projects attempted yet, GrassAcre. This idea falls firmly under my favorite motto "act now, think later." My vision was to abstract the idea of the meadow into a living painting using big swaths of green, blue and red-tinged grasses. The meadow conveniently lies on a slope rising gently from the Wiggle Waggle, sitting like a large canvas on an easel. A broad grass path cuts across it diagonally and narrower ones separate the different colors. I selected three grasses: little bluestem 'The Blues' (*Schizachyrium scoparium* 'The Blues') for the blue; switch grass 'Shenandoah' (*Panicum virgatum* 'Shenandoah') for red; and prairie dropseed (*Sporobolus heterolepis*) for the green—all native as it turns out.

My reading instructed me to thoroughly rid the area of the existing plant material using herbicides applied several times over the course of between twelve and eighteen months, which I dutifully did, creating a terrible eyesore. The blackberries, morning glories and poison ivy were the last to give up.

We had timed the delivery of our new grasses to coincide with one son's return from college, and counted on help from several of his friends who had a few days before they began their summer jobs. It was a great beginning, but soon it was down to Bob and me. I had totally convinced myself that if all those women in Asia could plant entire mountainsides in rice every year, then surely I could plant just once what we exaggeratedly called an acre. I was wrong. I became intensely discouraged. I recently came across a letter dated June 2, 2003, in my mother's files, in which I wrote (and must have included a picture): "The large expanse of dirt is our GrassAcre. Thank goodness only 8,600 plugs of the 12,000 came. The rest were back ordered. I planted one day for a total of eleven hours and that included a nap in the middle. When I was done, I had completed a four-foot strip."

I withdrew in shame. Meanwhile, the indefatigable Bob was working out his theory of the most efficient grid pattern to plant the plugs. My contribution became flattening the cardboard boxes, bringing them to the dump and providing food. Bob proceeded to spend his summer vacation on his knees, listening to the radio on his iPod, laughing out loud, calling the station to win free tickets and planting the rest of the field.

As it turned out, planting was the easy part. We were fortunate to have planted the field at a time when it

Facing page: Art can provide a layered experience in a garden. It can create a mood; provide gravitas; be a backdrop for my flamingos, in this case; and change dramatically when covered with snow, mist or ice.

rained frequently during the plants' critical first month. That was unfortunate as well. Within that month, the plugs disappeared in a sea of opportunistic weeds. This project was looking like the most expensive mistake I had made yet; unlike the Torii, there was no changing my mind. Someone suggested covering the plugs and spraying the area with weed killer. Luckily, having left Bob to execute much of the repetitive task of planting, the grid pattern he settled on was hexagonal like a honeycomb, which made it much easier to guess where the plugs might be hiding. We marked each one with a white plastic eating utensil then inverted a red plastic cup over them and sprayed, moving the waves of cups along. A brainstorm. And we are still uncovering bits of white utensils.

Years of weeding and dividing have followed. Weeding grasses out of grasses is tricky even to the educated eye. In 2015, we had our first dedicated GrassAcre weeders from Craigslist who came whenever they had a few hours. It's a job like painting the San Francisco Bay Bridge—never done.

About eight years into this project, I decided we had given the pokiest of the grasses—the prairie dropseed—enough of a try and we finally kicked it out. Its personality was not robust enough to play with the other two. The switchgrass was thick at the end of the first year; the bluestem, while much slower growing, had thickened up with frequent spring dividing. The dropseed flopped like a mop. It was the tallest when it was in flower, but they were so airy and delicate they made for a blurry effect lacking oomph.

Top: The early days of the GrassAcre.

Bottom: The grass plugs are marked with plastic utensils.

Facing page: Volunteer weeders pose in front of the *Syncopeaks* sculpture in the middle of GrassAcre.

We transplanted them to Cannon Hill near the Belvedere, where they feel more at home.

I took a risk subbing in a grass that has plenty of personality but is listed as growing best in the shade. Hakone grass (*Hakonechloa macra*) is native to Japan and is most often grown ornamentally in its variegated forms. I chose the green form, which is larger and meatier with the added feature of being slightly shiny, so it really shows up in a large mass. I had grown the green form for five years on the baking west side of our house so I was somewhat confident it would do fine in full sun, but when ordering 3,500 plugs, you can lose your nerve. As an aside, the switchgrass stands up straight in a breeze, but when you see a large planting of Hakone grass sway in the slightest breath of wind, it can almost make you seasick. The movement of the bluestem falls in the mid-range. They all have such different personalities.

For this planting, Bob measured out the area with the transit, vectors, and measuring tape, and stuck an orange flag for each plant. It looked like Arlington National Cemetery from the air. Someone attending an open house around this time wondered if it was a sculpture, which I took as a compliment.

For many years the GrassAcre looked like hair transplanted on a scalp. Even as it gets better established it goes through a long, homely spring phase. I have pondered underplanting it with a spring blooming

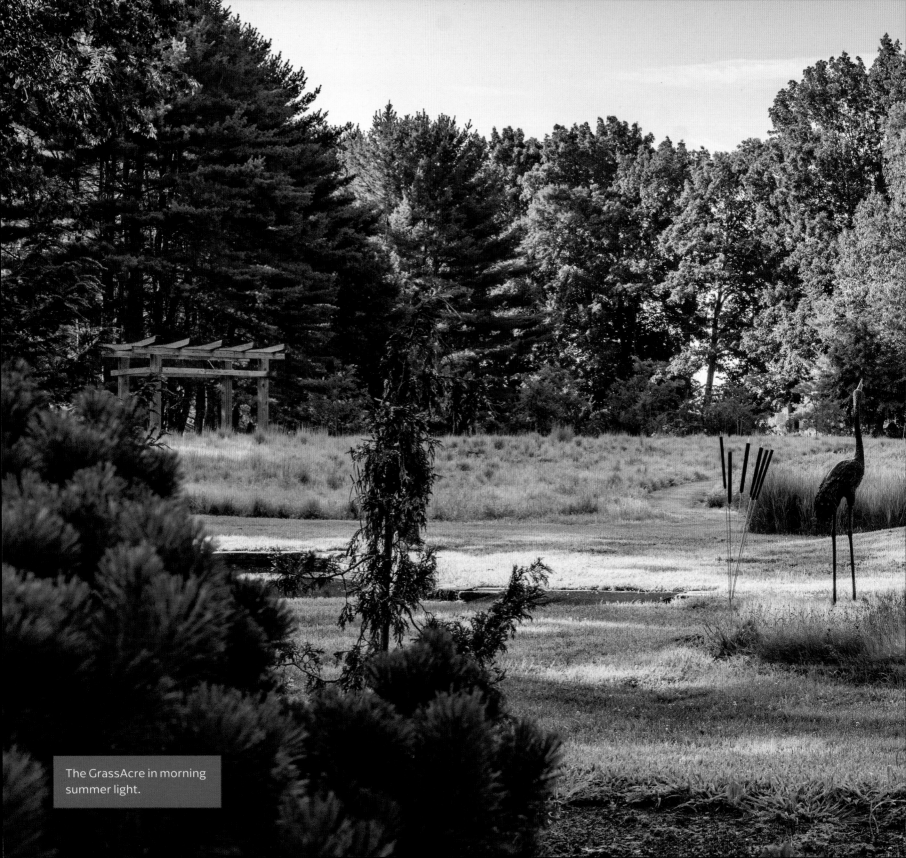
The GrassAcre in morning summer light.

145

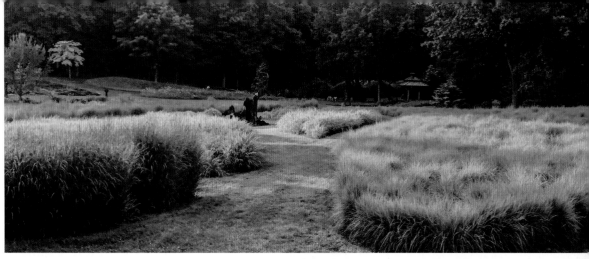
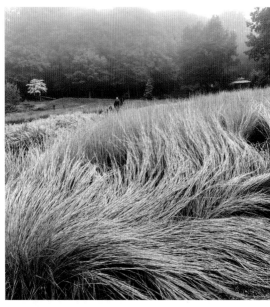

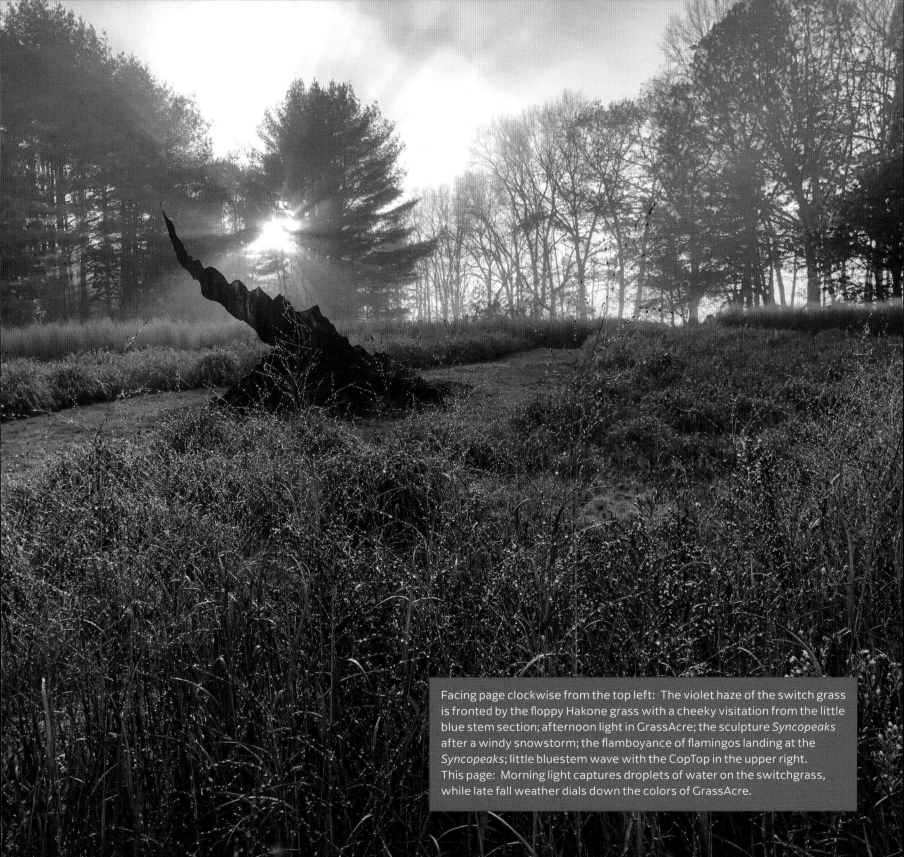

Facing page clockwise from the top left: The violet haze of the switch grass is fronted by the floppy Hakone grass with a cheeky visitation from the little blue stem section; afternoon light in GrassAcre; the sculpture *Syncopeaks* after a windy snowstorm; the flamboyance of flamingos landing at the *Syncopeaks*; little bluestem wave with the CopTop in the upper right.
This page: Morning light captures droplets of water on the switchgrass, while late fall weather dials down the colors of GrassAcre.

Facing page: The remarkable color metamorphosis of the GrassAcre from September (top) to November (bottom).

groundcover, which would disappear under the thick summer growth of the grasses, but I haven't come up with the plants, and spring chores keep me busy enough to forget that idea again.

GrassAcre certainly has its times of magic. When the bluestem is fully grown in midsummer, it is a wonderful blue-gray color with a hint of red purple on some stems and the wind rippling through creates a moiré effect. Then as the weather cools, it first turns a beautiful violet, then gradually becomes coppery orange and eventually cinnamon. In the fall when it flowers, it transforms from one day to the next into a haze as the light catches the tiny feather-like structures on the tips of the stems. It happens so suddenly it feels like popping popcorn or like the way ginkgoes shed their leaves all at once.

The switchgrass is also beautiful—with wider blades, some of which are blood red, others maroon. It makes a more subtle color statement than the bluegrass. But, when seen together they create a striking color effect. There have been little musical chairs, I am pleased to say, with an occasional switchgrass turning up in the bluestem and recently one prominent clump of steel-blue bluestem cheekily turned up in a sea of waving Hakone grass. I did dread the potential here.

When I mow the bluestem down in the spring, the ground is covered with a warm cinnamon-colored blanket. The Hakone grass leaves a pale buff carpet and, very occasionally when the weather gods are with me, I can burn the switchgrass. Otherwise I have to wait until late spring before it dries itself out enough to mow.

Syncopeaks is the name of the large sculpture in the middle of GrassAcre. To me its shape evokes the layers of peaks in the White Mountains of New Hampshire when they are slightly shrouded in mist. But I seem to be the only person who sees that—most folks see a dragon or an elephant. The sculpture is fabricated from two air-compressor tanks salvaged from the Exeter Fire Department, which we sliced into strips and welded together in a convex/concave pattern. Here I had set myself the challenge to use up every scrap of the tanks in this one sculpture, which we did—save the profile of the Old Man of the Mountain my fabricator snuck in and I cut out. Initially, the interior and exterior of the tanks were different colors, which created a striped pattern that had a harlequin feel when looked at on end. It has developed a rich overall rust patina that obscures the distinct striped effect, and an interesting blotchy pattern is emerging that looks almost like leather.

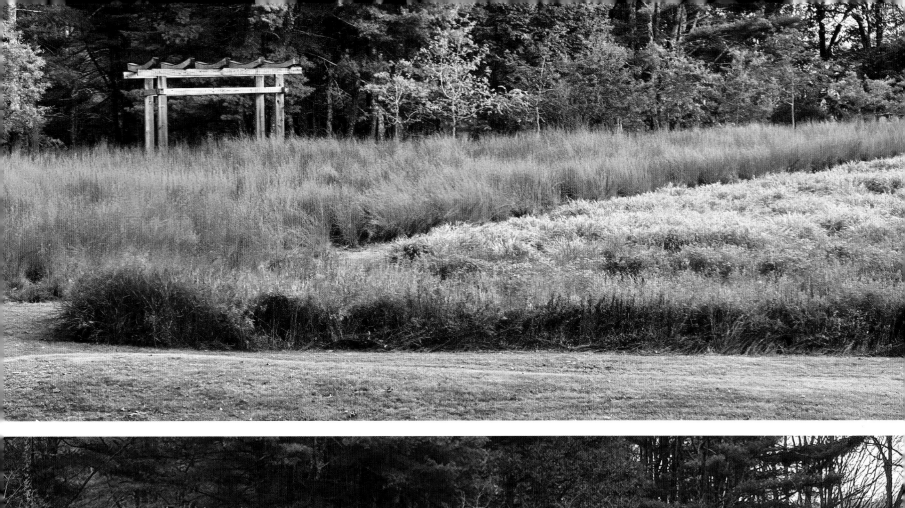
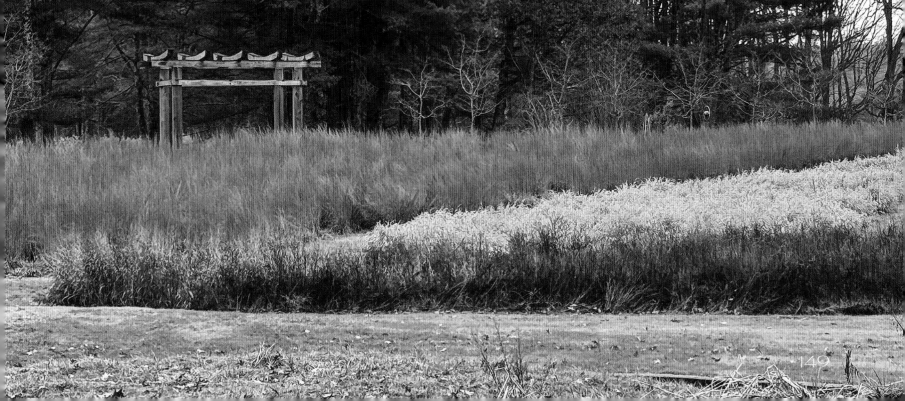

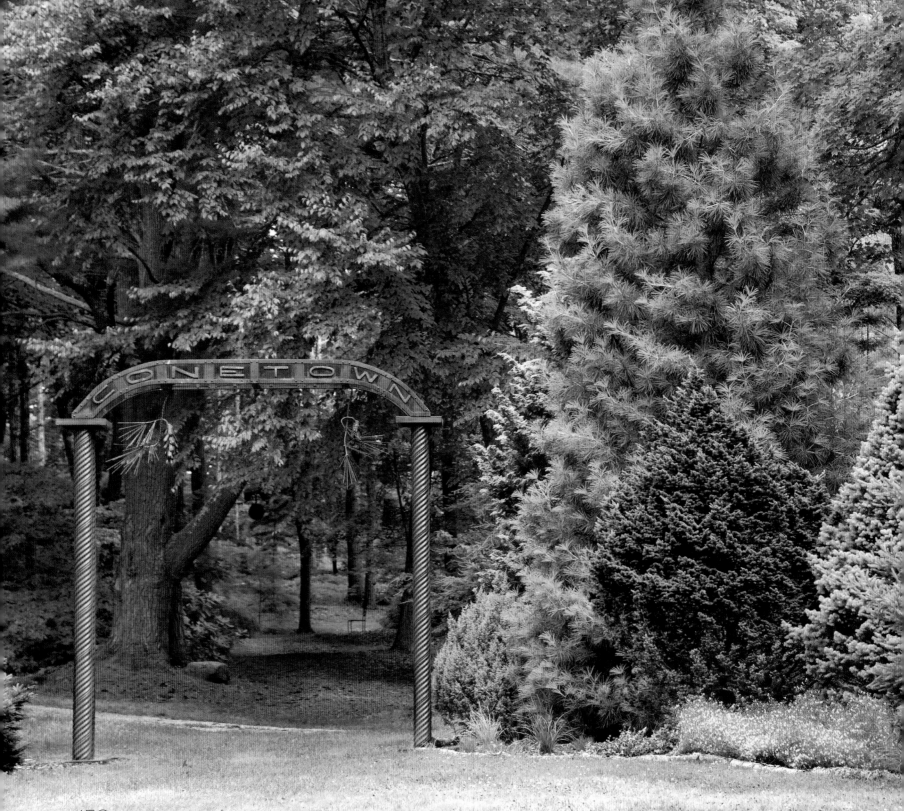

25

ConeTown

The first stop for my new plants is usually a planting bed, but it does not mean it is their last stop. Eventually plants need to be rearranged. I collected dwarf conifers furiously in the early 1990s and they became a reason to create a new garden. Bob's father had a tremendous collection of dwarf conifers and Japanese maples in his garden in Virginia. I am sure my early exposure to his stunning garden led me to search out some of his choices.

Even dwarf conifers can put on some weight in thirty-plus years—in fact there are some who take issue with the word "dwarf" regarding conifers and suggest calling them slow-growing instead. Most likely some of these plants were too newly introduced to have longitudinal studies documenting their growth over many decades.

Be that as it may, it became clear that not all played well with their fellow perennials. For example, the skirt of the Skylands oriental spruce (*Picea orientalis* 'Skylands') was extending into a walkway, getting shaded out on the sides and turning green instead of gold. The lower limbs of the dwarf Alberta spruce (*Picea glauca* 'Conica') lost all their needles.

Our solution was to round up many of the conifers into a garden all their own that we called ConeTown, a garden of cone-bearing plants. On several occasions we rented a tree spade to move them. First we tied up the branches

The ConeTown arbor (looking towards Shrubaria) is flanked by a tapestry of conifer textures. From the left to right are the chartreuse foliage of *Chamaecyparis obtusa* 'tetragona aurea' partially seen on the right, fluffy plastic-like needles of the upright Japanese umbrella pine (*Sciadopitys verticillata* 'Joe Kozey') in the center, the dark green tear-drop shape of hemlock (*Tsuga canadensis* 'Armistice'), and the powder blue of a spruce (*Picea*). The foamy pale yellow ground cover is lance-leaved loosestrife (*Lysimachia lanceolata var. purpurea*).

Above: A pine cone sculpture hangs on either end of the sign.

papoose-style, then the spade was able to cut right into a perennial bed and lift the plant up in a cone of soil about three feet at the widest. The transplants took several years to catch their breath and begin to fill out.

After a couple of fall sessions with the tree spade, we graduated to yearly visits from a master at balling and burlapping shrubs and trees of any size. He could work in areas a machine could not, such as in the rock garden or deep within a bed. Knowing that such transplanting could be accomplished relatively easily (except for lifting the heavier root balls) led me to look at our garden in a fresh way, as though the elements in it were like pieces of furniture that could be easily rearranged.

In ConeTown, the plan was to create a garden where the conifers became sculptures. The varying needle colors and textures would be animated with the added dynamism of the red, bright yellow, lime, and pale green spurt of new spring growth. The conifers seem like old souls, stalwart and unmoving. After fifteen years they began to knit together, and every now and then I add a few six-inch specimens similar to the original stock. I have also removed some because of disease. This happily lets more sunlight in.

Since ConeTown evokes a Wild West image in my mind, I made an arch patterned like those featured at the entrance to a dude ranch. We sited it on the north side of the area and

Top: Bob and Tim, the master ball and burlapper for trees, move a conifer from the front of the house to ConeTown.

Bottom: The early days of ConeTown show the Japanese umbrella pine to the left of the sign and the CopTop in the center still waiting for its roof.

Facing page: The ConeTown arbor exhaling in the autumn morning sun.

made it ten feet high and eight feet wide to easily accommodate access for large equipment.

The uprights were four six-inch-diameter metal culverts—two on each side—powder-coated a dark earth brown. The top arch was made of two pieces of identical farm equipment that had been lying around for years, waiting. We welded them together with a foot in between, which gave the flattened arch the volume its scale required. As it turns out the arch had cross bracing that formed the right number of openings to spell out the name "ConeTown" in big cutout letters on both sides. Then I hung a couple of foot-long cones that I made from small rectangular pieces of metal that were sitting in a spackle bucket in the barn. All they needed was to be rounded on one end and assembled in a spiral pattern of scales like those on pine cones. The pine needles were easily made from a few dozen coat hangers.

On the ground around the conifers I am making a crazy quilt of different colored and textured sedges, rushes, and grasses. I have never seen a sedge-rush garden so this was a fun way to learn about a plant group new to me. Some I particularly like are golden variegated sweet flag (*Acorus gramineus* 'Ogon'), creek sedge (*Carex amphibola*), Appalachian sedge (*Carex appalachica*), blue arrows rush (*Juncus inflexus* 'Blue Arrows'), and autumn moor grass (*Sesleria autumnalis*). I like having a kind of plant zoo to get to know a variety of plants. No longer a purist, I have introduced some perennials such as lance-leaved loosestrife (*Lysimachia lanceolata* var. *purpurea*), hairy alumroot (*Heuchera villosa*), Hubricht's bluestar (*Amsonia hubrichtii*), sedums and ferns. The stalwart and serious nature of the conifers—like Auguste Rodin's sculpture *The Burghers of Calais*—needs the leavening of a playful, colorful ground cover. Time will tell.

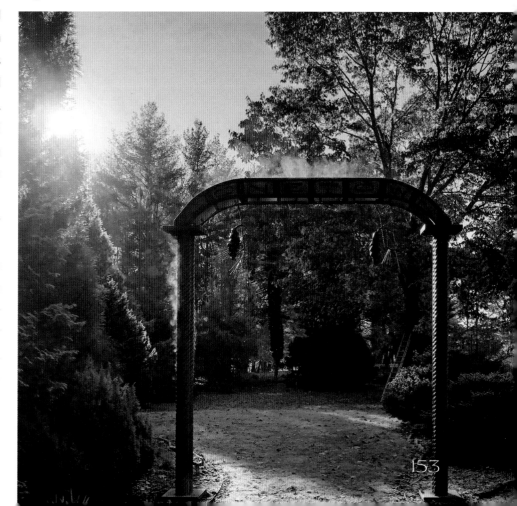

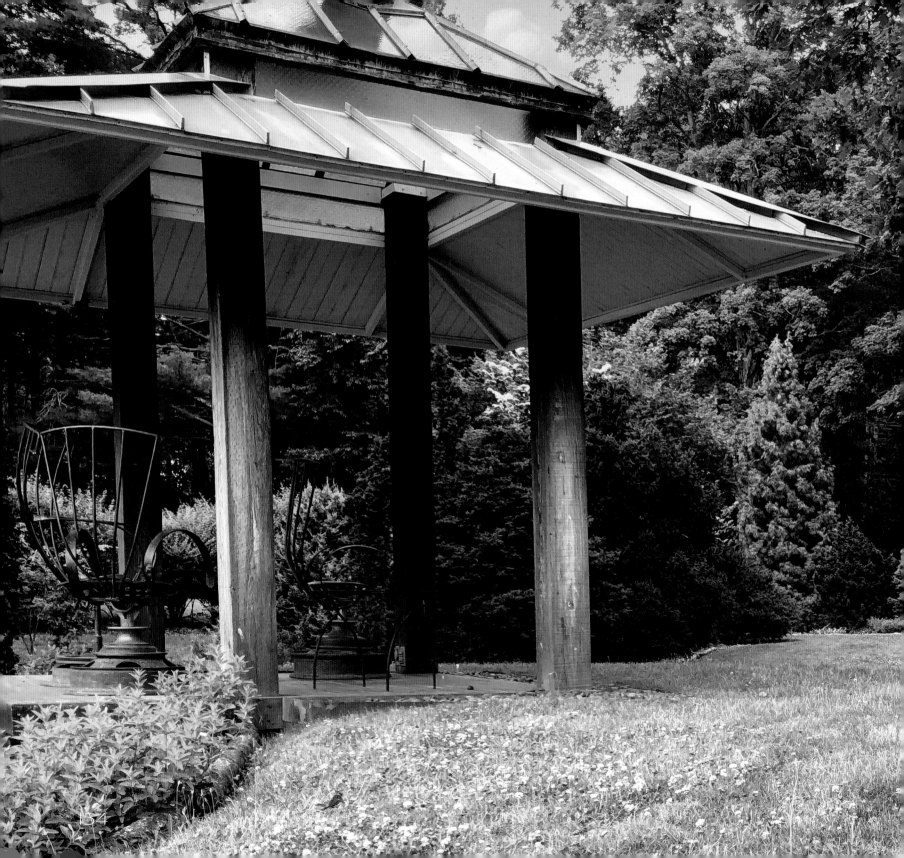

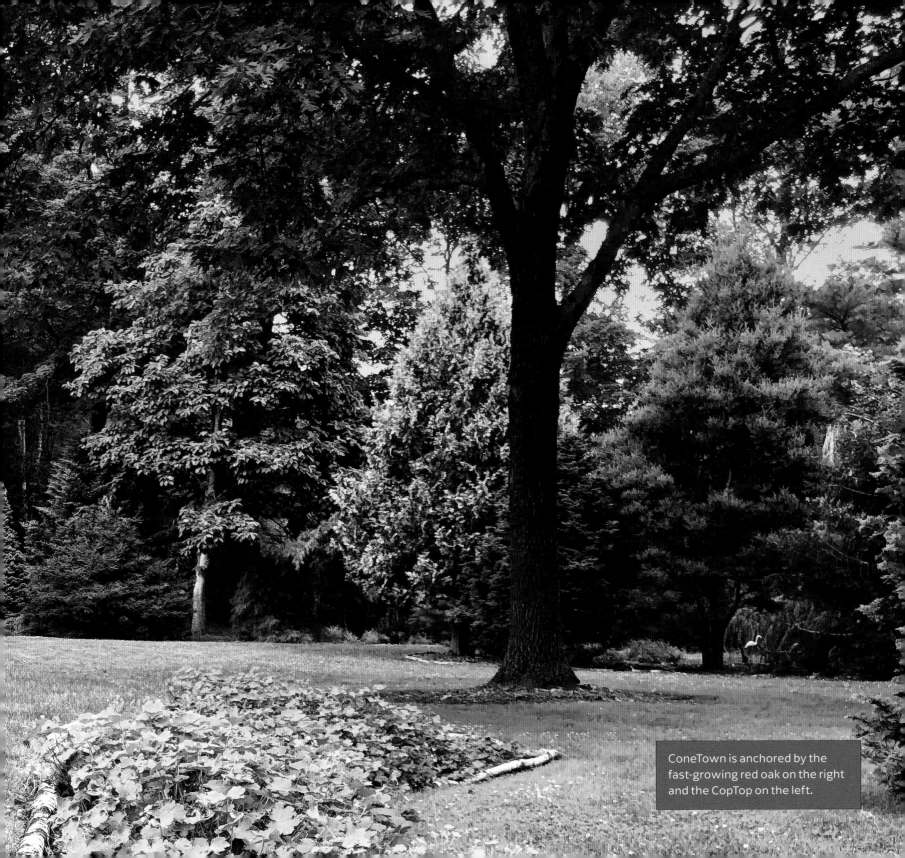

ConeTown is anchored by the fast-growing red oak on the right and the CopTop on the left.

26

SHRUBARIA

Shrubaria is a half-acre area between the Tea House and ConeTown that began in 1995 as Della Rhodia, a dell of rhododendrons. This was the period in my gardening career when the color pink reigned. I remember feeling transported by an experience of walking between two rows of fifteen-foot rhododendrons blooming in different shades of pink when visiting the Case Estates in Weston, Massachusetts. It didn't look difficult to re-create. I thought it was a matter of just making the correct selections and waiting. I painstakingly selected and ordered a group of rhodies each year for the next eight years from Greer Gardens in Oregon, Roslyn Nursery and Cummins Nursery in New York, Weston Nurseries in Massachusetts, and others to create a collection of what I imagined would be a billowing grove of pink confection blooming over a month's time.

But I was wrong. The plants arrived in the mail and it was a good five years before they showed their colors, which, for starters, were not what I had in mind. I had selected them based on their written description. Did they send the right plants? Did I really know what color cerise was? Then there was placement. The planting design made more sense before we changed the path system. Now the rhododendrons looked strewn about the way we are instructed to cast bulbs to create a natural-looking planting. The fact that rhododendrons in a bunch are boring most of the year hadn't crossed my mind—I was wedded to the fairy-tale feel of the Case Estates.

Around 2011 we moved the rhodies to the periphery of this clearing. Taking a step back to evaluate, I realized that the clearing and the sugarbush adjacent to it were the only areas of high deciduous shade on the path system. The area around the Tea House, just fifty feet away, was almost all white pine with a nascent Japanese maple understory. In this area the oak trees read like a cathedral. To amplify the effect, we cut down some of the small remaining non-oak trees and had an arborist with a bucket truck limb up and otherwise fine-tune the five seventy-five-foot-tall red oaks that remained.

The plant material connecting the canopy with the ground plane is a collection of shrubs, hence the name Shrubaria. Shrubs can be difficult to incorporate into flower gardens because of their ultimate size. I plan to use them here as one would plant perennials in a flower garden: to capitalize on their variety of form, color, leaf texture, flowers, fruit, and fall color. A couple of decades from now it should really sing.

Facing page clockwise from the top left: *Riblets* is a sculpture made using cutter bars and leaf springs; *The Sacrificial Table*, made from an old well head, is a place to sit and view the pond; the sculpture *Great Balls of Fire* fits right in with the fall foliage scheme; rhododendrons bloom with the ConeTown arbor in the distance.

27

Petit Pond

Petit Pond began its life as a wet depression in a little clearing at the foot of a pine-covered hill. It cried out to become "a place to stop along the way." I wondered if we could make it into a proper pool. In addition to being a talented heavy equipment operator, our contractor Ron Cote was also a dowser skilled in sensing where underground water lay. He brought over his forked piece of wood—a divining stick—and told us he was quite sure there was a spring feeding this wet spot. We were thrilled. He began to dig and we went up to the house for lunch.

When we returned we were looking at a hole twenty feet long, twelve feet wide, and ten feet deep. The soil had been distributed by the accompanying dump truck onto our new trail system. There was no sign of water pooling on the bottom and no way we could fill it back in. It seemed we had an instant safety hazard on our hands. We quickly surrounded the hole with orange perforated plastic fencing. It would have been so nice to have natural water occur somewhere where we wanted it. Not this time. So we took the next step and ordered a rubber liner for our newest

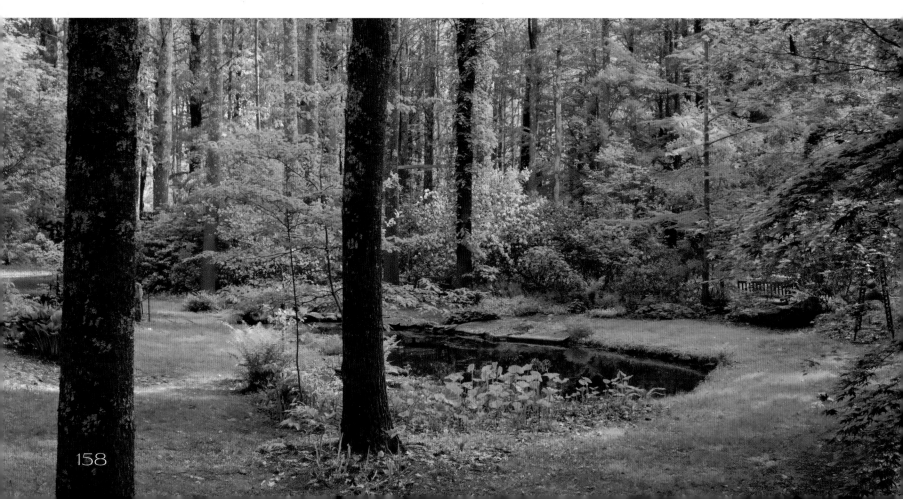

feature, which we called Petit Pond—pronounced "petty pond"—to distinguish it from the big Pond.

The liner weighed 1,500 pounds. I was the only one home when the tractor trailer delivered it. I received the liner into the bucket of our twenty-five-year-old Leyland tractor that seesawed on its front tires.

Our generous neighbor and his excavator bailed us out again. Since the liner was rolled up like a five-foot-long toilet paper roll, we slipped a three-inch steel pipe through the roll, threaded a heavy chain through that, attached it to the excavator bucket, and hoisted it into the air. We clamped the end of the liner between two pieces of lumber, bolted a generous length of chain at each end and attached it to our truck on the far side of the hole. As we slowly drove forward the liner unrolled over the length of the hole.

Once the liner was installed we filled the pond from the spigot in the barn, using many lengths of hoses. Later we trenched a water line from the barn to keep Petit Pond topped up.

Petit Pond's surround took two years to complete. The area of grass edging, the stone walkway over the bog garden and the rock edging were all carefully considered elements. Up the hill, the cascading watercourse took another seven years to complete. Bob did all the work himself, and his evolution in technique and confidence is plain to see.

Facing page: Petit Pond in spring, with the pink Carolina azalea (*Rhododendron carolinianum*) in bloom.

Right: Spring bloomers include trillium (*Trillium grandiflorum*) in the foreground, the petite yellow daffodil (*Narcissus triandrus* 'Hawera'), white and pink colored barrenwort (*Epimedium x* 'Domino') in the center with wild geranium (*Geranium maculatum*), completed by Eastern redbud (*Cercis canadensis*) on the upper right.

Once again, we had to use our neighbor's more powerful tractor to place the Turtle Rock at the north end along with another four or five large stones. As Bob was completing the beautiful watercourse, I suggested he make the top pool deep enough to include a bluestone bench to sit on as a kind of plunge pool. Even when it is very hot outside the water remains as cold as a mountain stream, without any leeches, so far. As an aside, the flow of the water in all our water features is powered by submersible recirculating pumps. This one gets turned off in the fall.

Although over the years we have purchased pallets of smaller stone-wall building rocks, like some of the ones around Petit Pond, all the big ones come from our property. There is a relatively small area close to Route 125 near the spring where we have harvested almost all the large impressive rocks we have used in the garden.

As is our custom, as soon as we complete a spot, we add seating and admire it. In this case we installed a swinging bench, which started out sited nakedly between two trees like a swing on a playground. In my mind's eye, however, it would become a surprise one happens upon when the berm

I planned behind it was grown. Petit Pond served my design purposes perfectly. It was someplace to go and linger.

Around 2010, Bob decided to bring the power washer out near the Tea House and spray a moss-covered ledge. What emerged was a large water-worn outcropping about five feet long and eighteen inches high with a smoothly rounded front face of ribbons of rock looking like a small waterfall. It was stunning. I wanted to find a way to incorporate it into the path system. A fifteen-foot stretch of ledge occurred thirty feet farther up from our petrified waterfall so the area between them would become a place to sit for a while. "Roji" is a Japanese term meaning a simple garden through which one passes on the way to a tea house. There is nothing authentically Japanese about the Tea House or the area around it, but the term has stuck as its name.

To create more of a sense of place and feeling of enclosure, we slightly bermed up the side of the Roji along the road. We had just finished with our Grass Family exhibit at the Boston Flower Show and I planted the fifteen clumping bamboos (*Fargesia rufa*) that we had used in the show on the low berm. This was a very satisfactory design element—they grew slowly to a height of five feet, began to thicken and added the delight of movement when the wind blew. Then in 2017, a most surprising thing happened. They flowered and I remembered hearing about this—it is called gregarious flowering. This is how Bamboo Botanicals, a private collection in British Columbia, describes the process on its website (bamboobotanicals.ca):

Gregarious flowering, the most impressive pattern of bamboo flowering, is when all populations of a particular species flower all at once. For most species of bamboo, this can happen at intervals anywhere between sixty to 130 years. This flowering cycle is genetically pre-programmed into each species.

Once a species reaches its life expectancy, the bamboo will flower and produce seeds. When a bamboo flowers gregariously, it expends a tremendous amount of energy producing flowers and seeds. The mass flowering stresses the bamboo to such an extent that it will die. A particular species can flower and die worldwide, regardless of the geographic location. This means that for the most part, the same plant in North America will flower and die at roughly the same time as the same plant in Asia! Most bamboos are simply divisions taken from a mother plant, unless they're grown from seed. These divisions are re-divided over time and shared across the world. Although the divisions are geographically in different locations, they still carry the same genetic makeup. That means your bamboo can pretty much be older than you!

I never imagined my life span would cross with that of this bamboo.

Facing page clockwise from upper left: The amazing rock formation hidden under decades of debris that Bob and the power washer revealed; early spring blooming Asian twin-leaf (*Plagiorhegma dubium*) on the left and Kitaibel's bittercress (*Cardamine kitaibelii*) on the right; the dainty bottle brush flowers of Vanilla Leaf (*Achlys triphylla*), with woodland peony (*Paeonia obovata*) on the upper left; the *Scroll* sculpture inspired by our trip to Thailand.

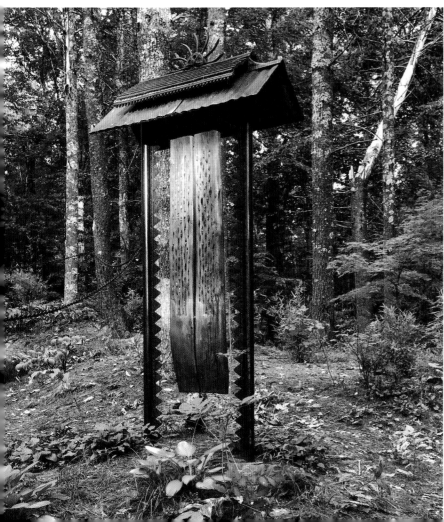
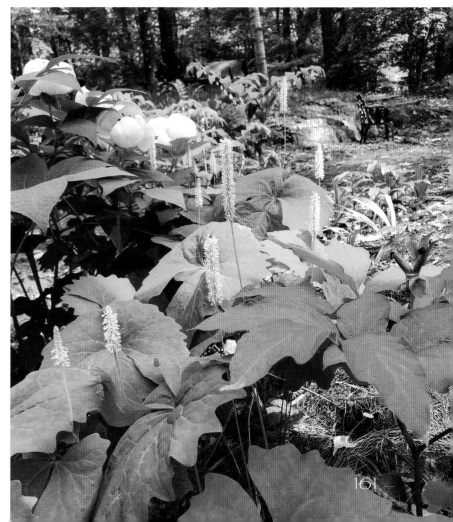

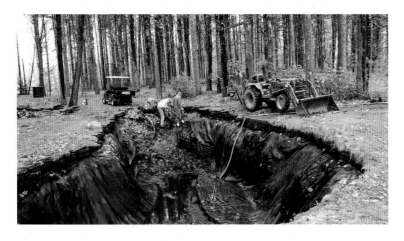

I so liked the bamboo's look that I searched for replacements but it was several years before I could source them as they had to be started from seed. I felt honored to be a part of this unusual phenomenon instead of just reading about it.

Back to the Roji. Making the path to get there involved rerouting the existing path to the Tea House. Instead of the direct path over the little stream, we diverted it away from the Tea House and toward the petrified waterfall traversing three handsome yard-square flat rocks we had been saving for just such an occasion.

The following year we fabricated the Halo, a fifteen-foot circle of two-inch steel pipe strung twelve feet off the ground and wired to four trees. We co-opted the twelve visiting sculpture students of Francine Kontos, Bedrock Gardens' board president for many years and a high school art teacher, to carry the circle down from the welding studio to the Tea House.

In 2017, one of the four trees with a supporting cable blew over and the Halo had to be rejiggered to work with three trees. So many trees in this area have keeled over, the Tea House seems blessed so far.

This page top: Digging the Petit Pond and creating a safety hazard.

Middle: The neighbor's equipment and expertise helped place some large anchor rocks.

Bottom: Draining the Petit Pond to fish out the sculpture the tractor knocked in.

Facing page top: Bob secures the *Halo*'s two half circles we had fabricated offsite to be able to weld them together onsite.

Bottom: Francine's sculpture class walks the *Halo* down to the Tea House.

In 2010, we added a piece of sculpture at the entrance of the path to the Roji: a Thai-inspired roof under which hangs a long, rectangular wooden piece, an agricultural antique from Spain. There are long rows of small sharp stones pounded into it, creating a primitive look, evocative to me of Chinese calligraphy scroll painting.

In 2012, we traveled to Southeast Asia and in Siem Reap, Cambodia, visited an artisan's workshop. Bob and I were both drawn to the stone carvings and took no time to settle on a five-foot-by-one-foot sandstone plinth. It was carved with a larger-than-life Buddha face on all four sides. It arrived in New Hampshire about a year later and we installed it under the *Halo*, a perfect setting. Circles have no beginning and no end, and the *Halo* quietly mediated between the earth, the tree canopy, and the sky.

As an aside, there is a stealth quality to the Tea House area. Most of the year it is a quiet spot. However come November, this place is on fire with thirty Japanese maples turning screaming blood red, orange, and yellow in a parade of succession that lasts three weeks and occurs a month after the sugar maples, viburnum, stewartias, and Korean dogwoods have gone by. It still surprises me.

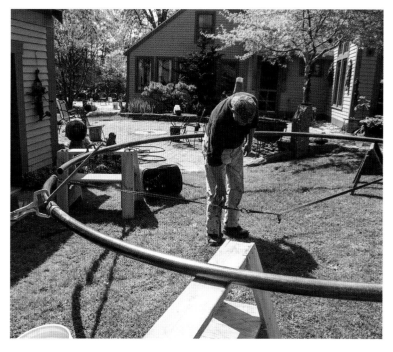

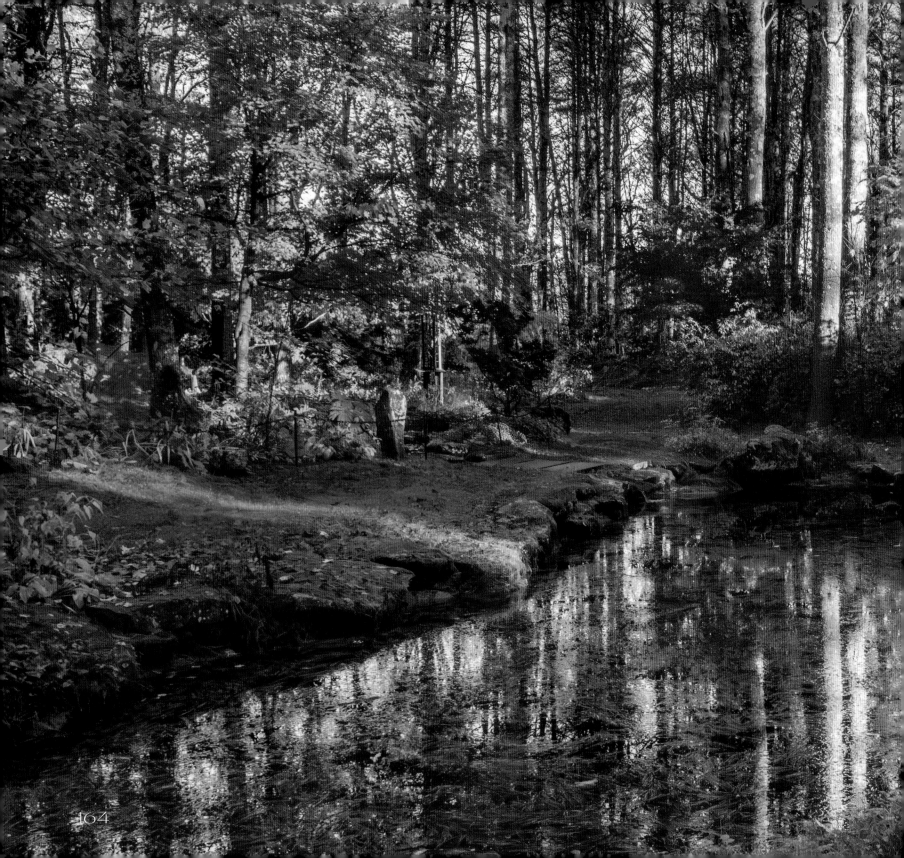

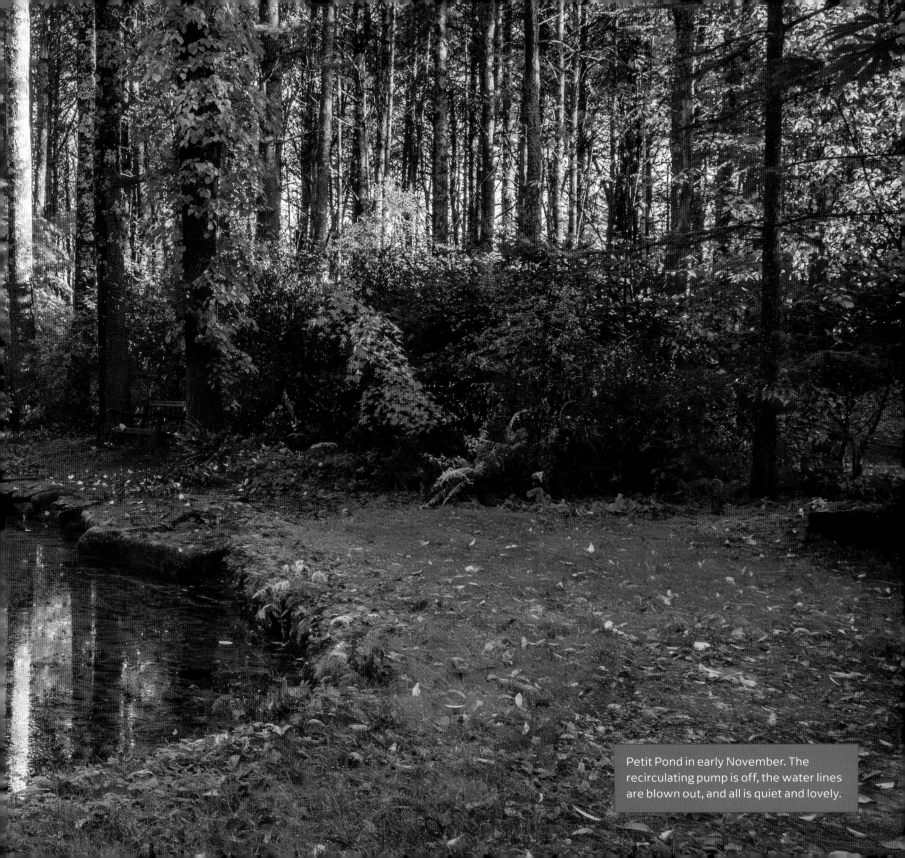

Petit Pond in early November. The recirculating pump is off, the water lines are blown out, and all is quiet and lovely.

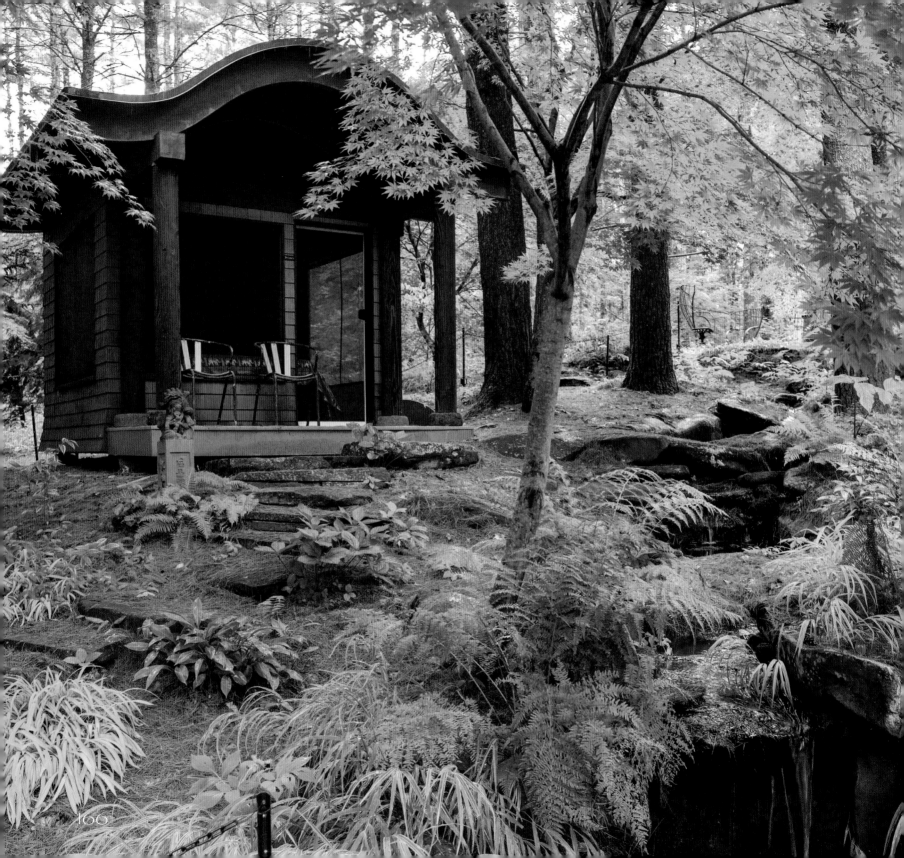

27

Tea House

We took a fabulous seven-week trip to New Zealand one winter, touring the country in a campervan. I loved waking up in the morning, with the back door of the campervan wide open all night so we could luxuriate in the fresh air and tranquil view from our bed with no bugs and no noise. At that moment I knew we needed to make a place to sleep out at home.

Bob grew up in Lexington, Virginia. When he was eleven his family moved to the country, which was a mile walk from school. The move was isolating for him, which was offset one summer by spending most weekends building a cabin with a local preacher. This cabin was located even farther out of town on a large farm Bob's father owned on the Maury River. It was a much cooler spot in the blistering Virginia summers. Bob knew about sleeping out and I was just catching up.

It had been decades since Bob built anything out of wood so he practiced his carpentry skills by making a guinea coop, which sits behind the barn across from the Wave. One of the roof ventilators in my collection had a blade that looked like a chicken's tail so I riveted a chicken head and body to it, painted it, and mounted it on the roof.

Next Bob started on the Tea House. We had a section of a deck that had collapsed under snow one winter. He began by hauling it to Petit Pond, placing it where we might want to site the Tea House, and occasionally moving it around. After placing two swivel farm chairs on the deck, it became a destination point for two or three years. Eventually we got around to the next step. I estimate most of our construction projects

take a couple of years, but if we add the contemplation period, I would give this process a five-year time frame.

We built a model and consulted with an old friend and architect who created scaled drawings. We then hired a seasoned carpenter from nearby Nottingham, New Hampshire, to fashion the curved beams and work with and mentor Bob.

The eight-foot-by-twelve-foot footprint allowed for a bed inside and a three-foot deck out front to sit on. We wanted a queen-size mattress with space enough on either side to navigate. Our big mistake was thinking it would be just fine to have a six-inch clearing at the foot of the bed. By now I have worked out a way to slither past it without falling through the screen. We went through the trouble of installing a Murphy bed because I imagined using the space as a screen house by folding up the bed as well as adding a table and a couple of chairs so we could read the paper bug-free. We don't sit outside and read anywhere. I don't know what I was thinking. Now we only put the bed up for winter.

Facing page: The cascading water course flowing in front of the Tea House muffles the sound of traffic.

This page: The *Spirit House* sculpture was inspired by our trip to Thailand.

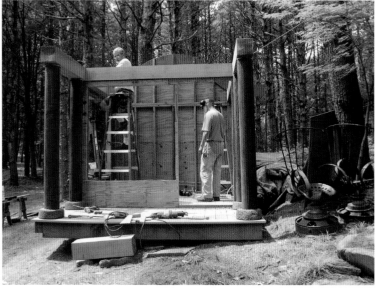

Two of the footings were right on bedrock so Bob had to drill holes into it and epoxy rebar sections to anchor the concrete. The area in the middle of the floor plan was thankfully easy digging. Bob had his heart set on including a crypt—possibly for our cremains—under the Tea House, accessed by a trap door in the floor. You can hear its metal lid faintly rattle.

The curved beams were fabricated by gluing several layers of exterior plywood together in a vacuum vise; the outer layers are mahogany veneer. I had collected some salvaged beadboard from a building being renovated next to my office in Exeter, and they became the ceiling. The boards turned a beautiful butterscotch tone when they were planed, which established the color scheme of the structure and is incidentally the exact hue of the pine needles blanketing the ground in fall.

Bob sided the building with cedar shakes, engineering a slight flare on the bottom. The columns supporting the roof on the deck portion were left over from a project I scratched. We placed them on top of stone grinding wheels as I had seen in books on Japanese gardens. We added a cabinet with a breadboard-like pullout table on each side of the bed and finally we clad the interior walls with cork tiles. We tied into the electricity nearby, allowing us lights and more importantly a heating blanket.

Top: Dylan and Bob wonder which of the pines whose roots we disturbed was most likely to fall on the Tea House.

Bottom: Bob and the carpenter prepare to install the arched roof trusses.

Facing page: The *Halo* hangs above the four-sided Buddha, with a stem of the bamboo hedge on the upper left.

169

Custom screens made the Tea House bug-proof. The door, however, was a puzzle until someone mentioned a retractable screen door like a vertical window shade, which pulls shut and snaps open. Sleeping out one evening years later, it snapped open three times before we retreated to the house at 2 a.m., allowing the dexterous fingers of the recalcitrant raccoon to win.

The Tea House was completed in November 2009. The water pump for the adjacent waterfalls had been turned off for the winter but we snagged as many nights as we could stand waking up to ever-colder mornings. When we returned in the spring to sleep out, we turned the water on, and I remember waking up to the disconcerting feeling that someone had left the bathtub running and it was flooding our house.

The first year we slept out forty nights; now we go out whenever the mood strikes us, probably averaging one night a week. We have watched phoebes build nests under the eaves, two on either side, and feed the babies; seen an adolescent moose trotting along a path toward the manure pile; had many sightings of our resident hawk; listened to the weird, loud screeching of coyotes and owls, and been woken up by rainstorms.

Left: Looking across the Tea House deck. Note the millstones supporting the columns.

Right: An antique washbasin or tsukubai used to purify oneself before entering a sacred place.

Facing page: One of several waterfalls with spring blooming pink primroses (*Primula japonica*) and the variegated leaves of Japanese clethra (*Clethra barbinervis* 'Takeda Nishiki') on the left.

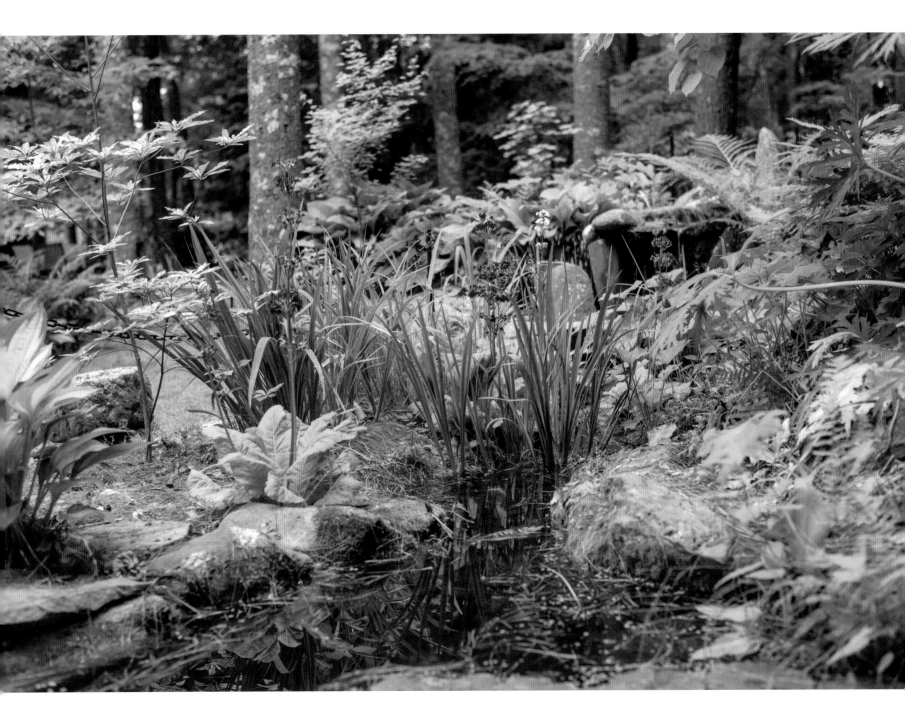

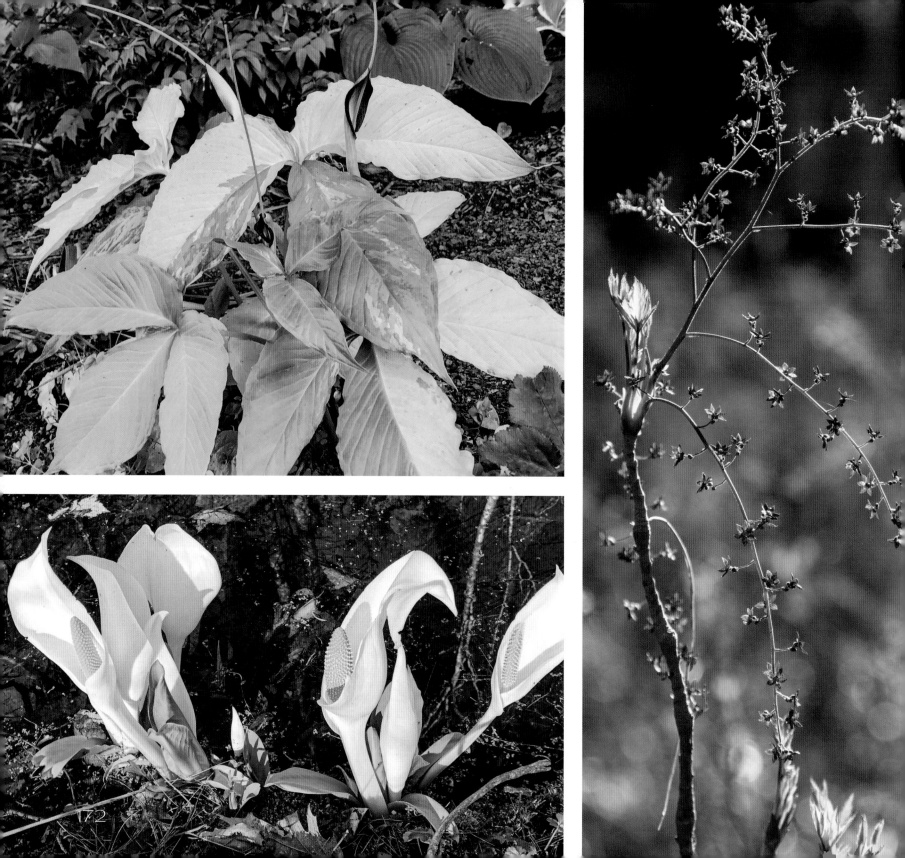

This is a collection of unusual blooming plants, some located around the Tea House and others elsewhere in the garden. Shown clockwise from upper left: a Jack-in-the-pulpit cousin from Japan (*Pinellia tripartita*), with its exuberant but diminutive flower spikes and its maroon interior; delicate maroon flowers of yellowroot (*Xanthorihiza simplicissima*); purple dragon (*Pinellia x cortita* 'Purple Dragon') with its wild spathe; the strappy blooms and mottled foliage of an Asian mayapple (*Podophyllum delavayi*); seed heads of Allium *pskemense*; Farges's cobra lily (*Arisaema fargesii*) dressed to kill; and the elegant blooms of the Asian skunk cabbage (*Lysichiton camtschatcensis*).

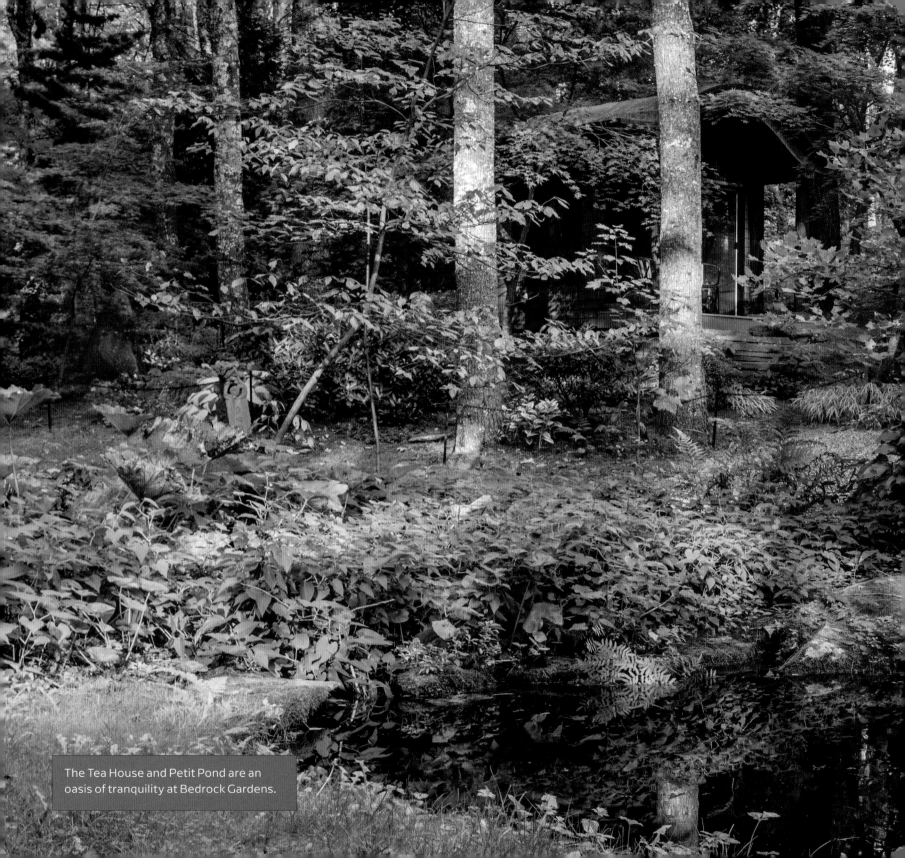

The Tea House and Petit Pond are an oasis of tranquility at Bedrock Gardens.

28

THE FERNERY AND THE STUMPERY

I have been attracted to stumps—and rocks and plants—for as long as I can remember.

The moss-drenched trees and stumps in the Hoh Rain Forest on the Olympic Peninsula in Washington would make anyone weak-kneed, but I am also partial to the large, tipped-over, dendrite-like ones around New Hampshire. And we even have a couple tucked away here at Bedrock Gardens. Dried in the sun they become striking sculptures, and in the shade they gradually become their own ecosystem sprouting ferns, mosses, saplings, and spider webs. I even asked our go-to guy, Ron Cote, if he could harvest one for me. He said he had no way to access the ones I wanted (on someone else's property) without making a big mess.

I had seen a large stumpery in a children's garden in Invercargill, New Zealand, and the idea stuck with me. Luckily in 2020, an opportunity arose to create a smaller stump-themed event here at the garden. The process of building the parking lot created many useful raw materials. I already mentioned repurposing the blasted rocks to build the Belvedere, but I was also left with a mountain of fill and a pile of stumps.

The area between the Welcome Court and the Nexus was a perfect shady wooded site for one of our own.

I selected a location that was adjacent to a service road for easy access. Constructing the foundation berm was remarkably easy. I let the piles of dirt settle for a few months. Our first effort to soften the berm was to add several mature rhododendrons that we harvested in full flower from Shrubaria. We then forked over the stumps with the tractor and dug a shallow bowl with the backhoe to set them in. We added a few rocks for interest, followed by Hands in Dirt volunteers and others who planted a collection of thirty different species of ferns (twenty-four of each in 4-inch pots). Since the fern berm is predominantly in the shade, we only needed to water it the first few months. To make it look more lived in, we added donations of mosses and pine needles. Now, after four years, our Stumpery and Fernery looks established. The area requires some weeding, and I top it up yearly with fresh stumps as the old ones return to the soil. I like dedicated plant shopping, and the Fernery provides a fun focus to collect new varieties in my travels. In our educational workshops, we describe the Fernery as a habitat for wildlife and so it is. I made the mistake of planting a great number of adorable miniature bulbs on the bank and they became a smorgasbord for chipmunks. One only needs to do that once.

Above: The *Gnome*, whose cousin lives at the Arnold Arboretum in Boston, has a face made from a birdcage seed feeder.

Facing page: The Fernery is a collection of fill, stumps, mosses and ferns, and home to many creatures.

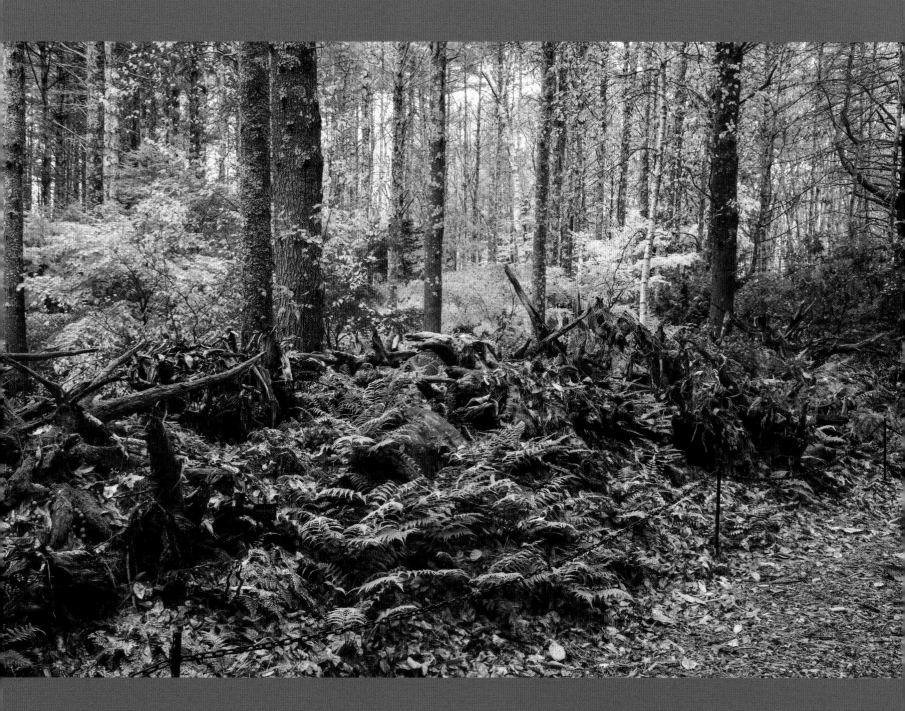

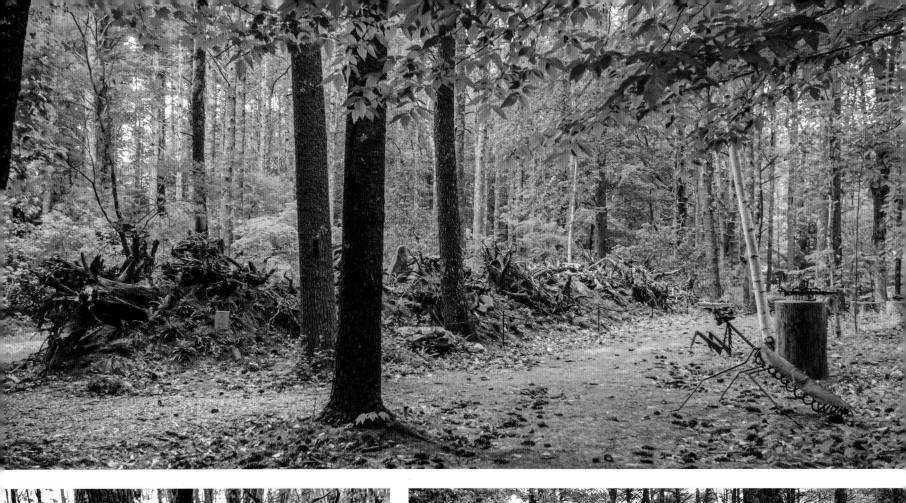

Facing page top: The stumpery grows in.

Facing page lower left: The elegant emerging stems of a maidenhair fern (*Adiantum pedatum*) is one of the thirty varieties growing in the fernery.

Facing page lower right: Bob transplants a full-grown, blooming rhododendron on the berm.

A wonderful quality of a fern berm is its aspect. It lies like a painting on an easel or a living wall, both of which invite close inspection of the variety of plants as well as a chance to slow down and observe.

On the opposite side of the path, parallel to the fern berm, is a row of bug sculptures I made, during my "bug phase." I gathered them up and placed them on stumps at the eye level of small children, to provide another visual event to capture one's attention on this path as it leads back to the Welcome Court. I call it Bug Alley.

It is fun to have one of everything and our Fernery and Stumpery are felicitous additions to my collection of landscape events. A pleasant side effect of the fern berm is that it visually screens the Welcome Court from the seating area perched uphill from the Tea House.

Top right: The *Gnome Home* is a hollow sycamore tree cut down by the utility company. It just needed a roof.

Bottom: Planting the berm.

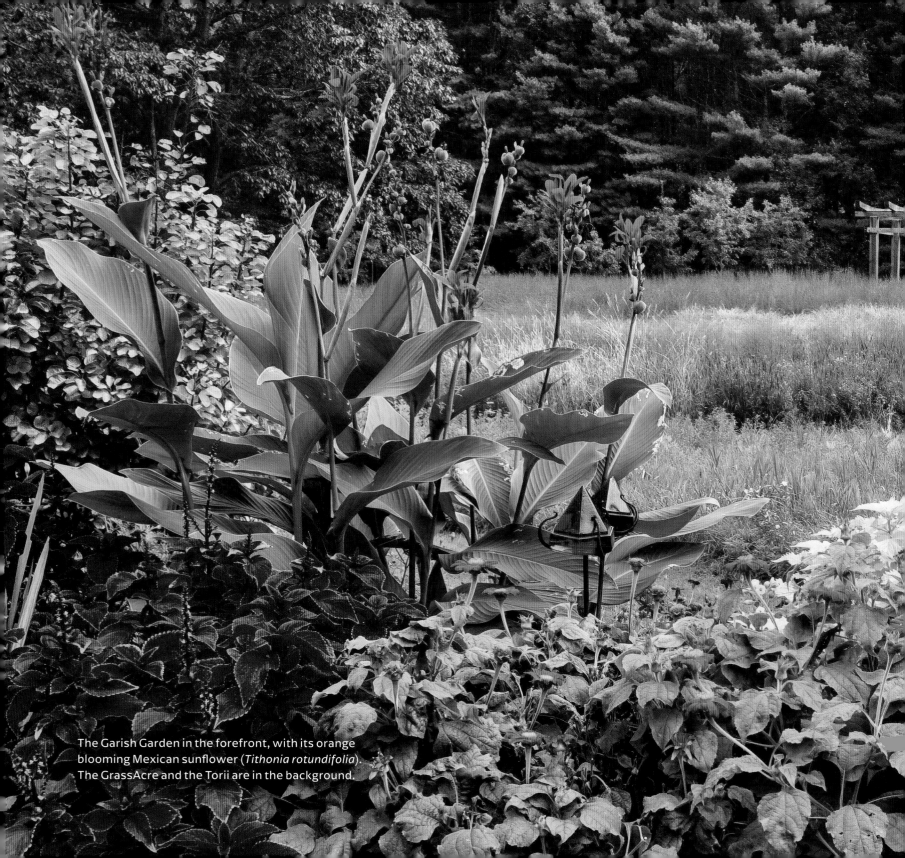

The Garish Garden in the forefront, with its orange blooming Mexican sunflower (*Tithonia rotundifolia*). The GrassAcre and the Torii are in the background.

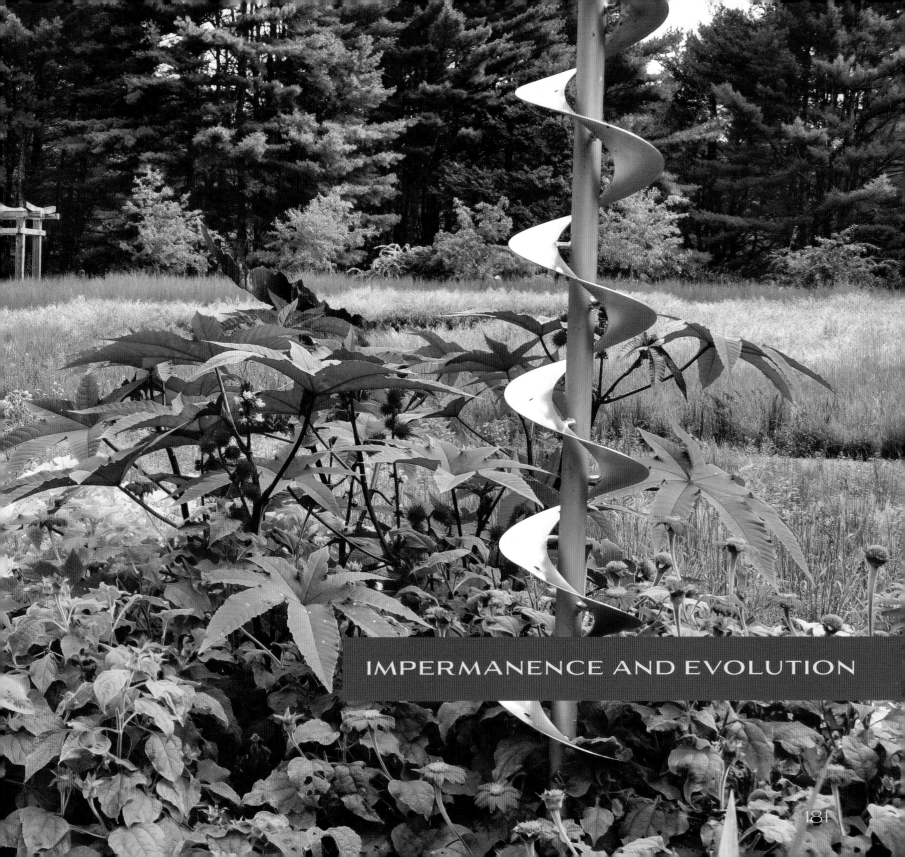
IMPERMANENCE AND EVOLUTION

Repairing things

One thing that's really annoying about working forty years on a property is that the time comes when you must repair things you made yourself. One should not live that long.

The Rustic Arbor, constructed of maple saplings, was designed to look like a kid's line drawing of a house with a roof, walls, and windows. It was located next to the Spiral Garden in a break in the stone wall, which our neighbors graciously permitted us to breach. After five or so years, the wood deteriorated and fell apart. After I heard someone say, "Black locust lasts one day longer than a rock," we boldly rebuilt the arbor in locust. After about ten years, this structure twisted out of alignment, and when a large limb from the overhanging maple fell on it, we took it down.

We made the third iteration from steel secured by concrete footings. In 2019, we removed that one and filled in the gap in the stone wall as the second-generation neighbor was not so keen on the permission granted to us by the prior generation. In 2020, we hoisted a six-foot-wide, gold-painted metal ring eighteen feet in the air. It hangs between the flanking trees and acts as a focal point when sitting nine hundred feet away on the thrones at the Termi. When I think on it now, there is a certain symmetry between this golden circle hanging vertically here and the Halo, which hangs horizontally at the Tea House, and the Ring at the Nexus.

This reconfiguration is minor compared to the Wiggle Waggle, which began its life looking perfect. Over a number of years, the lower section started to look like a crooked

Above: The phases of the Rustic Arbor. The top arbor is made of maple. The one made out of black locust is missing. The bottom left structure is made from steel with a concrete footing. The bottom right shows the structure now gone with a golden ring marking the end of the axis extending from the Termi.

Top: Replacing the beams on the Landing by welding square pipes onto the bucket of the tractor to create a lift.

Bottom: Bob deep in contemplation.

set of teeth with the top stones tipping down toward the water and occasionally slipping in. To repair this Bob drained the water course, removed the rocks, peeled back the liner, dug a large deep trench into which he poured six inches of gravel, tamped it down, leveled the surface with stone dust, laid two courses of cement block, pounded rebar into the holes, welded a rebar jail, filled the holes with gravel, reset the liner, and rebuilt the block wall, this time mortaring square coping on top. All this for each side.

It took six more years for the upper section to start caving in and need repair. Now it again looks perfect. We even have grass growing right up to the edge after it was damaged by years of rebuilding.

In the latest round of repairs, the liner appears to have sprung a leak. We fixed this by digging a four-foot-deep trench from the barn to the Spring House to bury a water line that tops up the water year-round, protecting the integrity of the walls.

Built in 1992, the Torii was made from Douglas fir planted in the ground. By 2016 the structure was starting to tilt and a couple of the top beams were rotting so we decided to replace it for safety reasons. This time we fabricated metal brackets and anchored them in metal garbage cans filled with concrete. This allowed the uprights to avoid contact with soil. Amazingly, the same contractor who supervised building the initial Torii was still around. He supported our wish to overbuild this version, which included copper flashing on the tops of the beams. Bob invested in

a chainsaw guide, a kind of jig that allowed him to cut the swoops himself, and we found a wood carver to scribe our names again.

In 2020, the water level in Petit Pond seemed to be dropping; we were already supplementing it but things were changing. When we closed for the season, Bob decided to drain it. A few feet down he found a stob (a broken branch) sticking perpendicularly into the liner like an arrow. It was now November and getting cold. He was able to patch that hole but was not convinced it was responsible for so much water loss. So he continued to lower the water down ten feet to the bottom of the pond, where there was another branch sticking directly into the bottom of the pond. I was now down with him in the cold muck in the deep shade of afternoon as we pulled the branch out. With my finger in the hole I tried to pull the liner up from the bottom to be able to dry it long enough to paint on a layer of glue. Bob operated the hair dryer until it shorted out, so then we both started to blow on the hole until finally accepting we had done the best we could. We slapped on the glue and patch. It was not an encouraging result, but we weighted it down with some muck and I told myself that the gravity of a full pond would surely help. Our son suggested gunite should be the next fix.

When you live on a property for a long time, you count on the garden and its features needing a facelift every twenty-plus years. It is the oddest feeling to move from nurturing and encouraging plants to wishing they would stop

Left: Bob and Spencer erecting the scaffold to hang the *Great Balls of Fire* mobile in Shrubaria.

growing or even shrink back into proper scale. It is sometimes a relief to cut them out and acquire some needed breathing space. A maturing garden needs constant evaluation and judicious editing as it slips past that perfect point you didn't even realize you should have noted.

Garden maintenance

Making and keeping a garden offers so many ways to spend time. Five minutes allow for quick deadheading or cutting a few tomato hornworms in half. In two-and-a-half hours I have time to mow most of the garden. In a day I can plant a thousand bulbs. When my hip (I've since had both replaced) made bending at the knees difficult, I switched to gardening on all fours. It is surprisingly efficient. I scoop up leaves in the beds with my arms, causing less damage to plants and no fussing with rakes; I never have liked rakes. I developed an efficient method of spreading manure provided you are not a neatnik. I dump a pile near a bed, bend over and hurl it between my legs backward. Then I crawl around and distribute it more evenly. I get a rhythm going that makes me feel like a manure-spreading machine.

Leaf collecting is accomplished with a blower, which corrals the leaves into piles that I then attack with my mower, going around and around until I am left with a cloud of flakes. I feel like I am sitting on my mount and rounding up cattle. In the small areas, I use my mower to blow the leaves into the

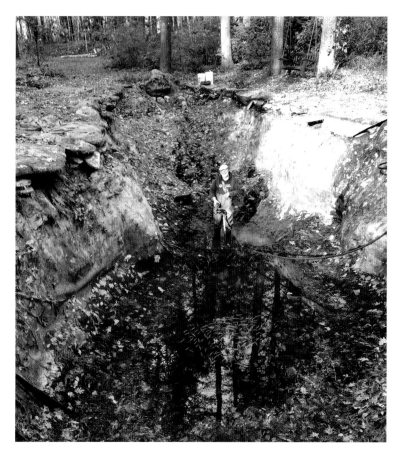

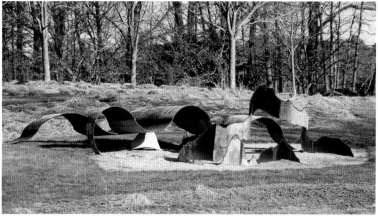

Top: Repairing puncture holes in the lining of the Petit Pond. The Golden Orfe fish are circling in the middle of the remaining water. In 2023, for safety reasons after the garden became public, the pond was filled to a depth of 3 feet.

Bottom: Recurring wind damage to *Syncopeaks*.

beds to decompose. I have always been a practical gardener and do not as a rule edge, stake, spray for bugs or fungus, collect grass clippings, or keep a vegetable garden. But now that we are open to the public we have a cutting garden at the Welcome Court to make bouquets for our visitors.

I rarely use fertilizer. Paul Rogers, a Radcliffe teacher, said if you are going to add anything to your garden, use lime to modify the effects of acid in rain and granite and I have done that sporadically. I used to top-dress the beds yearly with manure, but now I do it as I have the material and time. I don't want to encourage too rampant growth. Since 2020, I have begun mulching with arborist wood chips following the persuasive research of Linda Chalker-Scott.

I love mowing. I have found the least time-consuming activity that nets the greatest visual effect is maintaining the grass. On the mower I can survey the garden broadly as well as inspect it close-up. Mowing allows me to see all parts of the garden at least once a week. It smells good and gives me a chance to sit down and relax while providing a sense of accomplishment and deep aesthetic pleasure.

In 2004, I graduated to a zero-turn mower with a forty-eight-inch deck, from a conventional mower that did not go as fast or maneuver as nimbly but also did not get stuck in the slightest wet spot.

The grass that, for the most part, began its life as a mown field now includes waves of flowering dandelion,

Top: Remaking the *Great Stakes* sculpture, thanks to Dan Tauber for his Eagle Scout project that impressed us all.

Bottom: I dug up an overly rambunctious shrub paper mulberry (*Broussonetia papyrifera* 'Golden Shadow') and put it on the roof of the golf cart. Notice the impressive dangling yellow roots.

veronica, clover, plantain, and hawkweed. During summer dormancy the brown patches serve as a kind of X-ray of the soil's depth. Bedrock shows itself as the skeleton on which the garden rests. One day in 2019 my mower stopped in the field. To my horror it was out of oil and the engine had seized. Since there wasn't time to wait for the engine to be rebuilt, we purchased another zero-turn mower but with a fifty-four-inch deck. Having a mower out of commission has been one of my ongoing fears. It is a great comfort now to have the rebuilt mower as a backup. Something is always breaking on our equipment, and Bob keeps an inventory of front wheels, cotter pins, springs, blades, and belts, and even had an extra mower deck for a while. Sometimes, years later, the missing part turns up in the grass.

Grass, leaves, and sticks get jammed in a thick wad under the deck of the mower, sometimes dislodging the belt. It occasionally smokes and once caught on fire. Our son was mowing on that occasion, with an ankle that had just come out of a cast. He was acres away from the house, yelled, urinated on the fire, and started hopping to the house. Luckily I heard him and all turned out fine.

This property is large enough that I always have something to prune. I am rarely without my clippers, which fit in a side pocket of my pants. Like mowing, pruning is a deeply satisfying activity. I edit branches to suit my own eye. I aim to reveal a structure that not only opens a tree or

Top: Starting over—beams arriving to entirely remake the Torii.
Bottom: Carving our names on the beams, again.

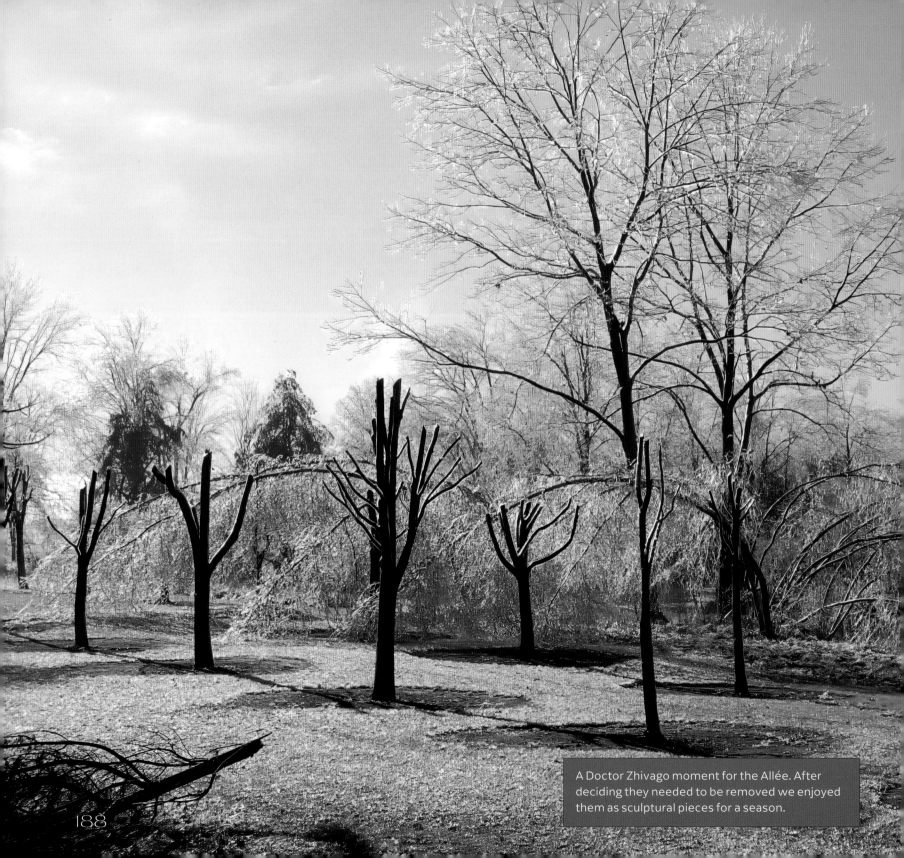

A Doctor Zhivago moment for the Allée. After deciding they needed to be removed we enjoyed them as sculptural pieces for a season.

Impermanence

A garden helps soften loss with its constancy, indifference, and its gratuitous beauty. There is beauty in death and dying. Clockwise from top: The severed tops of the trees in the Allée enjoy another season of being debutantes; a dead tree painted cobalt blue is accented with emerging fungi; wrapping a special tree as we observed in Thailand.

shrub to greater air circulation but also suits me aesthetically. This can mean shaping a plant into a round form, as those in the All You Need Is Balls garden. Or cutting off the leader of a crab apple to encourage a free-form shape of a dancer, which is silhouetted against the clapboards of the shed. I have made large lollypops out of deer-grazed arborvitae and sat in the bucket of our tractor to lop off the top five feet of another arborvitae that was outgrowing its spot. I find a clipped round form interspersed in the borders creates a visual sense of order. Maroon and golden barberry (*Berberis thunbergii f. atropurpurea* and 'Aurea'), Goldmound spirea (*Spiraea japonica*), and Vardar Valley boxwood (*Buxus sempervirens* 'Vardar Valley') lend themselves to this treatment.

Another pruning rite of spring is snapping off conifers' new candles. By limiting the new shoots, the trees' expansion is slowed. I use clippers or my fingers to break these off when they are ripe enough to snap, and leave them scattered on the ground like petals. If done all at once this could be a time-consuming chore, but I take a relaxed approach

and do it as I feel the urge. I even clip midsummer's growth if I have missed some.

My favorite tools are Felco clippers for small diameter branches and a reciprocating battery-operated saw for larger ones. The saw sits easily in the crotch of a tree while I am climbing up and miraculously falls flat on the ground when I toss it down. Bob removes limbs out of my reach with a chainsaw mounted on the end of a long pole. I now have a battery-powered chainsaw that works so effortlessly I have to remind myself it is not a toy and could cut off my leg.

I train my trees from very early on. It is a coming-of-age moment when I can climb into a tree I have been working on since it was a foot tall. The paperbark maple (*Acer griseum*) on the south side of the house arrived in the mail ten inches tall from Carroll Gardens Nursery in Maryland. I planted it right where it is today with the hope it would provide summer shade for the house, as well as what was then a deck and now is a patio. It has an opposite, as opposed to alternate, branching pattern, which has proven harder to artfully shape. Removing one half of an opposite pair initially creates a zig-zag pattern until further growth softens the edges. The beauty of this tree—along with others, like the seven sons tree (*Heptacodium miconioides*), Japanese maples, and stewartia (*Stewartia pseudocamellia*)—depends on how well it is pruned.

Right top: This paperbark maple (*Acer griseum*) was planted as a ten-inch whip.

Right bottom: I'm clipping a shrub that had grown too big to reach from a ladder.

Facing page: A hundred-year-old sugar maple keeled over and slumped gently on the barn.

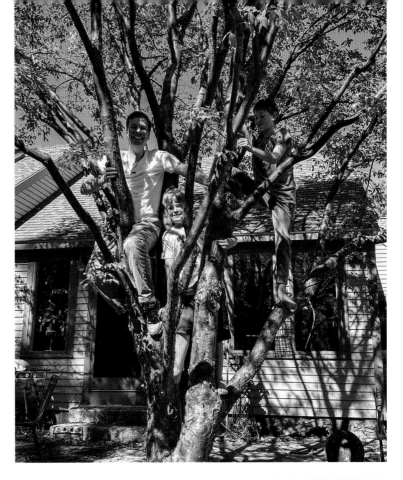

WIPs

The patio by our house took two years to complete. Since we did virtually all the work ourselves, it was slow going. We both worked full-time and were raising a family. As a result, we have become accustomed to having several unfinished projects at any one time. We call them WIPs (Works In Progress).

In my mind's eye I saw these projects as finished, and the incremental steps as just coloring in a drawing that is essentially done. Sometimes this protracted construction method allowed for important revisions as well as time for more money to pool. Occasionally it provided time to recover from an injury, like when Bob lost the tip of his finger moving a large rock. There were also a few hernia operations here and there, a broken rib, a spinal surgery, a couple of hip replacements. At one point the projects proliferated so quickly that I limited Bob to three WIPs at any one time.

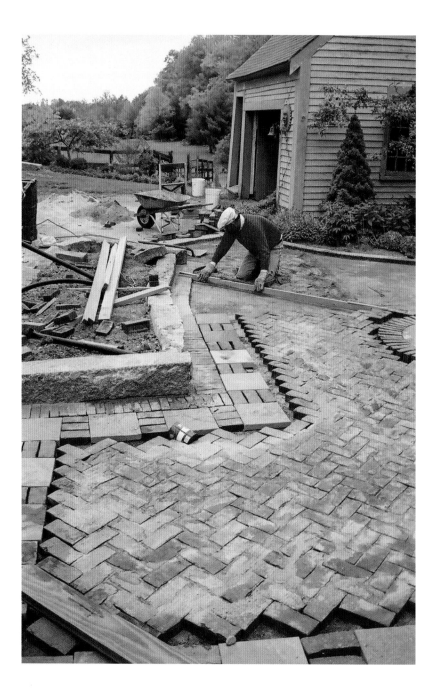

Above: The kids pull up the driveway to make a new patio.

Right: Bob lays the herringbone brick pattern with the paddock in the background.

Facing page: Three WIPs—the CopTop getting a waterproof membrane before the tin roof is installed, the Wiggle Waggle in process of being completely remade, and the trench dug for a Belgian block edging on the left that is so old it is growing grass.

There is no gardening without humility, an assiduous willingness to learn, and a cheerful readiness to confess you were mistaken. Nature is continually sending even its oldest scholars to the bottom of the class for some egregious blunder.

—*Alfred Austin, English poet laureate, in* The Garden That I Love, *published in 1894*

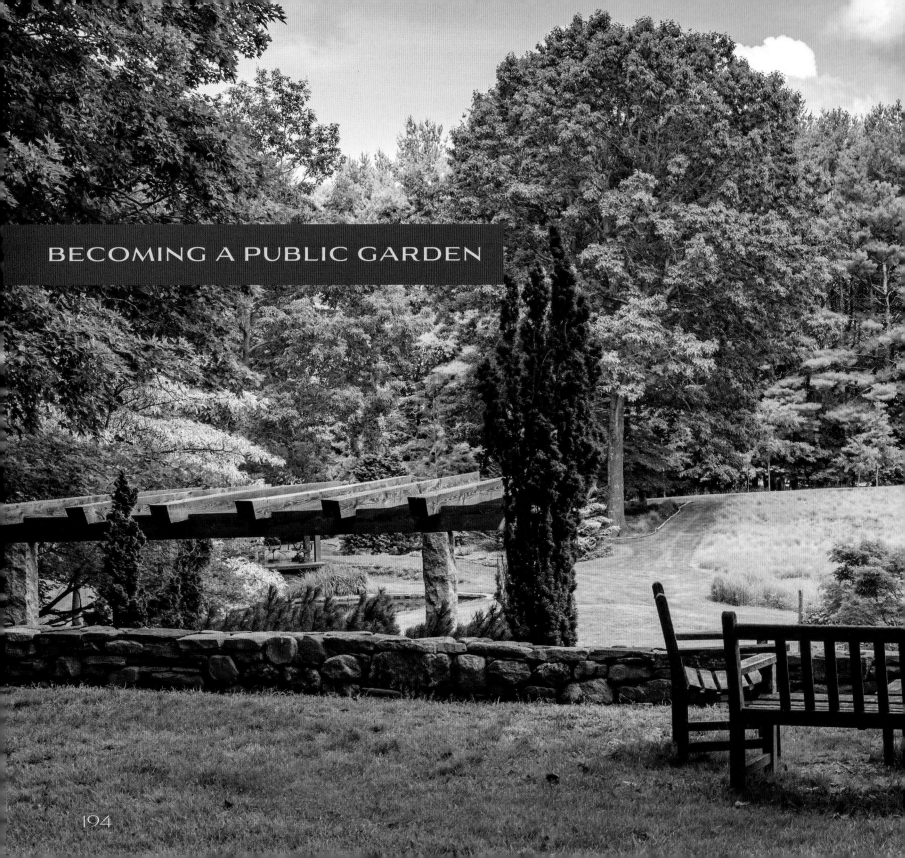

BECOMING A PUBLIC GARDEN

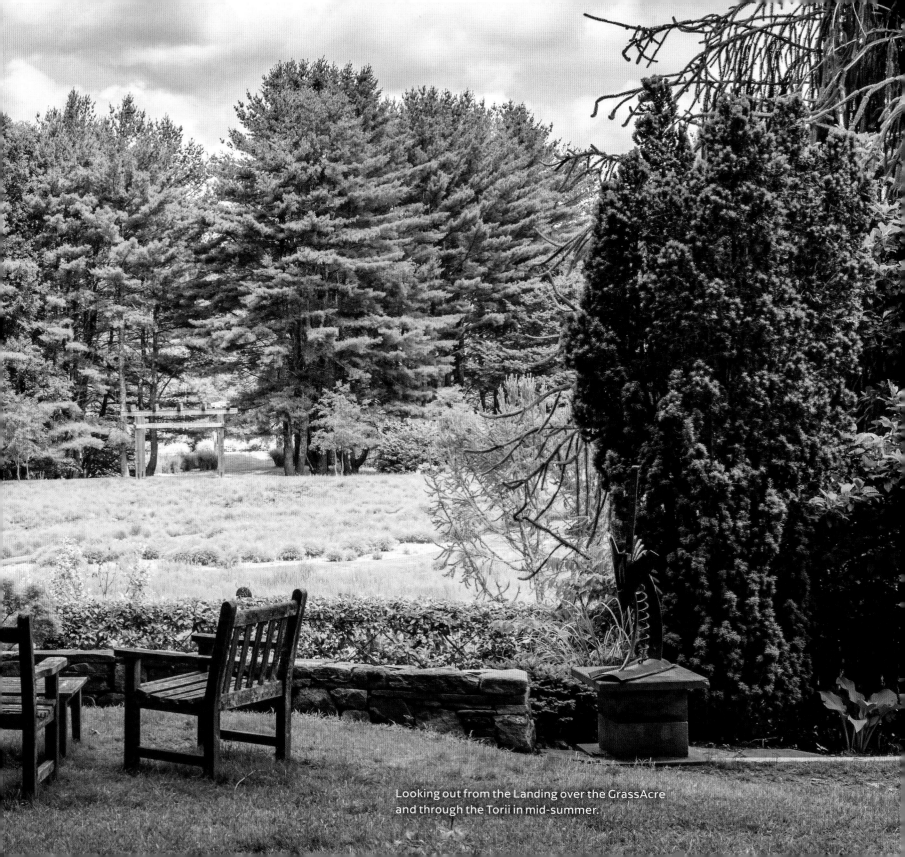
Looking out from the Landing over the GrassAcre and through the Torii in mid-summer.

LOOKING TO THE FUTURE

In 2010, we began to get serious about creating a succession plan for the garden. We had created this living work of art that could be viewed as either a treasure or an albatross—a treasure for all our visitors who visit again and again, and an albatross for our kids who love and appreciate the property but have their own passions.

Who would buy Bedrock Gardens after we're gone? Any person seriously interested in horticulture, garden design, or art would hardly want to buy a ready-made work. A person not wanting to maintain a garden could clear it all away, let it revert to the wild or maybe have a plant sale. With all its road frontage the property has considerable potential to be developed. That would break our hearts, since the land is an important piece of a greenway stretching for two hundred acres. We talked longingly about having a sugar daddy or mama and naming the gardens after him or her. Coming back to our senses, we turned to the long tried-and-true grassroots approach, building little by little from the ground up, gathering folks together who were drawn to the garden and wanted it to have a future beyond our lives. This approach felt right but was achingly slow.

In January 2010, we invited a group of interested folks to meet at the Exeter Library. We decided to meet monthly and eventually gave ourselves the name Friends of Bedrock Gardens. In 2013, on our fourth attempt, we were awarded nonprofit status. Three years later, in 2016, I had the idea of calling a summit of professionals in the world of public gardens to help us determine if our goal to go from a private garden to a public one had a chance. With the help of a $10,000 grant from the New Hampshire Charitable Foundation, we invited six professionals to spend a weekend in June at the garden. All willingly gave up prime summertime to essentially volunteer their time. Gardeners are a generous lot. We put them up in a local hotel where we hoped they would have more time to talk among themselves in the evening.

The primary person to lead the summit was Lee Buttala, whom I had never met but cold-called on the recommendation of a West Coast landscape architect. As the former preservation program manager for the Garden Conservancy in Cold Spring, New York, Lee took very little convincing. He also generously offered to write up the results—he wrote the Foreword to this book as well.

The assessment team included: Lee, the director of marketing communications for the Berkshire Botanical Garden in Stockbridge, Massachusetts; Cindy Brockway, program director for cultural resources at The Trustees of Reservations in Boston; Bill Cullina, the executive director of the Coastal Maine Botanical Gardens in Boothbay, Maine; Michael Dosmann, the curator of living collections at the Arnold Arboretum in Boston; Jeff Lynch, grounds manager at Chanticleer in Wayne, Pennsylvania; and Joann Vieira, director of horticulture at Tower Hill Botanic Garden

Facing page: Members of the 2016 Summit at the Termi, a group of public garden professionals who helped guide us. From the left are Jeff Lynch, Joann Vieira, Lee Buttala, Bill Cullina, Cindy Brockway, me, and Michael Dosmann.

in Boylston, Massachusetts. After an intense day and a half—including a tour, meeting with interested parties, meals and presentations—the group's conclusion was positive. While many gardens have the draw of art collections, plant collections, and innovative design, there are few that have all three, which, along with our fortunate location between Boston and Portland, Maine, on a road leading to the Lakes Region, made the group hopeful for us. Bill strongly encouraged me when I bemoaned, "Where will we get the money and board talent, and how do we get from here to there?" He predicted in 2016 that the garden would eventually attract 10,000 visitors a year. Five years later in 2021, we had 14,000 visitors.

In 2017, we were fortunate to hire John Forti as our first executive director. He had spent his professional life working for nonprofits, had extensive knowledge and passion for plants and horticulture, was a gifted teacher, and had deep roots in the New Hampshire Seacoast area. He was the perfect welcoming face to a public garden.

In 2019, with help from John, our capable board, and some outstanding donors, we were able to construct a proper Welcome Court with bathrooms, an admission building, a gift shop, and a ninety-eight-car parking lot.

I have been gobsmacked by the critical part these precious people played in the unfolding drama of this garden. We could not exist without them.

Bob and I, in 2023, gifting our garden to the Friends of Bedrock Gardens.

In addition to being an oasis of horticulture, art, and inspiration, Bedrock Gardens in its constancy is the keeper of memories. The land holds the memory of glaciers thousands of years ago and the DNA of the people who lived on it, which the trees, stone walls, barbed wire, bottle dump, and old farm equipment still testify to today. Gardens create a space inside each of us that expands our hearts and brings out the best in us. Here folks meet up with their far-flung families to have a picnic, visit the spot where they proposed marriage, or spend time sitting on a bench dedicated to a lost loved one. Bedrock Gardens is a calm constant touchstone that welcomes everyone and keeps them company through the stages of their lives.

It is our profound pleasure to bequeath this property, whose dedicated stewards we have been honored to be, and entrust its garden to the hands of those who will continue to cradle it as a crucible for experiences that move the spirit.

I remember saying to Bob that I imagined it would take us ten years to sort out becoming a public garden and if unsuccessful it would not have been a dull way to spend a decade. We were also bound to have many adventures and meet some wonderful people along the way, and we have done both.

On June 3, 2023, we deeded twenty-five of the garden's thirty acres to the Friends of Bedrock Gardens with the understanding that I will remain the horticultural and artistic director until I run out of steam or fall off my perch. We couldn't be more pleased.

I want to share an unsigned letter that was handed to a volunteer and then given to me in 2018—see next page. I always choke up when I read this letter aloud. It is such a gift to Bob and me. It came unbidden and goes unthanked. I feel it captures the perfect combination of appreciation for beauty; acknowledgement that we are all just passing through, that we only borrow a piece of land; and recognition that we all need places of solace and joy. I would dedicate the book to the letter's author if I had not already dedicated it to Bob. Then again, maybe the dedication should be to the many visitors who see the garden as their refuge and whom I desperately hope will gently shepherd it into a long future.

Dear Jill and Bob—

This is the 3rd time I've had the chance to experience this gorgeous oasis you have created. I was very pleased to be able to attend 2 of your concert events last year—the 1st of which being the 1st time I had "discovered" Bedrock Gardens.

Over the past year I have frequently driven by this spot, travelling down Rte. 125, usually on my way to visit my elderly parents and bring my dad to chemo treatments for stage IV lung cancer. Many times last winter, during that difficult emotional time, I would glance over towards your property, picturing this garden as it looked in its summer splendor. Knowing that such a place exists and that I can return to it in memory, even in the depth of literal winter and my own "winter of the soul," was uplifting and restorative.

All my life by nature I have been an "ocean" person and have sought walks on the beach as a calming restorative in times of stress or emotional pain. The Book of Revelation says that in the "new heaven and earth" there will be no more sea and that always made me sad, but we got our start in a garden and it is to a garden we all will, and ultimately long to, return.

Thank you for creating this sacred space, for sharing it, and for giving us a glimpse of eternity–

VOLUNTEERS

I am not much of a joiner, instead preferring the company of one or two people, and have never volunteered any significant time to an organization. So Bob and I felt somewhat incredulous that folks asked if they could help us. At first they asked to help in the garden. A group of several women, some master gardeners, came for two hours twice a month to help with maintenance. At that time in 2016, we were open one weekend a month, and since I was still working I left them a list. It felt like fairies had dusted the property when I got home.

This group has swelled to about eight regulars, some of whom have been coming since the beginning. In 2020, when the garden was open an average of five days a week these regulars, called Hands in Dirt, suggested they come every week. By this time some leaders had emerged and I made up T-shirts proclaiming them the Dirty Docents and saying, "Want the dirt, just ask us." The number of tasks they can accomplish in two hours is astounding. I fear overloading them, and they are done frequently before the two hours are up. I am deeply in their debt. Their skill, reliability, good cheer, work ethic, and love of the garden is a great comfort to me. They are the invaluable life blood of the garden.

Many other volunteers keep the cogs moving. They include knowledgeable guides who give daily tours, a computer whiz who maintains our data base, greeters at the Welcome Court, up to thirty people who help with spring and fall clean-ups, and an entire team that coordinates the very successful Fairy Hobbit House Festival in October.

Add to that our board of directors who contribute hours of their time, led by the indefatigable and cheerful Marc Bono, board president since 2018.

Top left: Volunteers assemble for spring clean-up day.

Bottom left: Boy Scout troop cleans out the bottom of the barn.

PHOTO CREDITS

Most of the photographs in this book were taken by Jill Nooney. Others are by the following photographers on the pages noted.

John Hession: VIII, 20 bottom right, 23, 49
Jonathan Hornbeck: XX, 58–59, 118–119, 134–135, 136, 158
Josh Jameson: 20 bottom left, 24 left, 26 left, 46 left, 51, 110, 111 right
Morgan Karanosios: XIV, XVII, 27 right, 34–35, 36, 41 left, 65 bottom, 66–67, 68 left, 69 right, 72–73, 87 top, 88–89, 93 left, 104 left and right, 107 right, 112, 120, 121 top, 124 left, 144–145, 150, 151, 154–155, 157 bottom left, 170 right, 171, 178 top, 194–195
Francine Kontos: 39 bottom, 163 bottom
Ted Kontos: 38 top
Bob Munger: 14 center, 38 bottom, 40, 101 top left, 189 bottom, 191 bottom, 197, 199 top
David J. Murray, ClearEyePhoto.com: 37, 198
Dinanda H. Nooney: 4 bottom, 6 top
Pam Pennick: cover, 18, 61, 87 bottom, 94–95, 124 right top and bottom, 126–127, 180–181, 203
Michael Sterling: 121 bottom, 204
Wendy Tauber: 39, 186 top right and left
Bob Woodward: 42

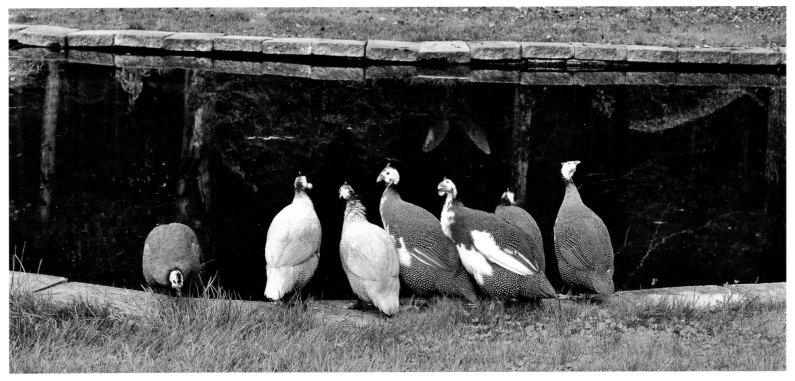

The guinea hens at the Wiggle Waggle giving their opinions.

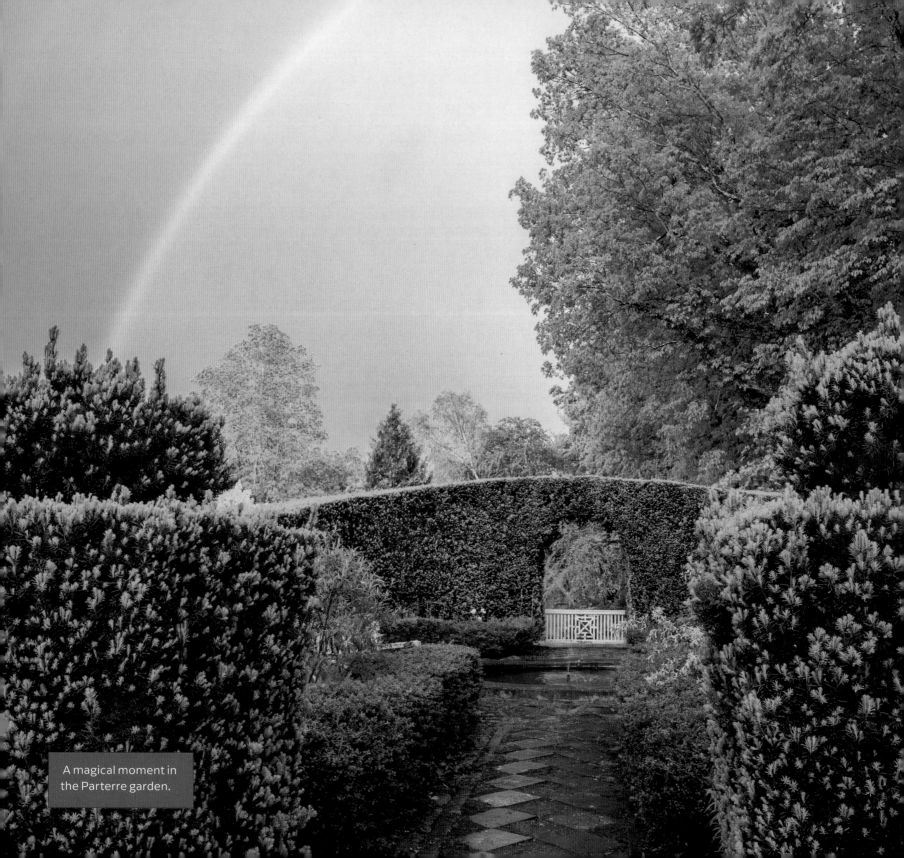

A magical moment in the Parterre garden.

REFLECTIONS

One lesson the garden has taught me is to listen. The Torii is a good example. When the timber was delivered, I immediately knew I had envisioned it in the wrong place. Putting my embarrassment aside, I knew the garden would tell me where the timber should be. I just needed to wait and turn my attention elsewhere. This has happened so many times that now, when stumped, I shrug and say, "It will come to me."

Another lesson from the garden is about acceptance. Things change and we all toggle between desperate caring and surrender. I lose sleep over a rainless month and fret about depleting our fragile well. I worry that my new plants won't make it and then later come to feel if they die, they die. I surrender.

There are other lessons. Be careful about introducing plants in an ornamental garden that are known opportunistic spreaders, both for your sake and for those who follow you. Nature makes it difficult enough to manage plants.

The garden has taught me about scale. The out-of-doors is big. The floor is the ground and the ceiling is the sky. So when you introduce a feature, bigger is often better.

The garden has invited me to peer closely at it down to the stamens and stigmas and the bugs on the undersides of leaves, to slow down and to marvel at the beauty and complexity of the natural world.

Most helpful, the garden has taught me to cultivate loving detachment. I made the garden but it is not mine. I love it and it comforts me—but it doesn't love me back. This feeling is captured so well in this Mary Oliver poem:

I Go Down to the Shore*

I go down to the shore in the morning
and depending on the hour the waves
are rolling in or moving out,
and I say, oh, I am miserable,
what shall—
what should I do? And the sea says
in its lovely voice:
Excuse me, I have work to do.

— from *A Thousand Mornings*

But most important, the garden has taught me to trust—to trust that folks are deeply moved by the garden, as I am, and that they see something in me that I don't see. To trust that people who may not know each other, but who love the garden, will keep it safe and nurture it for our grandchildren's grandchildren. I believe that the power of beauty and love and care unites us, and makes me certain we have made the right decision to entrust Bedrock Gardens to others to care for after we are gone. The garden has taught me to trust this community of loving stewards, a kinship of like-minded souls.

Please be careful with the garden—let it speak to you and please listen.

* "I Go Down to the Shore" by Mary Oliver is reprinted by the permission of The Charlotte Sheedy Literary Agency as agent for the author. Copyright © 2012, 2017 by Mary Oliver with permission of Bill Reichblum.

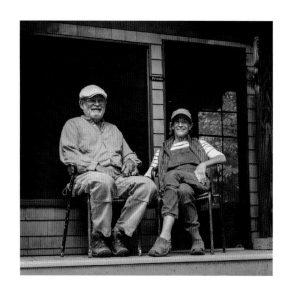

ABOUT THE AUTHOR

Jill Nooney grew up in rural New Jersey. She attended Bennington College, Smith College School of Social Work, and the Radcliffe Seminars Program in Landscape Design. She has had a lifelong interest in plants, art, and healing the human spirit. She lives with her husband, Bob Munger, in an old farmhouse in New Hampshire. Together, over the span of forty years, they created Bedrock Gardens and in 2023 they gifted the garden to the Friends of Bedrock Gardens to be enjoyed by all. This book tells their story.